SHANGHAI STYLE

SHANGHAI STYLE
Art and Design Between the Wars

Lynn Pan

LONG RIVER PRESS

Published in the United States of America by
Long River Press
360 Swift Avenue, Suite 48
South San Francisco, CA 94080
www.longriverpress.com

Editor: Tina Kanagaratnam
Designer: Edith Yuen

Published in Association with Joint Publishing (H.K.) Co., Ltd.

Library of Congress Cataloging-in-Publication Data

Pan, Lynn.
Shanghai style : art and design between the wars / Lynn Pan.
 p. cm.
Includes bibliographical references and index.
ISBN 978-1-59265-078-1 (pbk.)
1. Art, Chinese—China—Shanghai—20th century.
2. Design—China—Shanghai—History—20th century.
3. Art and society—China—Shanghai—History—20th century.
I. Title.
N7347.S48P36 2008
709.51'13209042—dc22

2008001525

Printed in China

ISBN 978-1-59265-078-1

10 9 8 7 6 5 4 3 2 1

I am grateful to the individuals and institutions who granted me
permission to reproduce the images included in this book.
I have made all reasonable efforts to contact the owners of rights
to obtain their permission. Any omissions or errors are entirely
unintentional and will be corrected in subsequent printings if
brought to the attention of the publisher. — L.P.

For Michelle Garnaut,
most stylish of Shanghailanders

JACKET ILLUSTRATION adapted from the back cover of a magazine, *Yinse lieche*, published in Shanghai in 1935.

CONTENTS

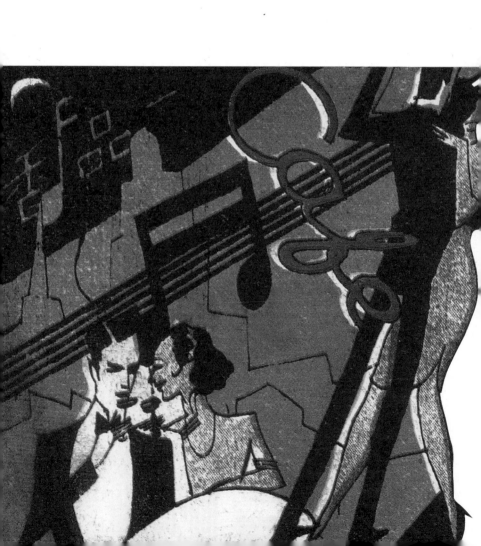

PROLOGUE

Any new arrival sailing into Shanghai in the period between the two world wars, 1918 to 1939, would be struck almost immediately by the contrasts and anomalies which gave the city its peculiar fascination. It was exotically Chinese, yet familiarly European too. The humanity that met the eye at every turn was certainly Chinese. Yet if he were a first-time visitor and a naïve European, and had expected to see the China of stately pleasure domes and fanciful tea pavilions, our visitor would have been sorely disappointed. Why, the place was more like Liverpool, he would think to himself as he surveyed the skyline of the Bund, the waterfront that was for him and many other travellers their first landfall in China.

Our visitor had been booked into the Cathay Hotel, only a stone's throw from where he had landed. Ushered into the foyer, he noticed instantly that the place reeked of wealth, albeit of a rather new kind. Now here was a place where he could easily indulge his liking for creature comforts; indeed, its coveys of liveried Chinese menials would probably see to it that he did so more luxuriously here than he could at home.

(Opposite) 'Shanghai nightlife,' reads caption to sketch by Zhang Zhenyu in *Shanghai Sketch*, Mar 22, 1930.

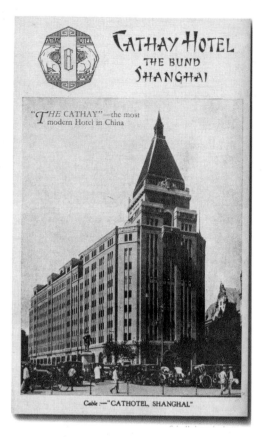

Yet if luxury implied plush, chandeliers, gilt cornices and pilasters in Ionic order, then the Cathay Hotel was luxurious in an altogether new style. True to its time, the hotel was frankly and fashionably modern, with a décor contemporary with the style of such hotels as the Waldorf-Astoria in Manhattan and Claridges in London. No wonder the Shanghainese believed theirs to be an up-to-date city, one that was ahead of other Chinese centres in its embrace of the twentieth century.

Shanghai accepted what the twentieth-century world had to offer more readily than other parts of China, be it new technology, ways of thought, cultural forms or artistic styles. Where but in Shanghai would a Chinese so quickly find such modern symbols as escalators, cinemas, dance halls, advertising billboards,

popular magazines, gramophone records, motor cars and women's fashions?

No city in China had so much of the West in its make-up. In the preceding century the sightseer from the Chinese provinces was invariably dazzled by the brightness of the street lighting, those gas and, later, electric lamps that according to him turned 'night into day,' just as he never failed to marvel at the wide, paved roads and the horse-drawn carriages that travelled up and down them. Bearing out all that they had heard of it, Shanghai stirred the curiosity and fancies of writers and illustrators, by whose work it came to be more intensely portrayed than any other Chinese place. In their work fact and fantasy folded into each other, and the distinction between Shanghai as it was and Shanghai as it was imagined broke down – or was deliberately smudged. Cities have ever been the subject of mythmaking, and Shanghai too became a city continually and breathlessly defined by metaphors, three of the most constant being 'paradise,' 'dream' and 'playground,' with the emphasis always on the place's uniqueness, prodigiousness and, to Chinese eyes, its foreignness and strangeness. To these characteristics were added the clichés of extravagance, vulgarity, corruption and criminality, complicating the dream image of Shanghai with nightmare, and lending revulsion to the fascination it inspired in both Chinese and Westerners.

The romanticized image persists, as is evident in the survival into the present of the clichés which Europeans had attached to its earlier, pre-communist incarnation, the two most frequently invoked being 'Paris of the East' and 'the Paradise of Adventurers.' Nowadays the image is even parodied, not always consciously, in the décor of bars and restaurants, and in the fusion cuisines, designs and fashions (this last exemplified by clothes sold under the label 'Shanghai Tang') that today play on the nostalgia for the lost world of a supposedly stylish and seductively decadent Old Shanghai. These pastiches strive for something which copywriters call 'Shanghai Chic,' cashing in on

a reputation for glamour which the city enjoyed in its heyday, before socialist drabness set in. They look back to a time when a peculiarly Shanghai style held sway, one that was constituted as much by an attitude, a context, a way of living and behaving as by an aesthetic or a set of definable formal features. In that style, tendencies predominantly artistic in emphasis cross with others chiefly behavioural in emphasis and with still others social in emphasis.

A conventional handle for describing those qualities which set the Shanghainese apart from other Chinese was 'Haipai' (*hai* being the second syllable of, and a shorthand for, Shanghai), a term sometimes translated as 'Shanghai School' but more often as 'Shanghai style.'

The Shanghai School, of which more in the next chapter, comprised professional painters who found patrons in Shanghai's thriving art market in the late nineteenth century. These patrons were mainly merchants whose taste was less highbrow than that of the high officials and gentry collectors who traditionally defined the canons of taste. The merchants' taste was for more popular subject matter drawn from real life or from legends and stories from the past, and for a more colourful, decorative and indeed more ostentatious style. To look down on such artists, and to their patrons as money grubbers of dubious lineage, would be natural enough, but Haipai paintings had something new and innovative to them, the best of them flouting long-established conventions to create fresh and arrestingly original works.

To use the term 'Haipai' of these painters is to use it retrospectively and inclusively. Over-inclusively, say purists, who point out that the term was not coined until the 1920s, to characterize the Shanghainese adaptation of the musical drama called Beijing Opera. People sometimes spoke of 'Haipai Beijing Opera,' and by this they were referring to the changes undergone by the style and staging of the opera after it took root in Shanghai. From the start Shanghai was a nursery for not only new forms of traditional opera

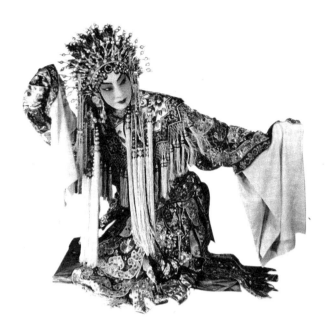

but experiments in drama; it was the first to introduce the so-called 'civilized plays,' the Chinese name for purely spoken plays adapted from, or imitative of, modern Western theatre. In this its dramatists and actors were inspired by Japanese examples rather than those they could have found closer to home if they had looked in theatres like the Lyceum in the foreign settlements. However, together with establishments which Shanghai's theatre reformers had visited in Europe, the Lyceum did provide ideas for the founding of the New Theatre (1907), the first Western-style theatre to be built by the Chinese. A Beijing Opera staged there would be noticeably different from that performed in the old style: for a start, the theatre was not synonymous with the teahouse, where watching a performance did not stop the audience from simultaneously sipping tea, eating snacks and chatting.

The form changed not just in the staging, but in other ways too, with the plots and performances taking on many of the characteristics of 'civilized plays.' In aspiring to be more relevant and modern, it

tended towards greater realism, at times sneaking in politically progressive themes. And as it did with much else, Shanghai also reinvented the form to broaden its popular appeal, bringing to the staging of it such novelties – or travesties, purists would say – as lighting, sets, props like real swords or even real animals, arias sung in the vernacular or snatches of local folksong, all these done to meet the exigencies of the box office. As some of these novelties were first seen in the Western theatre, the bastardization was made worse, in purists' eyes, by foreign corruption. In time the Shanghai way came to affect even performances in Beijing, much to the chagrin of the opera fans there; and to distinguish it from its Beijing form, as well as to discredit it, they affixed to it that slur, Haipai, and named it 'Shanghai-style Beijing Opera.'

A slur, because to its detractors Haipai illustrated their belief that to commercialize an art form was inevitably to vulgarize it. This belief lay behind a slanging match that Beijing- and Shanghai-based writers engaged in between the 1920s and 1930s, with the former characterizing Haipai literature in the worst possible terms. What it is, said one Beijing-based writer, is meretriciousness, opportunism, affectation, pretentiousness, imitation, plagiarism, rumour-mongering, the 'artiness of celebrity men of letters' conjoined with the 'auctioneering of traders'... and so on and so forth. Another identified Shanghai's culture with 'compradors, hoodlums and prostitutes,' one that was focussed on 'money and sex' and covered over with a pall of decadence.

The Shanghai-based writer's defence was: we might indeed write for the market, and so have to write faster; how could we not when, simply by virtue of our place of residence, we lack access to the privileges that Beijing's writers enjoy from their professorships? We should hardly be damned for this, any more than the Shanghainese variety of Beijing Opera should be disparaged by having the term 'Haipai' applied to it. Perhaps Haipai is only 'the style of the metropolis' by another name, and, with the rapid growth of modern

industrial society, Beijing itself might find itself quickly overtaken by that style, just as has happened with Beijing Opera.

If Shanghai was the metropolis, then where was Beijing? Part of the denigration of Haipai came no doubt of its affront to the capital's sense of imperial selfhood. The rivalry between the two cities was to endure, and Beijing is still the Other by which Shanghai's identity is defined. That Haipai is better understood by being contrasted with Jingpai, Beijing style, is implied by Lu Xun (1881-1936) when this famous writer weighed in with his renowned essay (*Jingpai versus Haipai*) reconciling the two sides of the squabble. It is really, he suggests, six of one and half a dozen of the other, hangers-on both, with the difference only that while the Shanghainese feed off businessmen, the Beijingnese do so off officialdom, openly in the one case, and surreptitiously in the other. That the latter could hide their dependence, and the Shanghainese could not, allows the Beijing types to put on airs before outsiders, forgetting themselves.

Fiction Bimonthly (Xiaoshuo banyuekan), one of numerous outlets for the Haipai writing which Beijing-based writers denigrated, 1934. Cover designs by artist Huang Miaozi (b.1931). From Huang Miaozi, *Miaozi za shu,* Shijiazhuang, 2003.

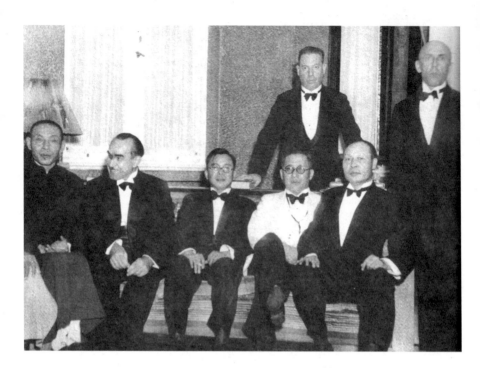

Haipai personified: underworld boss Du Yuesheng (*far left*), one of the three types identified with Shanghai's culture by its detractors, the other two being compradors and prostitutes. Next to him is Shanghai's Russian consul, and fourth left (seated) is Mayor of Shanghai Hu Tiecheng, 1934.

Thus the two, Beijing and Shanghai, came to exemplify the two sides of that familiar question: whether to cleave to tradition, or to modernize. Through any arena – writing no less than art and design – this problem ran as a leitmotif, manifesting itself as a conflict between old and new, nostalgia and progress, self-absorption and openness, country and city, indigenous and foreign, disdain for the marketplace and eagerness for profit. The Jingpai versus Haipai controversy is but another face of this conflict.

It is clear from the words exchanged in that controversy that Haipai was seen not only as a style of writing or theatre but, more broadly, as a type of behaviour and character. The treaty port that was Shanghai, a city of capital and labour rather than of nobility and commoners, gave birth or favour to many sorts of men. There was, for example, the man who made his own fortune. There was the comprador, the business go-between and speaker of pidgin English.

Famously, there was the munificent gangster, pre-eminently exemplified by Du Yuesheng, better known to the foreigners as Big-Eared Du. This is how an American observer has described him: 'Du is a compound of an Al Capone with social standing, a Lucky Luciano on a Wall Street scale, and a Shanghai Rockefeller badly in need of an Ivy League to put him right with the public.' To his contemporaries in the early decades of the twentieth century, Du was the quintessential Haipai man, a risk taker who was in the habit of 'staking a thousand pieces of gold on one throw,' spending money like water, open-handed to a fault. In him they saw the extravagance, showiness and flair that, together with a pronounced desire for social esteem, observers simultaneously admired and reproved as typically Shanghainese.

Knowing themselves to be the arbiters of taste and fashion for the whole country, and not feeling that their cultural expression was ever at risk of being obliterated by larger powers, the Shanghainese sometimes used 'Haipai' of themselves in ironic self-assertion, pejorative as it was. Indeed, in time the term shed its negative connotations and, instead of denoting all that that is wrong with Shanghai, nowadays it signifies all that is right with it. From being a term of opprobrium, it has become a proud defiant banner. Developers use it today to market their condominium blocks, restaurateurs their fusion cuisines, conveniently forgetting its sugguestion of a meretricious culture given over to surfaces, all style and no substance.

Looking back, we see that it was a product of a rapidly expanding commercial society where taste was not simply expressed through visual style but could be translated into fashion, the better to market it to people who, by following and consuming it, could quickly communicate their collective and individual identity. It revealed the fine line between culture and commerce, and the interconnectedness of identity with fashion. Fashion is intimately linked to style. The blurb to Witold Rybczynski's book *The Look of*

Fashionable Shanghai girl with lipstick, nail polish and cigarette, 1930s.

137

Ballroom dancing, a qualification for *modeng*, pictured on cigarette card, 1930s.

Brand of cigarettes named 'Modern' manufactured by Yongtai Tobacco Company of Shanghai, 1930s. From Hong Lin and Qiu Leisheng, *Zhongguo lao yanbiao tu lu*, vol 2, Beijing, 2001.

Architecture (2001) describes style as the language, and fashion 'the wide – and swirling – cultural currents that shape and direct that language.' Rybczynski agrees with the French fashion designer Chanel when she remarked, 'Fashion passes, style remains.'

However, this is not to say that style doesn't change, because it does so with regularity. To take an example from architecture, just the fact that different periods favour different materials means that styles change. Moreover, styles themselves come in and out of fashion, giving rise to revivals. In art and design, style can be generated from adaptations of visual conventions (such as realism or abstraction); it can equally derive from technique (ink vs oil, woodblock vs lithography), or from the artist's choice and treatment of subject. All these, adaptations no less than techniques and artists' choices, are subject to the conditions of their age. Chinese nowadays use 'Haipai' so broadly and ahistorically that it doesn't conjure up any particular period any more. But as this book understands it, Shanghai Style is a period style as well as all the other things I have mentioned, its climax being the years between the wars. So though Haipai customarily translates as 'Shanghai style,' what I call 'Shanghai Style' – 'style' spelt with a capital s – is in some cases less inclusive, and in some cases more, than Haipai.

Shanghai Style was given cachet by its connotations of modernity. In the Shanghai of the time what was smart and what was in vogue were inextricably intertwined with what was modern – or *modeng*, as the Chinese called it. *Modeng*, a word quickly absorbed into the Chinese lexicon, was much bandied about in the interwar period, popularly understood in the sense which *Modern Cinema* gives it when, in an issue published in 1933, the magazine breaks it down to ballroom dancing, brilliantined hair, crimson lipstick, multi-coloured nail polish, automobile, Western-style villa, Western food, handbag, high heels, falling in love, feeling depressed and so on. But these are all signs of an inauthentic modernity, the magazine writer

goes on to say, authenic modernity being defined by a strong, supple and healthy physique, and an interest in and knowledge of science, particularly social science. The ambivalence which many felt towards the *modeng* echoed the ambivalence felt towards Haipai, with some talking about it as though it were something harmful, a '*modeng*-poison' by which an out-of-towner could be infected once he found himself in Shanghai.

From ballroom dancing to knowledge of social science, what the *modeng* comprehended for Shanghainese was recognizably Western. The Shanghai Style which comprehended it in turn was certainly a mix where cultural frontiers crossed, Chinese with foreign. Of course the foreign, principally the West, was no more at one with itself than the Chinese – to begin with, the influences which worked their way from the West to Shanghai broke down into not one but several phases, each with its own stylistic tendencies. The prevailing patterns as found in the arts as well as in the broader cultures and institutions of the West changed with time as each generation bequeathed what it had inherited from its predecessors, as well as what it had itself created, for its successors either to accept or

Design of sweetmeat box (*below*) advertised in *Shenbao* is based on abstract, rectilinear geometry, 1934. Stylistically, it poses sharp contrast to packaging label on (Guangjixiang brand) mooncake, late 1920s (*above*). From *Shenbao*, Feb 7, 1934, and You Guoqing, *Zaijian lao guanggao*, Tianjin, 2004.

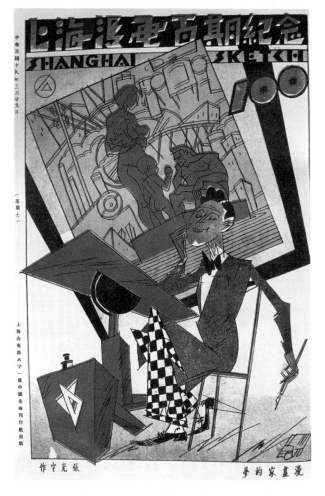

Entitled *A Cartoonist's Dream*, this cartoon cover by Zhang Guangyu (see Chapters 3 and 4), celebrating the hundredth issue (March 29, 1930) of *Shanghai Sketch*, incorporates his cover *Cubist Shanghai Life* for its inaugural issue on April 21, 1928. Hard-edged planes and geometric forms allow subjects to be depicted in a modernist guise.

reject. As these patterns changed, so the influences on Haipai changed. Thus Chinese artists were confronted by two pasts – their own and Europe's.

Of the European influences they felt, none was wider, went deeper and lasted longer than the collection of movements, ideas and tendencies covered by the blanket term 'modernism,' understood here in its broadest sense, as comprising a wide range of styles exemplified in the visual arts by the flattening of painted images and various degrees of abstraction, and as having as its chronological outside limits the

years 1880 and 1950, with its high season somewhere between the two world wars.

It is not hard to see why modernism had the impact it did: it was the most influential movement of the twentieth century, and it was international and cosmopolitan in outlook and practice. From Paris, Berlin, Moscow and New York, it spread across the whole world, arriving in Shanghai either directly or via Japan. The work of fine artists was less pronounced in this process than that of designers and architects; and it was as one of a number of style choices whose forms were copied and adapted for various artefacts from magazine illustrations to buildings that modernism had its greatest impact in Shanghai, an impact all the stronger for the commercial, mass-produced guise the style had assumed from its appropriation by the American marketplace. In its hospitality to it Shanghai was not exceeded by any other Chinese place, and if we call Haipai an eclectic style, which it was, there can be no doubt that one of its sources was modernism.

It would be hard to understand Shanghai Style, then, without recognizing that modernism was integral to it. Without forgetting the behavioural slant that has been given to Haipai, this book explores the modernist strain in Shanghai's cultural productions, specifically painting, graphics, architecture and interior decoration. As the mixing that begot Shanghai Style reached a peak in the period between the wars, it is on the 1920s and 30s that I mainly concentrate, treating earlier and later periods sketchily. By 1949, the year of the communist victory, Shanghai Style had had its day. The passing of styles is a familiar story everywhere, but Shanghai Style was a chapter not so much ended as blotted out, excised by fiat from the collective memory along with an entire way of life. Between 1949 and the start of the reform era in the late 1970s, it was written out of history as though it had never happened. This lends it added poignancy, and makes it a story worth telling.

1

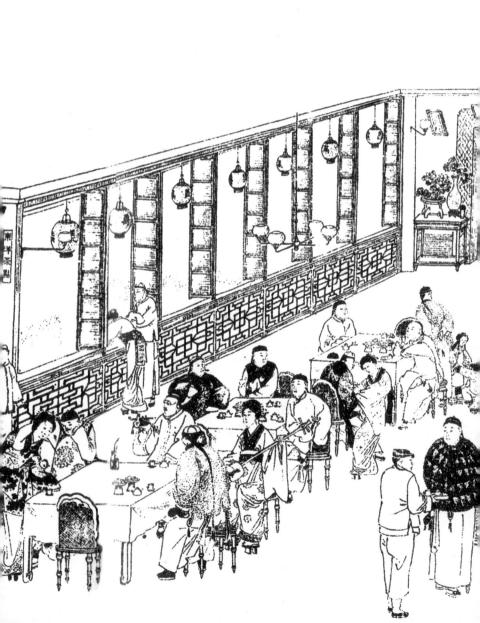

ORIGINS OF AN URBAN STYLE

To set Beijing Style against Haipai, as Lu Xun has done, is to oppose officialdom to the marketplace, north to south, East (or Chinese) to West, and highbrow taste to popular culture. (That, any rate, is how the Shanghai historian Li Tiangang has analyzed it.) But another way of understanding Shanghai Style better is through the notion of not only 'Jingpai versus Haipai' but 'Shanghai versus the rest.' There runs through much writing about Shanghai the suggestion that it had no like. The city has been called 'the other China' and it has been said again and again that 'Shanghai is not China.' To see how that difference from the rest of China emerged and what constituted

(Opposite) Japanese teahouse in Shanghai patronized by Chinese customers with geishas to entertain them. Wu Youru, *Shenjiang shengjing tu*, 1884.

it, one must go back in time to 1843, the emblematic starting point of Shanghai's opening to the West.

On a grey November day that year, Captain George Balfour of the British Madras Artillery Force arrived to become Shanghai's first British Consul and to declare the port open for business. These British arrivals had come to claim the concessions they had won by defeating China, then ruled by the Qing imperial house, in the first Opium War. The war had been fought to make it easier for British merchants to sell Indian opium to the Chinese – there was not much else the British *could* sell them, the Chinese thought, believing themselves self-sufficient in most things. The British were much the most numerous and successful of the merchants who operated 'factories' or warehouses in Canton, the one port in China where foreigners were allowed to trade until the start of the war. In exchange for opium, they, and the traders of the other foreign powers with 'factories' in Canton – among them the Americans, the French and the Dutch – bought from China large quantities of tea, rhubarb, and the silks, porcelain and lacquer so fabled in the West.

To open up China and to make it a commercial

Opium, balls of which are being dried in British East India Company's factory in Patna, India, was the 'foreign mud' on which Shanghai's booms were founded.

20

extension of India would widen Britain's imperial horizons even further, at a moment when its trade and influence were supreme in Eastern waters. An ill-fated attempt by the imperial court to stamp out the trade in opium and cleanse Canton of 'foreign mud,' the Chinese name for the drug, gave Britain the opportunity. Gunboat diplomacy ensued and British naval squadrons arrived off Canton and then in Ningbo, to the south of Shanghai on the other side of the Yangtze estuary. On June 19, 1842, the British landed in Shanghai unopposed by its panic-stricken inhabitants and quartered a few regiments in the gardens of the Temple to the City God.

Brought to its knees by British technology and firepower, the Qing government was forced into negotiation. The Nanjing Treaty of August 29, 1842, concluded the war. The agreement, signed aboard Her Majesty's ship *Cornwallis* and ratified ten months later by Queen Victoria and the Daoguang emperor of China, turned out to be the most important settlement in China's modern history. As one of the five 'treaty ports' named by the agreement – the others being Canton, Fuzhou, Ningbo and Xiamen – Shanghai was to be opened up to British trade and residence.

And now, the first British contingent had arrived in Shanghai. The Chinese officials turned down Balfour's request to be housed within the walled city, but officials were one thing and merchants quite another, and the new arrivals had only to step out of the government office to have a Chinese merchant approach them with an offer of rental accommodation. This gentleman was happy – and money-minded – enough to lease them his fifty-two-room furnished mansion inside the city walls and, once they had ensconsed themselves there, to sell tickets to curious Chinese to see the 'white devils' go about their business. So already, early in their acquaintance with the place, the newcomers discovered the Shanghainese to be Shanghainese – quick to seize an opportunity and to think up ways of making money.

Unlike the island of Hong Kong, which the treaty

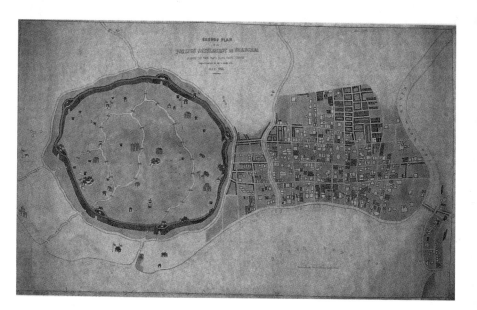

To left of map, 1855, is circular walled town of Shanghai with Temple to the City God (in map's southwest quadrant). Immediately to its right, wedged between two creeks, is the French Concession; and to the right of that is the British settlement, amalgamated with the American settlement across the Suzhou Creek in 1863 to form the International Settlement with a single government, the Shanghai Municipal Council.

ceded to Britain 'to be possessed in perpetuity by Her Britannic Majesty, Her heirs and Successors,' what the British secured in Shanghai was a 'settlement,' an area in which British subjects might acquire land from Chinese owners, the titles being granted in the form of a lease under which a small annual rent was reserved to the Chinese government. If the settlement was a colony, it was one in fact but not in name, brought within the ambit of the British Empire's overseas possessions informally.

The British enclave was to be built on a marshy site to the north of the walled city, one bounded to the east by the Huangpu River, to the south by a creek called the Yangjingbang, and to the north by where Beijing Road stands today. It was to be a proper British port, Bombay replicated perhaps, with an anchorage, a river frontage, a cemetery, quays and land for warehouses and residences. The site was jointly chosen by Balfour and the Chinese authorities, and must have satisfied both parties – the British for its adjacency to the only deep-water anchorage suited to Western shipping, and the Chinese for its distance (nearly a mile downriver) from the walls of

the city. The two sides had this in common at least, that neither relished the prospect of living at close quarters with the other. If the Chinese liked to keep foreigners at arm's length, it suited the British to live well away from the natives – a stance consistent with the practice of segregation in the colonies, where British rulers held themselves separate, the better to maintain their cool superiority and keep natives in their place.

Other foreign nationals had designs on Shanghai too, chief among them the French and the Americans. The French, who wanted not so much a trading post as the furtherance of the cause of Catholic missions in China, acquired a large plot of church land to the south of the walled city but also based themselves on a wedge of territory between that city and the British settlement. Bounded to the north by the Yangjingbang Creek and to the south by the walls of the Chinese city, this area came to be known as the French Concession.

The Americans, for their part, staked their claim to the other side of the Suzhou Creek, just beyond the northern limit of British jurisdiction. Later, they decided it suited them just as well to merge their jurisdiction with that of the British, and the two were amalgamated to form the International Settlement. The idea of teaming up with Anglo-Americans held no appeal for the French, however, and they chose to run their municipal government on their own. Shanghai thus became three cities in one – the native city, the International Settlement, and the French Concession.

The International Settlement ran to the British colonial pattern in being a segregated space, kept at a distance from the native city and inhabited by Europeans only. But all this changed when, in quick succession, the so-called Small Swords Uprising and the Taiping Rebellion threatened Shanghai. The Small Swords was a secret society, a subdivision of what might loosely be called the Triads. Formed by gangs of opium smugglers, boatmen and out-of-work

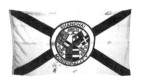

Banner of the Shanghai Municipal Council, which ran the International Settlement. Shanghai History Museum.

labourers from the south (chiefly the provinces of Guangdong and Fujian), the Small Swords laid seige to the walled city in 1853. Badges of insurrection distinguished the toughs of Guangdong, the southern province of which Canton was the capital, from those of Fujian, its southeastern neighbour, with the former sporting white head cloths and the latter red.

They appeared, though, to have no quarrel with the foreigners, who could walk unharmed through the city and who rather enjoyed being the object of the insurgents' curiosity. The British chose initially to remain neutral, but then they were based further from the native city than the French, who thought it more expedient to side with the imperial Chinese forces that had come to oust the rebels. Eighteen months after the seizure of the city, the imperial forces marched through the gates, beheaded those who had not already deserted, and reclaimed the city.

Meanwhile armies of the Kingdom of Heavenly Peace, or Taipings, advanced upon Shanghai. Sweeping up from the south in 1850 in a wave of savage destruction, espousing a strange sort of Christianity, these insurgents had seemed unstoppable at first. But when, in the summer of 1860, they came within sight of Shanghai's native city, they were taken aback to see British and French flags flying on its walls. The Taipings did not take Shanghai, and it was a combination of Chinese and foreign defences that eventually suppressed the rebellion itself. One foreigner who made his name fighting alongside the Chinese imperial forces was the legendary Charles 'Chinese' Gordon, he who led the foreign-officered mercenary army against the Taipings and who was later famously to lose his life in Khartoum. Apart from naming a street after him, Shanghai raised no other memorial to the man who, by stopping the Taipings in their tracks, helped to consolidate the foreign settlements' reputation as a safety zone.

If the Small Swords sent Chinese scurrying for

safety to the settlements from mainly the native city, the Taipings drove them from a far wider area, one encompassing the neighbouring provinces. Nor were these newcomers poor Chinese only, but gentrymen, mandarins, landowners and merchants. And this moneyed class brought their assets and cultural tastes with them. With the incoming Chinese occupying every bit of available space, segregation broke down and the characteristically colonial distinction between native and European areas blurred. The foreign settlements became what they were not meant to be: safe haven, immigrant destination and melting pot. From the 1850s until China turned communist in 1949, every social disturbance in the interior would trigger a wave of in-migration. The spectacular leaps in population and wealth Shanghai experienced during those decades were accompanied by staggering rises in property values, beginning with as much as a 160-fold increase in land prices in the aftermath of the Taiping Rebellion.

The influx of so many diverse groups from the provinces diminished the indigenous Shanghainese element, but immigrants began to think of themselves as Shanghai belongers soon enough, so readily did this city assimilate its immigrants. In any case most of them had come from the neighbouring provinces, and people from northern Zhejiang and southern Jiangsu spoke the Wu dialect, of which Shanghainese speech is a variant; so language was no barrier to integration, and within a single generation these people considered themselves 'Shanghainese.' When you said that an individual's behaviour was 'Haipai,' you didn't necessarily imply that he was a Shanghainese native, only that his character or identity was. To that character or identity had been attributed a wide range of characteristics, most of them stereotypes; yet like all stereotypes they had a grain of truth in them.

One of these is that Shanghainese loved the new. And all too often, 'new' was but another word

for 'foreign.' The Shanghainese love of novelty was another facet of their relative openness to the West. This is a trait that is brought into sharper relief when the Shanghainese are set against Chinese from elsewhere in China.

When the first foreign merchants set up shop in Shanghai, they brought with them the Cantonese compradors (or agents), factotums and even the cooks they had previously employed in Canton. One day these Cantonese would be challenged by people hailing from the port of Ningbo, but until this happened they dominated the burgeoning world of East-West business in Shanghai. Indeed, in the second half of the nineteenth century, as many as twenty-four of the twenty-seven compradors in the British and American firms there were Cantonese. And it was Cantonese traders too who were first off the mark when opportunities beckoned with Shanghai's opening and Chinese from all corners of China began flocking there.

The Cantonese dominance in those early years is easily explained. Canton was the one Chinese port open to European trade after 1759, though even there foreigners were forbidden residence except during the trading season, from October to March. All the same, the Cantonese were the only Chinese to have had close dealings with the Europeans before trade was thrown open to all by the terms of the Nanjing Treaty.

Of the five treaty ports, then, Canton with its deeper and wider experience of foreign business might now be expected to flourish the most. Yet of the five ports, only Shanghai became a boomtown. Canton lost its lead for many reasons, geographical, political, economic and social, and of this last factor one facet was its intenser dislike of foreigners. Among other things the foreign merchants were put off by the local antipathy, which had been expressed in waves of anti-British attacks by Cantonese mobs in city and country. In the face of such hostility, only the most foolhardy European would try to make a home and establish a business

Tong King-sing (Tang Tingshu), Cantonese comprador to Jardine Matheson & Co. in Shanghai from 1863 to 1873.

there. Ostensibly anti-foreign incidents occurred in and around Shanghai too, but closer scrutiny reveals them to involve either incomers from other parts of China, or reasons other than anti-European sentiment. A British Royal Naval commander wrote after five years of travelling and living in China in the 1840s that while experience had taught the English merchant that even his own house in Canton might be 'a very unsafe refuge from a furious and ignorant mob,' in Shanghai he was surrounded by 'a peaceable and hospitable community.' He had good grounds, the naval commander continued, for saying that in Shanghai 'insults or annoyance of every kind' were 'less frequent to strangers than any part of the world.'

If the Shanghainese appeared more tractable, if they came to be known for their relative pliancy and tolerance, it was partly because so many of them were immigrants. To these immigrants, Westerners were but outsiders like themselves. Besides, why would they want to make trouble – to escape trouble was why they had come here in the first place? That and to make their fortune. To the natives, already surpassed in number by immigrant communities speaking other Chinese dialects, Westerners added to the diversity but did not inaugurate it; as merely the latest strand in Shanghai's polyglot patchwork, they did not have to be singled out for ill-will. Perhaps the Shanghainese readiness to live and let live was only the flip side of their insouciance. Whatever it was, they did not get worked up about the strangers in their midst.

Being mixed-up was a Shanghai condition, which is not to say, however, that the place was a melting pot from the start. Though they would think of themselves one day as Shanghainese, just then the immigrants had yet to settle deeper into their collective identity. Every regional group rubbed shoulders with every other group, but Ningbonese stuck together with Ningbonese, Cantonese with Cantonese and so on. The collective identity that was to emerge subsumed

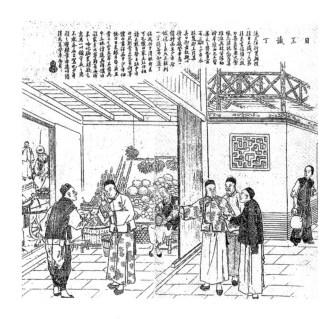

Pretending he can read, an illiterate comprador mistakes a request for dogs for an invitation to dinner, and is discomfited when his servant puts him right. Lithograph, *Dianshizhai Pictorial*, 1897.

Scene of Englishmen playing cricket in Shanghai accompanied by comment, 'Western and Chinese men and women alike arrange with their friends to come and watch the matches.' Lithograph, *Dianshizhai Pictorial*, 1891.

these affiliations, but came also to imply a ready acceptance of things Western. So, looking back now to the start of the treaty port era, we see that already, long ago, the heterogeneity, the tolerance of outsiders and the openness to the West were there.

The first Shanghainese to serve as intermediaries between the native and foreign worlds were those who acted as purchasing agents for Western firms, the compradors who, as earlier mentioned, came initially from Canton. Many of them exemplified the rags to riches story of the middleman, becoming wealthy but unlettered upstarts of the kind Chinese of the old scholar class disdained. In a world made fluid, even dizzy, by new money, to be born into a family of cultured lineage no longer assured you of social superiority in Shanghai. 'The world is turned upside down,' a commentator noted in the 1880s, with people 'unprepossessing in appearance' and 'vulgar in speech' – in short, compradors and interpreters – aspiring to elegance. In place of class distinctions, writes the classically educated Wang Tao, who worked with English missionaries in Shanghai in the 1850s, 'Extravagance and profligacy are the rule. Wealth is

power. Overpowering dandies and bullying merchants know how to display their wealth, but they are illiterate.'

Since the Europeans knew no Chinese, those who dealt with them either spoke English or a kind of orientalized English called 'pidgin.' Because pidgin crossed Chinese vocabulary with a smattering of English, it was creolized speech, disparaged as being half-baked by the Shanghainese, who called it 'Yangjingbang' after the creek which divided the International Settlement from the French Concession. (It was at a spot near the creek that Chinese and Western merchants habitually talked business in pidgin.)

Entertainment guide shows one Shanghai diversion is to dine at Yipinxiang, which, though Chinese-owned and Chinese-run, is the city's best-known restaurant for European food – with of course a courtesan (here accompanied by her maid) for company. From Hushang Youxizhu, *Haishang youxi tu shuo*, Shanghai, 1898.

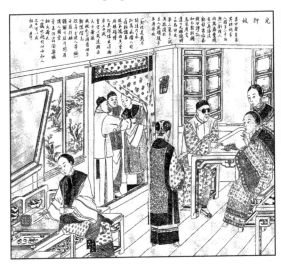

Close association with Europeans affected not only the way the locals conducted business but how they entertained themselves. Western sport and diversions quickly caught their fancy, so much so that a veritable wall of spectators, women included, would form whenever the British raced their horses or boats, or played cricket. There was novelty, even cachet, in doing things Western-style. You couldn't not have tried Western food, for example, if you wanted to be thought up-to-date. The restaurants offering such cuisine were in fact a curious mix of cultures, Chinese- rather than

(*Left*)Customer at bordello has to steal money to settle his debts, but dark glasses and pocket watch (on vest) show him to be a man about town. Lithograph, *Dianshizhai Pictorial*, 1887.

29

European-run, where the rooms were said to be elegant and the knives and forks to be 'bright as snow.' Chinese customers could be seen happily ordering champagne, beer, pork chops, steak or beef broth, the last two items a departure for the Shanghainese, for whom beef would not have been a choice earlier. For tourists from the provinces, until they had sampled European food there was a gap in their experience of Shanghai.

The men sporting pigtails and the women swaying on bound feet, the locals would still have been dressed entirely in traditional Chinese style, in long robes of silk and satin or cotton. But the playboys and dandies among them struck a fashionably foreign note by wearing sunglasses, and wearing them indoors to boot. Foreign was fashionable, as it was modern, and one showed it by how one was turned out – with shades over one's eyes, a cigarette between one's lips, a watch in one's vest pocket, an umbrella over one's arm. There is a sketch published in 1888 in which a courtesan is seen wearing European dress, with her bound feet showing beneath her skirt. In a world turned upside down, it was the courtesan who led fashion, not upper-class ladies. Such a world also produced 'hollow grandees,' young men affecting an elegance far beyond their means.

This conspicuous consumption was fed by the goods that poured into Shanghai in the wake of opium, to be displayed in foreign-run shops and marvelled at by those for whom Western things had still to seem commonplace. In a pictorial published in 1886, Shanghainese men are seen examining a fire extinguisher in a shop as its European proprietor looks on. They are gawked at by Chinese onlookers crowding the entrance. Hanging from the ceiling above their heads are the globes of a selection of Victorian chandeliers. One day these onlookers would scarcely look twice at such goods, so much would they take European material culture for granted, and so much would that culture have changed the way they consumed and conducted themselves. But just then such goods were new objects of desire.

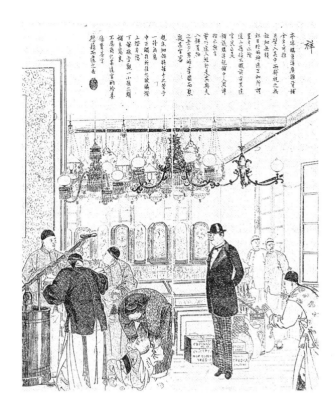

Genial European shopowner explains unfamiliarly foreign merchandise to intrigued Chinese customers while curious passersby look on. Lithograph, *Dianshizhai Pictorial*, 1886.

They were said to be undiscerning when it came to one particular object of desire, scroll paintings. Shanghai with its art dealers and picture-mounting shops was where professional artists migrated to from elsewhere in China, finding its atmosphere less stuffy and more hospitable to their unapologetic commercialism. These artists painted for city dwellers, *nouveau riche* merchants no less than refined scholarly patrons, and they painted unabashedly for money. They painted like their classical precursors, but also breached the boundaries of tradition, attuned to changes wrought in visual culture by technical novelties like lithographic printing and photography. Additionally, they evinced a familiarity with Western conventions and styles of representation, producing images with a whiff of the foreign about them.

Wang Tao observed in the 1870s that when Shanghai's men of business wanted 'to take on airs

of elegance' and bought calligraphies and paintings, they did so 'without any real appreciation,' going only by the artist's name. It was paintings of this ilk that cultivated fellows disparaged as being in the taste and style of Shanghai. That Shanghai was a commercial crossroads must somehow impact on the art world, and upon the patrons and painters who belonged to it, giving the latter enough of a distinctiveness to justify applying the label 'Shanghai School' to them. As an art that grew from the juncture of commerce and culture, Shanghai School painting couldn't be accused of being insipid or lacking in immediate appeal; on the contrary, it was characteristically bold, even flamboyant, in its brushwork and use of colour. In the depiction of the folds of garments in figure paintings, the line work was characteristically erratic, even agitated. And as the urban, even cosmopolitan, aesthetic that it was – Shanghai being a cultural as much as a commercial crossroads – this style of painting was exposed to the prints, paintings and illustrated books of Japan and open to the visual practices of the West, the latter comprising such techniques as the use of perspective to suggest recession into space and chiaroscuro to produce volume and mass in figures. Some Shanghai School painters sought inspiration in the past and incorporated epigraphs and inscriptions from ancient bronze vessels into their work, a practice that was true to the spirt of the city, whose modernizing trends could prompt one of two reactions: a search for new ways of being new, and for new ways of being old.

Historians today apply the handy label 'Haipai' to this school of painting. They have listed hundreds of artists under that rubric, and not just those specializing in the classical medium of ink and colour on paper and silk either, but illustrators, artisan painters, woodblock print artists and commercial artists painting backdrops and advertisements. Two ink painters who stand out from that crowd are the short-lived and remarkably talented Ren Xiong (1823-57) and, no relation, the versatile and prolific

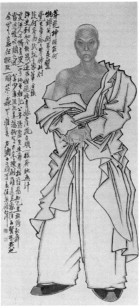

Ren Xiong's self-portrait, the representational techniques of which are European and Chinese at once. Hanging scroll, ink and colour on paper. Palace Museum, Beijing, 1856.

Ren Bonian's satirical portrait of fellow-painter Gao Yong as 'calligraphy beggar' with basket containing brush, paper and other tools of trade, 1888. Hanging scroll, ink and colour on paper. Palace Museum, Beijing.

Ren Bonian (1840-95). Ren Xiong has left us with an arresting life-size self-portrait which, when hung in an exhibition, has been something of a show-stopper, one whose feel is fresh and different enough from the run of Chinese likenesses to leap at the modern eye. What the viewer sees is a dramatic contrast, between the naturalistic modelling of the face and torso, rendered in shaded flesh tones suggestive of Western realism, and the schematic treatment of his garments, painted with the black-ink brushstrokes of Chinese

tradition. Western and Chinese representational techniques are clearly here together, but does the shaded face, art historians have wondered, also point to an acquaintance with the new art of photography?

Heavy shading of the face is also seen in portraits by Ren Bonian, counterbalanced in these cases too by agitated brush-and-ink movements in the rendering of robes and sleeve puckers. Chinese paintings might look repetitive to Westerners, but Ren Bonian's work was not just more of the same. He modernized the figure painting, showing some of his subjects in unorthodox dress and manner, quite lacking the solemnity required by custom. In technique too, continuity with the past did not preclude new departures, the possibility of which was afforded by his access to Western art. He is reported to have said that the difference between Chinese ink painting and Western oil painting was that the latter was harder. We know for a fact that he was exposed to European pictures and pictorial techniques, and though we can't be as sure that he did indeed, as has been reported, carry a 3B pencil about

Orphaned children at Tushanwan paint from plaster bust in studio hung with students' work, early twentieth-century.

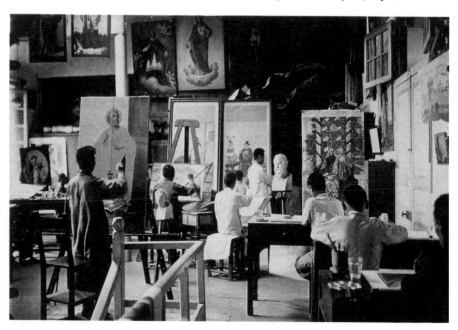

34

him so that he could make a quick graphite sketch of whatever caught his eye, his practice of preparatory pencil sketches in the Western manner is not in any doubt. Nor is the place where he procured his pencils: the Tushanwan Arts and Crafts centre in the outskirts of Shanghai.

Tushanwan warrants more than a mere mention, so important is it to the history of Western-style art in China. Today the name is all but forgotten (superseded by Xujiahui), but not the Jesuits who built their community there in 1864. These missionaries are still remembered by the buildings they left behind, chief of them the Cathedral of St Ignatius. An orphanage they established is gone, and so is the Arts and Crafts centre where Chinese children were taught and where, if they chose to stay on after their training, they were set to work. Brought in at the ages of between six and ten, some 2,500 children passed through the doors of the orphanage in the seventy years from 1864 to 1934. They learned woodwork, metalwork, stained-glass window-making, shoemaking, embroidery, lacemaking, printing, photography, sculpture or painting, and, once they had mastered their craft, produced things for sale in the Shanghai market or on commission.

One of their long line of teachers was Father Johannes Ferrer (1817-56). Spanish by birth, he had studied sculpture in Rome and, on arriving in Shanghai in 1847, found himself assuming responsibility for erecting a church, the Church of St Francis Xavier, in Dongjiadu, between the walled Chinese city and the river (see Chapter 6). His helpers were Chinese, and for them to be useful to him he had first to teach them. Another teacher was Nicolas Massa (1815-76), an Italian who has been credited with being the first to disseminate oil painting in Shanghai.

It was probably on images of the Madonna that budding Chinese painters and sculptors first cut their teeth. Religious images continued to be a staple of the painting department, and besides icons and stories from the Bible, the orphans learned to depict landscapes, birds and animals, all in the European style, using

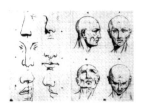

Drawing models which students learned to copy at Tushanwan painting school.

pencil, charcoal, oil and watercolours. Such practices were unknown to the run of Chinese painters. Just pencils would have been unavailable, which is why it is supposed that Ren Bonian got his from Tushanwan, which imported them specially from Europe.

Ren Bonian had a friend and intermediary in Brother Liu Bizhen (1843-1912), who had fled the Taiping rebels to Shanghai as a child, and who had attended school in Tushanwan, staying on to teach painting upon graduation. For a Chinese ink painter like Ren, Liu would have made a good inductor into Western art, for he had been trained in Chinese ink painting as well, and understood the two disciplines at first hand. Later generations would inherit this ambidexterity. But it was Liu and his cohorts who led the way.

Such was Tushanwan's legacy that Xu Beihong, a renowned painter of whom we shall hear again, would call it 'the cradle of Western painting in China.' He was like almost all other Chinese painters in disregarding the even earlier possibilities for gaining familiarity with Western conventions of representation afforded by the export trade in Canton. There, artisans and workshops had learned to produce pictures in the European manner since the eighteenth century, painting skillful copies of European prints on porcelain, say, or portraits of European subjects in oil. However, important as the Cantonese experience is to the history of Western art in China, it is hard to see how it could be integrated into the story of Shanghai Style, on which it appears to have had no bearing.

A prominent feature of the Shanghai School was the involvement of its painters with the publishing of illustrated books, an involvement so close that it is scarcely possible to separate Shanghai painting from printed images, the latter greatly increased by the introduction from the 1870s of lithographic reproduction. If a Shanghai visual style became familiar through the proliferation of images, this can be traced back, one way or another, to their reproduction by the new printing technology. Together with traditional Chinese woodblock

printing, the lithographic process supported the coexistence and interaction of several kinds of image production, from journalistic illustration to pictorial advertising. One who greatly enlarged the range of such imagery was the publisher Ernest Major, a Chinese-speaking British merchant who, with his brother Frederick, had dealt in tea and textiles, and opened one of the first chemical factories in Shanghai. In 1872, Ernest Major started China's first new-style newspaper, Shanghai's famous *Shenbao*.

This had a supplement, a pictorial named *Dianshizhai*, a publication influential enough to have played, as Don Cohn notes, 'the role of *Life* magazine in China before the age of photography.' The pictorial was published every ten days, aiming its illustrated news and at times sensationalized stories at a class of Chinese who Major believed would be informed and entertained by it. When it came to editorial content, though, Major seemed to have left it almost entirely to its Chinese editors and illustrators. Had he been more hands-on, he would surely have corrected the wrongly imagined scene of, for example, a frozen London river in one of the illustrations. A lighthouse the artist has placed beside an embankment is clearly out of place there, and the English skaters shown racing across the ice have no skates on!

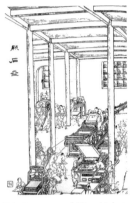

Printing press of *Dianshizhai Pictorial*. Wu Youru, *Shenjiang shengjing tu*, 1884.

Some readers probably thrilled to the strange and fantastical stories – of a six-legged ox and a mountain demon, for example – but others found it a useful source of information. A well-known Chinese writer, Bao Tianxiao, reports that it was from the pages of this magazine that he first learned of new inventions and things from abroad, though he does not say with how large a pinch of salt he took such tall stories as the one about Westerners having scientific means for chemically shrinking corpses to a small enough size to be put in a box they could carry around. When it comes to local Shanghai scenes, the illustrators are on much firmer ground, and whether the pictures are of Englishmen in Shanghai playing cricket or Chinese riding roller coasters, or of teahouses, bordellos,

37

temples, shops or clinics, the artists proved to be deft and observant, leaving to future ages images that charm and call up nostalgia.

The chief illustrator, and by far the best, was Wu Youru (d.1893). Wu had learned to paint in the old way, by copying models and, as an apprentice in a studio which sold calligraphy and paintings 'off the peg,' produced to order and painted for money. So commercialized had forms of pleasure, including visual pleasure, become that there was no shortage of demand for what he excelled in, namely figure painting and what was generically termed 'female beauties pictures.' His illustrations for the *Dianshizhai Pictorial* were line drawings made with the brush and ink of the traditional Chinese painter, and then printed lithographically. In these, his repertoire extended to images of Western locations, people and objects, but the best examples of his work remain his illustrations of local Shanghai scenes, the kind which the writer Lu Xun has categorized as 'Bawd beats Strumpet' or 'Hooligan assaults Girl.' Lu Xun supposes that it is because Wu had seen so many such scenes in real life himself. So great has been the influence of Wu's style, Lu Xun goes on to say, that even illustrations in textbooks, not to speak of novels, have come to portray children with the look of the hoodlum about them, their caps askew, their eyes slanted and their jowls fleshy.

Illustrated story of prostitute attacked by hooligan with awl in *Dianshizhai Pictorial*. From Don J. Cohn, *Vignettes from the Chinese*, 1987.

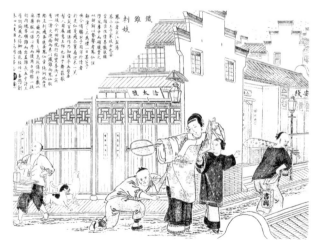

Lu Xun wrote on another occasion that deplorably, all women ended up looking like prostitutes if an artist drew them after looking at too many of Wu's pictures. He was exaggerating, of course, but there is no doubt that singsong girls or courtesans, denizens of what was called the 'world of flowers,' loom large in the imagery of *fin de siecle* Shanghai. A suitable gloss on Wu's pictures might be a passage from a contemporary guide or travel essay, the sort which cultivated men were fond of writing to evince their urbane connoisseurship of feminine beauty in conscious echo of the aesthetes and litterateurs of an earlier age. Waxing lyrical, a 1893 memoir likens the entrance of courtesans at the opera to 'the enchantment of summer orchids and musk-scented mist, elegant silk gathering like clouds,' ending with the exclamation that Shanghai was truly 'a fragrant city that knows no night.' Far from depicting it as sleazy, Wu represents the 'world of flowers' – the courtesan houses, the banquets and gambling parties that would be thought incomplete without the courtesan's presence – in a way that complements such writings visually. Together with the literary sources, Wu's pictures corroborate what a tourist might have discovered for himself after a day or two in Shanghai, which was that to be true to the urbanity of the time and the city, courtesans had to be part of the picture.

To be different is always to invite criticism, and we can tell that Wu was defending himself and his fellow-artists against rebuke by the conservative-minded when he said that yes, the paintings of earlier centuries were indeed elegant, anything but vulgar, but weren't they also scenes that met the artist's eye? Far from standing still, times change, throwing up new things. Why would he sniff at the new things that met *his* eye?

After six years of working for Ernest Major, he left to set up on his own, producing a competing pictorial called *Feiyingge* (literally 'Pavilion of Flying Shadow') that featured a mix of news, natural history, historical tales and 'Ladies in the Latest Fashions' calculated to find favour with Shanghai's increasingly worldly readers. As in the *Dianshizhai Pictorial*, he drew his

scenes with a degree of realistic detail more frequently encountered in European art, and he rendered his figures naturalistically, as a Western painter would. In the historical tales his figures and their settings are of course classicized, but his illustrations of contemporary Shanghai are rarely without a hint of the modern world breaking in, or of the treaty-port milieu in which he operated, even if it is in the form of only a clock or gaslight. And if modern material culture were grist to his image mill, so were Western techniques like perspective and shading. In all this, he was the model of what people came to mean by 'Haipai.'

Still more of the outside world broke in upon Shanghai when China lost a war to Japan in 1894-95 and had to give the latter all the privileges which the Western powers were enjoying in China, as well as the added right of establishing manufacturing industries using cheap labour in Shanghai and other treaty ports. So many Japanese came to live in Shanghai that they became the city's largest foreign community, far exceeding the numbers of British, French and American residents. As a militarily stronger Asian nation who had more successfully grasped the modernization nettle, the Japanese might have been an object of emulation. Shanghai did draw on Japan, but more for the access it gave to European culture than for anything of its own. For many a young Chinese, studying and staying in that country was tantamount to an induction course in modernity, Europe at one remove, so to speak.

The China which Japan defeated modernized less quickly. Shanghai might rush into the twentieth century but it couldn't drag inland China with it, certainly not all of it. Perhaps no one could, so old, so massive, so doggedly hidebound was it, but revolutionists cleared part of the way when they toppled the Qing in 1911 and brought 2,000 years of dynastic rule to an end. What would replace the empire? The Republic of China certainly, but how governed? Between then and the rise of nationalism under Chiang Kai-shek, a lasting political form eluded China, and the so-called warlords, regional

'Four Gentlemen,' trademark of cotton yarn produced by the Japanese-owned Naga Wata Kaisha Mills. Japanese money in Shanghai was heavily invested in silk filatures, cotton mills and other types of textile manufacturing. Labour unrest followed by the death of a Chinese worker at the hands of a Japanese foreman at Naga Wata Kaisha led directly to the 1925 May Thirtieth Movement, a high point of Chinese nationalism and radicalism. From Zuo Xuchu, *Lao shangbiao*, Shanghai, 1999.

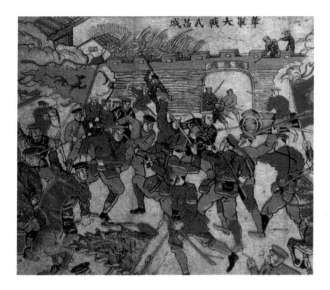

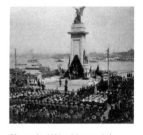

Print depicting Wuchang Uprising, trigger for fall of Qing dynasty and its replacement by Republican China in 1912. From Gu Yinhai, *Banhua*, Shanghai, 2003.

Shanghai War Memorial unveiled on February 16, 1924, its Angel of Victory symbolizing end to World War I. The war was a spur to Shanghai's manufacturing industry and, by extension, to consumption and the diversification of material and visual cultures. Shanghai History Museum.

military strongmen with their fiefdoms, assailed central power. It was a shifting world, the kind where some thrived even as others groped in the dark. Shanghai would thrive, it being true that China's trouble was ever Shanghai's chance. The good times, indeed the best of times, would befall the city not long after World War I broke out.

The war was the impetus for Shanghai's economic miracle. With European energies absorbed by the war and turned away from China, Shanghainese entrepreneurs expanded like fury into import-substituting manufacturing and modern banking, helped by the decline of foreign competition, the increase in the world demand for Chinese foodstuffs and raw materials, and the appreciation of the Chinese currency following the rise of silver prices on the world market. With Europe's attention deflected from China, the Shanghainese business class found room to come into its own. Nor was it alone in exploiting that breathing-space; American and Japanese interests too saw their chance to step up their presence and investments in British-dominated Shanghai. And better still for the Shanghainese, they had the Chinese government hand taken off them by political disorder elsewhere in the

country, and so could flex their entrepreneurial muscles more or less free of official regulation.

Trade and manufacturing flourished. Between 1915 and 1935, Shanghai's trade expanded six times. While the thirty-eight years before the onset of World War I saw the establishment of only 153 factories in Shanghai, the fifteen years between 1914 and 1928 saw as many as 1,229. And as silk filatures, flour, paper and textile mills, cement factories, the manufacture of matches, light bulbs, tobacco products and other light industries multiplied, so did small shopkeepers, craftsmen and labourers. Ever a magnet to the rich and poor of provincial China, Shanghai grew rapidly, its population exceeding 2.6 million in 1928, more than twice that of 1910. Great fortunes were made by property developers and contractors no less than by merchants and manufacturers. It was, as the French historian Marie-Claire Bergère has called it, the 'golden age of the Chinese bourgeoisie.' The bourgeoisie was a new breed of Chinese businessmen, one with a cosmopolitan bloom acquired through travel and overseas study. They would make sure that their enterprises struck a modern note.

Billboards, registered trademarks and advertisements bore vivid witness to this, just as they bore witness to the pervasive presence of foreign competitors. Foreign firms numbered in the thousands, with early British birds like Jardine, Matheson (which

Trademark of Carlowitz & Co dye. From Zuo Xuchu, *Lao shangbiao*, Shanghai, 1999.

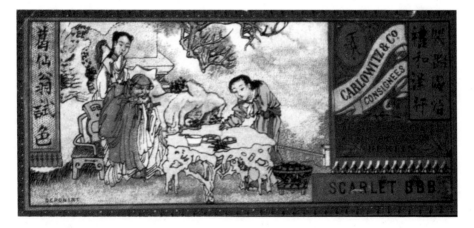

had diversified from opium into a host of other businesses) and Butterfield and Swire now joined by the German Siemssen and Carlowitz (whose many businesses included heavy machinery and, as sole agent for Krupp, weapons); the Japanese Mitsui Bussan Kaisha (insurance, shipping and cotton); the United States' Standard Oil Company, Singer Sewing Machine, BAT (British American Tobacco) and so on.

Foreigners had the know-how, and China needed it. These foreign interests were a highly recognizable type: the investor as middleman of culture. They introduced the Chinese to jazz and Greta Garbo just as surely as they did to electric lighting. Much that was disseminated through the world along trade routes, be it a new technology, social arrangement or design style, was channelled to China one way or another through these interests, which together made up the cosmopolitan fringe of the country's commercial and industrial sectors. Among other things, they relayed what could not be experienced at firsthand from Euope.

In summary, then, Shanghai emerged from a juncture of at least four identities. It was a port city, the sort a centralist power would judge too open to the influence of foreigners, offering easy entries and exits which a landlocked capital did not. It was a semi-colonial city exhibiting, as in the British Empire at large, textbook features of imperialism. It was a city of immigrants, polyglot, labile, with its shifting population being constantly refuelled by new blood. It was a mercantile city, a place of opportunity for old and new money. As such it became, from time to time, a boomtown where the profits were matched by the social iniquities. All this, fused, is what people hazily have at the back of their minds when they try to describe its character. It was this character which people were disparaging when they disparaged Shanghai Style, about which there would ever lurk a flavour of Yangjingbang, or 'pidgin,' even long after it had turned from a term of abuse to one of approbation.

Billboard for cigarette ad being painted. Cigarette card, Republican period. From Liu Yunlu and Lu Zhongmin, *Yang hua'er* (*Cigarette Cards*). Beijing, 2004.

43

2

PAINTINGS

For all the challenges posed by European art and photography, most artists of Ren Bonian's generation went on pursuing Chinese ink painting without feeling that their craft had got into a dangerous rut from which it must be lifted. They modernized Chinese ink painting, but did so in all good faith that they were doing something authentically Chinese. Indeed, there were artists in Shanghai for whom the way forward was a purposefully antiquarian kind of Chinese painting, one incorporating, for example, an intensely Chinese taste for ancient epigraphy. These artists did not think for a minute that Chinese tradition ought to be thrown over for a self-consciously new style of art. The whole idea of a painter renouncing Chinese ideals and taste in art would have appeared outrageous to them. How differently they would think in the succeeding generation.

The collapse of the Qing dynasty and its replacement by a Republican government in 1912 not only changed China politically, but also faced its intelligentsia with the question 'Whither Chinese culture?' with ever greater urgency. You couldn't be an

(Opposite) Detail of oil illustrated on page 77.

47

'Long live the Republic!' proclaims a red banner draped across a globe in an image which, though it advertises a German brand of dye, expresses Chinese nationalistic sentiments, showing Chinese men doffing their hats at a Nationalist soldier. From Zuo Xuchu, *Lao shangbiao*, Shanghai, 1999.

Cover of *La Jeunesse*, Shanghai, 1916.

educated individual, much less a writer or artist, and not be preoccupied by it. Some conflated 'Chinese' with the dead hand of the past. Others recoiled from the idea of 'out-and-out Westernization.' All were faced with a future darkened by China's political fragmentation and weakness. How to be strong, strong enough to ward off further incursions by Western powers and Japan; how to reinvigorate China and restore its lost dignity – these were the compelling questions around which debates swirled and articles were written. For the roots of China's weakness, many young intellectuals looked within Chinese culture itself. So long as Confucianism remained, China would stay backward. So long as the Chinese taught, wrote, treated women, made marriages, painted, designed, dressed and performed drama in the traditional way, China would not become modern. The call to the young to discard the 'old and the rotten' was issued from the pages of a new periodical. Named *New Youth* but known also by its French name, *La Jeunesse* (its founder Chen Duxiu was a great fan of French thought), this periodical was destined to become the house journal of the New Culture Movement, as the intellectual revolution of the early years of the Republic came to be called.

The numbers of Chinese receptive to the

messages of the New Culture Movement exploded when a huge wave of student protest was set off by the humiliatingly unfavourable terms the Chinese government had to accept at the Versailles Peace Conference which settled the issues of World War I. The date of this protest – May 4, 1919 – gave its name to a cultural upsurge which, as it spread from city to city, seizing in its ferment writers, teachers, students, workers, merchants or simply patriots, aroused passions and heart-searchings so profound that no less than a transformation of consciousness was effected. It is from the May Fourth Movement, as it came to be called, that historians would date the start of the social revolution to which the Chinese Communist Party would eventually lay claim.

New Youth called for a 'revolution in art' in its 1918 issue. What was needed to cure Chinese art of its repetitiousness and inconsequence, cried its author Chen Duxiu, was a good dose of Western realism (the style which represents the world 'as it really is.') The repetitiousness and inconsequence which people like Chen found so repugnant came of the immense power which the 'scholar-amateur' ideal had had over Chinese artistic practice and convention. This had privileged spontaneous creation over 'form likeness,' and favoured expressive freehand brushwork and economy of execution over careful and detailed representation of actual external appearance. You could imagine the scholar-amateur saying something not unlike the remark Picasso once made: 'I paint forms as I think them, not as I see them.' Apologists for scholar-amateur painting would argue that this made it 'modern,' seeing an analogy between it and modernism's rejection of art as a faithful representation of nature. Yet it is also true that the Chinese approach has its dangers: you could paint some vague forms of mountains emerging out of clouds and, on the grounds that it is the 'idea' of them that you are expressing, claim a value and merit for the picture it does not remotely possess. Far from being inspired, it is merely schematic and stale.

Cai Yuanpei as a student in Germany, 1907-11.

Not idea but truth was what Cai Yuanpei (1868-1940) wanted for Chinese painting when he returned to China in 1911 from four years of studying philosophy, literature, aesthetics and psychology at the University of Leipzig. Cai, perhaps best remembered today as the president of the prestigious Beijing University, whose doors he opened to women in 1920, was the most passionate of China's educationalists. He urged Chinese painters to look to Western art, particularly to its concern for verisimilitude (the 'form likeness' denigrated by the scholar-amateur painter). At the same time he liked the idea of science and progress and believed that art, too, must keep in step with the times. That meant taking an interest in the various European movements that are now usually called 'modernism,' and in the Chinese artists who embraced it. When in Europe, Cai had bought several Cubist paintings and even met Picasso.

Cai's shake-up of the educational system in China was a modernization based on a Western model. One aspect of it was aesthetic education, to justify which he drew on the philosophy of Kant. Art appreciation, Cai suggested in an important essay published in 1912, was what led one from 'the phenomenal' (Kant's term for things as we perceive or experience them) to the things-in-themselves, those existing independently of our experience. Aesthetic engagement with art, Cai also said, could take the place of religion in spiritually cultivating the individual and unifying society.

He found a kindred spirit in Lu Xun, last glimpsed in these pages decrying Wu Youru's fondness for depicting the *demi-monde* of Shanghai. There is a much reproduced photograph of the two, taken in early 1933, in which Cai and Lu Xun are towered over by a bearded European figure – George Bernard Shaw, who was on a visit to Shanghai. Lu Xun may come into everybody's mind as a writer first and foremost, but no history of modern Chinese art would be quite complete without mentioning this polymath. Working under Cai in the Ministry of Education, Lu Xun thought to encourage public engagement with the arts through the

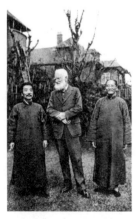

George Bernard Shaw flanked by Lu Xun (*left*) and Cai Yuanpei (*right*), Shanghai, 1933.

establishment of modern public spaces like galleries, museums, exhibitions and concert halls. It was probably a bit early in the day to be calling for these – there had just been a revolution – but Lu Xun's proposal gazed ahead to a time in the not too distant future when scores of such venues would open.

In the previous chapter I had mentioned the artistic ambidexterity of Brother Liu Bizhen, who was trained in both Chinese and European techniques and who, in all likelihood, taught some of the latter to Ren Bonian. Yet for all his awareness of the foreign tradition, Ren would not have regarded it as an alternative he could opt for if he chose. Since Ren's time however, a profound and irreversible shift had occurred in the artistic environment. To a new generation of artists, there was now nothing inevitable or absolute about Chinese ink painting, seen to be just one of several possible means of visual expression. These artists, however much they admired the native idiom, could no longer believe that its aesthetic resources were going to give them all the language they could use.

If one tried another language, one could now acquire technical proficiency in it. Even schools now taught Western-style drawing and painting – foreshortening, perspective, chiaroscuro and all. In 1902, the educational authorities had taken the bit between their teeth and, since China itself didn't have them, imported Japanese art teachers to run courses in European methods in schools across the country. The Tokyo School of Fine Arts had been training students in Western art and oil-painting techniques since the late nineteenth century, and many of these now arrived in Beijing, Nanjing, Hangzhou, Canton and other cities to teach them to the receptive Chinese. Their Chinese students had a utilitarian approach to European art to begin with, neither endowing it with the aesthetic value that it was to have later, nor generalizing to it any of the theory and criticism which had accreted down the ages around Chinese art.

The realistic and academic styles in European art gave to Chinese practitioners a visual means of

Portrait of Lu Xun on cover of *Lu Xun On Russian Literature,* Shanghai, published in 1949, thirteen years after his death. From Xie Qizhang, *Jiushu shoucang,* Shenyang, 2004.

rendering the visible world precisely and accurately, something which the expressionistic and non-representational conventions of Chinese painting did not. To reformers, Chinese tradition had become worn out and clichéd, and in order to renew its vitality, one had to tap new cultural resources: one-point perspective and modelling, for example. These might be old hat in a Europe swept by the great tide of modernism, but as a remedy for the perceived degeneracy of the Chinese pictorial tradition, they could seem just the thing, indeed a means of modernizing Chinese art. To echo the art historian Eugene Wang, it was a case of one man's traditionalism being another man's modernism. Some people could scarcely look at a scroll painting without seeing senescence. Others imagined a new art synthesizing the best of both worlds, Chinese and European. As is only to be expected, views and practices differed on how one went from renewing possibly passé conventions to grasping the nettle of modernity.

By learning Western art, was the answer given by the first art school of its kind to open in China, the Shanghai Art Academy (as it was later called). Founded in 1912, this opened a whole new world of art to its students, who came from the environs of Shanghai and further afield, some of the latter reached through postal distance learning. Together with the coteries its teachers and students established, the school became the seedbed of Western-style painting in China. The first and most influential of the local coteries was the Winged Horse Society, *Tianma hui* in Chinese, started in 1919 by six young teachers of the art academy, with its credo brought into the public eye in the usual way – through publications and exhibitions. *Tianma* names Pegasus, the winged horse which in Greek mythology is not only turned into a constellation but is the symbol of the Muses, of inspiration; it also evokes the compelling, untrammelled style of poetry and calligraphy represented by the phrase *tianma xingkong*, literally 'heavenly steed streaking across the skies.'

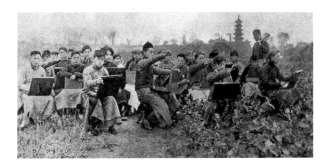

The society set itself against conservatism, imitation and frivolity, but its promotion of oil painting did not preclude hospitality to traditional brush-and-ink painters.

The person who would become the art school's longest serving head was a mere teenager at the time of its opening, the sixteen-year-old Liu Haisu (1896-1994). Liu had learned to paint in the Western manner from Zhou Xiang, a graduate of the Tushanwan workshop who had set up a school to teach its pupils to paint backcloths for the stage, and Liu now taught it to his students alongside the native medium. Precocious as he was, he was never, even in his maturity, as accomplished an artist as you would suppose from his reputation, which is high (high enough still today for a fair-sized museum in Shanghai to be named after him). Still, there is no question that he was a pioneer and an influential educator, and that without him the Chinese modern art scene in the early decades of the twentieth century would have been a great deal poorer.

Being a pioneer could be uphill work, as the *cause célèbre* for which he is perhaps best remembered is enough to demonstrate. When a photograph of a reclining female model in a classroom at his art school appeared on the front page of a new tabloid in 1925, it provoked an unprecedented uproar. A local government official went so far as to write to the President of the Republic, the Minister of Education and several Shanghai newspapers to get nude painting banned and Liu punished. Art school is not medical school, he fumed, why was it so important, as Liu Haisu had

Liu Haisu as a teenager, 1910s.

53

claimed, for students to observe 'the structure of the human body, the life process and the manifestation of the spirit' in the human body? He was shocked, the models were shameless, the scenario altogether 'unimaginable.' The students were male, so why not use male models? It was apparent that to this bureaucrat, disclosing female nakedness could only be lewd and those who looked on it could only be voyeurs.

Liu Haisu stuck to his guns, but Sun Chuanfang, the warlord then ruling the roost in Shanghai, weighed in with a threatening order for Liu to stop the practice once and for all. Bludgeoned for nearly a year, Liu finally gave in, but then the warlord got himself defeated by Chiang Kai-shek's forces and those watchdogs of social and moral propriety faded from the scene. We have a photograph from 1935, taken during recess, in which twenty-two of the school's students are shown with their favourite model, a seventeen- or eighteen-year-old Shanghainese girl they called 'Little Model.' By that time life drawing with nude models had become so routinized that, if told of the ruckus ten years before, this younger generation probably wouldn't know what all the fuss was about.

Nude model posing with students at Shanghai Art Academy, 1935.

In fact, it hadn't been at all easy to find female models at the beginning. The first had been a fifteen-year-old boy. Then, when the school did manage to get a female model five years later, she was a Russian woman. The school's life drawing classes were advertised in the local papers in the belief that they would be popular. Little did Liu realize that he'd be branded 'a traitor to art.' Of course in his way Liu Haisu was indeed making a statement about culture. Making pictures necessitates choosing a style, and since style could now be Chinese or Western, to make pictures was to make a statement about culture. He focussed his students on the physicality of the human figure, something that was emphasized in European art to a degree unknown in Chinese art. Any Chinese chauvinist who wished to read cultural treachery into this could do so easily enough.

So far Liu had had no firsthand experience of

the West, but now he travelled to Europe and saw what was being produced there at first hand. He had been to Japan, and would go there again, and he presently also visited Indonesia, Singapore and elsewhere in the Tropics. Years ago, as a boy newly arrived in Shanghai, he had discovered the works of Velázquez and Goya, and had learned Western oil and watercolour techniques by copying these masters. His later models were modern ones – Monet, for example, for the subject matter of his paintings of the façade of the Notre Dame in Paris (1930) and of the Houses of Parliament in London (1935), while an

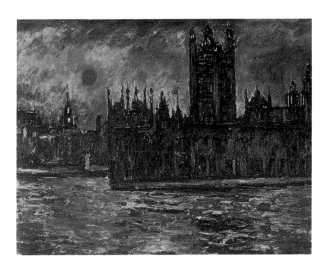

Houses of Parliament, London, painted by Liu Haisu, 1935. Liu Haisu Art Museum, Shanghai.

oil of two Balinese girls he painted in 1940 takes off from Paul Gauguin's Tahitian works. The model for the treatment of the sky of a later canvas, *Prosperous Shanghai* (1964), is so obvious that the art academic David Clarke can't help but 'read the work as an essay in the manner of van Gogh.'

Scene from express train painted by Liu Haisu, 1929.

Another initiator of the study of European art was Li Shutong (1880-1942), who if anything was even more of a pioneer than Liu Haisu, being the first in China to use a nude model in the classroom, the first to promote modern woodcuts, and the first Chinese to write a history of Western art. There is a photograph

dated 1913 of the first life drawing class he held at his school in Hangzhou, where we see the back of a male nude model standing on a table facing about thirty students seated behind their easels. This event is of more than anecdotal interest, not a one-off but part of a whole range of methods he introduced from the West, methods nothing short of revolutionary in the Chinese context. These included painting outdoors, sketching from nature, copying plaster casts and the recording of immediate visual experience.

Li was born to the concubine of a wealthy merchant in Tianjin. If ever a man seemed destined for the life of letters, that man was surely Li. Formidably talented, he received a classical education – the study of inscriptions on ancient bronzes and stone tablets, seal engraving, calligraphy, Tang poetry and all. Like many classical scholars before him, he was politically engaged, in close enough contact with the leading reformist thinkers of the day to be tarred with the same brush when powerful factions in the court suspected these thinkers of plotting against the Qing ruling house. The precocious Li was then eighteen. He got out of harm's way by moving to Shanghai, in whose foreign concessions anti-government activists could put themselves beyond the reach of the Chinese state. There, he attended a school where Cai Yuanpei taught. Later he fell in with coteries of painters and litterateurs, and lived very much the life of that class, writing poetry and keeping company with courtesans and performers.

Upon the sudden death of his mother in 1905, Li took himself to Japan, where he enrolled at the Tokyo School of Fine Arts and received a thorough grounding in Western art. He hired a model to pose for him and, as if acting out the popular notion of the model's life, this Japanese woman became his mistress and eventually went back with him to Shanghai, where she lived until 1918 (meanwhile, his wife from an arranged marriage remained in Tianjin with their sons). He was a man of many parts, interesting himself in Western drama and music, producing and acting in plays and studying the

piano on top of painting. For this last he had Kuroda Seiki (1866-1924) for a teacher, a renowned Japanese returnee from Paris whose own paintings blend early Impressionism with the academic school.

Li's confident grasp of the European medium can be discerned in a painting of his, a self-portrait that was executed before his return to China in 1911. The self-portrait, required by the school's painting department of all its graduating students, shows a conciliation of Pointillism with the faithful rendering of appearance, and is one of the most accomplished oils ever painted by a Chinese. It would be telling to set this picture next to one by, say, Ren Bonian, whom he had missed by only a few years in Shanghai. The difference between the two pictures measures the distance travelled by modern Chinese art. In the two you see Chinese art turning on the pivot of the nineteenth century to face the twentieth.

Li Shutong, *Self-Portrait*, painted in Tokyo before his return to China in 1911. Tokyo National University of Fine Arts.

A number of Li's published illustrations have survived, but it was thought none of his other canvases have until one was discovered in 2002. This bridges Eastern and Western aesthetic approaches, showing Mount Fuji with the intense colours – all blues and mauves and brick-reds – of a Japanese woodblock print by Hiroshige; but whereas the latter makes us expect flat shapes, Li's picture is attentive to depth and surfaces, light and shade, revealing the painter to be true to his training in a European tradition that emphasizes the realistic representation of nature.

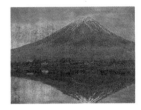

Mount Fuji by Li Shutong, 1910. Oil on canvas. www.hangzhou.com.cn

On returning to Shanghai, Li taught music, helped publish periodicals and joined other nationalistic voices in denouncing the Qing dynasty. In 1912, shortly after the dynasty fell, he left for the resort town of Hangzhou. The seven years he spent there teaching Western art and music (and also composing songs and lyrics) spawned a lasting legacy and brought Chinese artists that much closer to the artistic trends in Europe.

In 1918, he assumed his final persona, shaving his head and, like a man awakened to the realization that life's but a dream, took holy orders and entered a

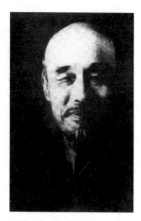

Li Shutong as Buddhist monk, 1937.

Xu Beihong aged twenty in Shanghai.

Buddhist monastery as a monk. He was thirty-eight. From then on until the end of his life, he devoted himself to editing Buddhist texts and preaching. His Japanese common-law wife, whom he would see in Shanghai every weekend, returned to Japan and was never heard of again. His life of art was behind him, but his engagement with Western traditions lived on in more ways than one, not least in his students, one of whom, Feng Zikai, we shall later meet. If Hangzhou was to run Shanghai a close second as a locus of modern European art, he was the one who paved the way.

Yet another artist to serve as a conduit of European painting to China was Xu Beihong (1895-1953). Xu loathed modernism and fervently espoused the sort of realism that was practised in the French academy. In promoting the latter in a place as susceptible to fads and fashions as Shanghai, at a time its young artists were embracing Impressionism, Fauvism, Cubism, Futurism and other modernist trends, he became a somewhat tragic, certainly dated, figure. Although it was in Shanghai that he cut his teeth as an artist, he would later be at odds with it, objecting to the growing vogue there for modernism and refusing to scramble onto the bandwagon.

As a child, Xu Beihong learned his art from his father, who sold paintings for a living, and from copying Wu Youru, the illustrator of the *Dianshizhai Pictorial*, and the realistically depicted animals decorating the cigarette packs produced by Western manufacturers in Shanghai. Struggles as an impoverished student in Shanghai were followed by a stint in Japan and, in 1919, by eight years in Paris and Berlin on a Chinese government scholarship which Cai Yuanpei had helped him to secure. In his second year in Paris he was admitted to the Ecole des Beaux-Arts, and this, together with his apprenticeship to Pascal-Adolphe-Jean Dagnan-Bouveret (an old pupil of Corot and Gérôme who has been described as an 'arch anti-modernist'), soaked him thoroughly in the methods of the academic tradition, even though that tradition had

long lost its pre-eminence in France. Whereas other Chinese students in Paris took enthusiastically to the modernism that was in the air around them, Xu would have no truck with it.

His dedication to realism rested on his training in Paris, but it also rested on his disavowal of the expressive and abbreviated freehand brushwork of the 'scholar-amateur' tradition of Chinese ink painting, whose practitioners he dismissed as people 'who flipped their brushes and dashed their ink, daubing in random abandon without a governing principle.' He had it ever in mind, as Li Shutong had not, to inaugurate 'a new era' in Chinese painting, and to do so by injecting it with the Western tradition of pictorial realism. In standing against the accumulated weight of Chinese tradition, and, what's more, in advocating Westernization, Xu Beihong would qualify

Xu Beihong's study of female nude, 1924. Xu Beihong Memorial Museum, Beijing.

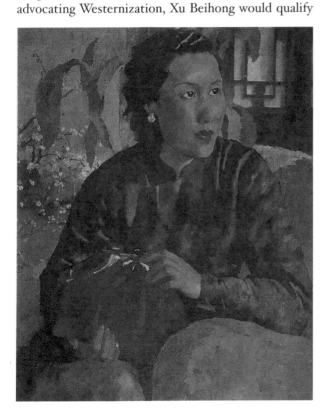

Xu Beihong's portrait of Liao Jingwen, his second wife, 1947. Xu Beihong Memorial Museum, Beijing.

as a radical and modernizer in the Chinese context, not at all the fuddy-duddy that a modernist would suppose him to be for not taking his art beyond realist practices. Just back from Paris, he would certainly have been admired as such in Shanghai, an image abetted by his self-presentation – it was easy to see where he'd been, a Western observer noted in 1927: 'The long hair, velvet coat and flowing tie and his detached languid mannerisims, as well as his excellent French, suggested the Latin Quarter.'

Yet he revealed himself to be a dyed-in-the-wool traditionalist when he attacked Cézanne, Matisse and others in 1929. He did so in no uncertain terms either, using words like 'despicable,' 'philistine' and 'superficial' of these modern French masters. The occasion was the first ever government-sponsored national art exhibition to open in Shanghai, a large show covering traditional Chinese art as well as Western-style painting and photography. Sharp words were exchanged with those who couldn't let those extreme views go unchallenged, with the polemics appearing in print in the exhibition's journal. 'The two-Xu's controversy' is how it is described in the literature, Xu Beihong's chief opponent being a poet with the same surname. Xu Zhimo (1897-1931) was vehement in his defence of Cézanne. Strange it was, he declares at one point, to find an echo of the public ridicule which Impressionists suffered in the nineteenth century reverberating in, of all places, China. Xu Beihong, he says, reminds him of Ruskin, the eminent art critic who demolished Whistler's *Nocturne in Blue and Gold* by equating it with 'flinging a pot of paint in the public's face' in 1878.

Xu Zhimo was another returned student who, as a poet, more properly belongs to the history of modern Chinese literature, but he was a writer with broad aesthetic interests, the horizons of which had been widened by his years of study in Cambridge, England. When in Cambridge, he had chanced upon the work of Walter Pater, the foremost British exponent of the principles of art for art's sake. This took place in a

Xu Zhimo's face dissected by knife in cover design of his essay collection *Self-Analysis*, 1928. From Jiang Deming, *Shuyi bai ying 1906-1949*, Beijing, 1999.

secondhand bookshop which had sheltered him from a sudden downpour, and Pater's writing had left a lasting impression on him. He had also been bewitched by Paris, and in a letter to his friend Liu Haisu, had asked, 'Did you not feel a sense of homecoming on arriving in Paris?'

Xu Beihong would go on to fame and prestigious academic appointments in Beijing, thereby passing from the Shanghai scene and out of our story. Though honoured as the patriarch of modern Chinese art, producing work that was indeed novel, he was not new in a new way. But there were others who were that, who came away from the cafés of the Latin Quarter with their heads buzzing with avant-garde ideas. These brought avant-garde techniques back to Shanghai, techniques which they thought were better suited to the times and to modern existence. They had learned to abstract physical reality into the 'lines, surfaces, shapes and colours' of modernist art, and they set about practising or teaching it to others on their return to China. In this way they pluralized the styles of Shanghai's art.

No artist illustrates this stylistic plurality more fully than Pang Xunqin (1906-85). Anyone trying to pin down visual modernism in China in terms of men, groupings and years would find his attention homing in first of all on this talented young artist, and on the art society he founded in Shanghai in the years between 1931 and 1937. Pang was born to one of the top families in Changshu, a town a three-hour drive from Shanghai today. In 1921 he won a place in l'Université l'Aurore, the earliest of the Roman Catholic universities to be established in China. The university had begun life three years before Pang's birth at the French Jesuit Mission we last glimpsed teaching European art at Tushanwan, but now it had its own campus in the French Concession. Pang completed the preparatory course, which was modelled on the French baccalaureate, and had not long embarked on the study of Medicine when he realized that he'd rather pursue art. So he left the university and began to learn

Pang Xunqin as a student in Paris, 1929.

oil painting from a Russian resident in Shanghai. In 1925, he left for Paris, and arrived in time to catch the Exposition Internationale des Arts Décoratifs et Industriels Modernes, an ensemble of pavilions and decorated interiors that brought together the various styles which make up what we now call Art Deco. Pang Xunqin was dazzled by what he saw.

At the insistence of the organizers, the room settings, furniture, ironwork, glass, ceramics, rugs, wallpaper and printed materials displayed in the exhibition showcased the latest ideas in interior decoration, indeed all that was original, new and modern. These ideas were later to impinge on architecture, interior décor, industrial design, fashion, graphics, photography and film not only in the rest of Europe but worldwide. Although the styles came together in Paris, their sources of inspiration were international. Cubism and other avant-garde European art; ancient Mexican and Egyptian motifs; African material culture; Japanese and Chinese art and design – all these fed into Art Deco. For it to have had such extraordinarily diverse origins must have abetted the speed and enthusiasm with which the rest of the world took it up, and for its success as a truly international style.

Curiously enough, the Chinese display at the Paris exposition seemed imbued with chinoiserie, motifs which European designers of the mid-eighteenth century fancied were evocative of the opulence of life in China, an exotic land of their imagination. No real Chinese room of the time would look like this strange ensemble. The individual elements were indeed staples of the Chinese visual repertory – stylized cloud motifs, scrolls of calligraphy, folding screen decorated with human figures, silk carpet, tasselled lantern – but the whole seemed more like a caricature, either a set for a Fu Manchu movie or a Paris-based Chinese restaurant outdoing itself in auto-orientalist kitsch. Though the designers tried for a new style of decoration, creative experiment was not much evident.

In fact the exhibition was mounted not by any

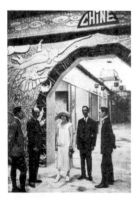

Chinese pavilion at Exposition Internationale des Arts Décoratifs et Industriels Moderne in Paris, 1925.

official organization in China but by Chinese students in France. Nor did these students, members of the Association des Artistes Chinois en France and the Société Chinoise des Arts Décoratifs à Paris, receive any government funding. Instead they did what they could with artefacts supplied by a number of Paris-based Chinese import-export companies. If the Paris exposition set a benchmark for modern living, it was not thanks to exhibits like theirs. The person chiefly responsible for organizing it was Lin Fengmian (1900-91), who is spoken of today in the same breath as Xu Beihong and Liu Haisu but whose reputation for modernizing Chinese art is, if anything, higher than theirs. To Lin's years of study in Dijon, Paris and Germany are owed the Fauvist and Expressonist styles of the works he painted then and later, when he taught among other places at the National Academy of Art in Hangzhou.

Composition by Lin Fengmian, oil on canvas,1934.

Pang Xunqin went again and again to the exhibition, greatly taken, as he was to recall, with the furniture, rugs and curtains displayed there. Just the brilliant electric lighting seemed amazing, to one who had read by the glow of oil lamps back in Changshu. What was borne in upon him was that art was not just pictures, but something no part of life was without. It also struck him that once architecture changed, everything changed. So inspired was he by the exposition that he applied straightaway for a place at the National School of Decorative Arts. He was turned down – the school did not accept Chinese, was how he later explained it – but with the help of Xu Beihong he managed to get into the Académie Julien. His commitment to painting was less than total, however, and in his hotel room in the fifth arrondissement, he continued to practise piano in the hope of becoming a musician. He also considered studying literature, until he realized that he couldn't be good at everything and got down seriously to painting.

Lin Fengmian, 1926.

He served the usual apprenticeship, copying endlessly – in his published reminiscences he particularly mentions Botticelli – and spending hours in the Louvre looking, many of them in front of the

Sanyu (Chang Yu) aged nearly fifty, around 1950. Photo by Arnaud de Maigret.

Pang Xunqin's *Nude in Rattan Chair*, particularly the elephantine legs, is in the style of Sanyu, 1930s.

Venus de Milo. In his five years in Paris his artistic energies were variously expressed – for more than a year he designed costumes for a dancer at the Moulin Rouge, introduced to her by a Chinese pedicurist he knew (pedicure was a niche occupation in which the local Chinese were over-represented). He practised composition by having a German poet friend read lines of poetry to him to trigger forms and visions. He'd conclude that more is owed to friends and colleagues in the making of an artist than to teachers or one's own efforts.

When eventually he quit the Académie Julien to do life drawing at the more casually run Académie de la Grande Chaumière, it was at the suggestion of a young Chinese artist by the name of Chang Yu, better known in France as Sanyu (1901-66). Sanyu, who had arrived in Paris in 1921, himself sketched the models there, idiosyncratically using Chinese ink and brush instead of the more conventional pencil or charcoal to draw his cursive and highly distorted yet sensual nudes. He had been in Shanghai in 1919 and 1920, far from his hometown in Sichuan in the Chinese interior – the name 'Sanyu' may have come of his being called that in Shanghai, since saying 'Chang' in Shanghai dialect is how 'San' sounds in French – and his work was known and admired in art circles there. Pang Xunqin, who later reminisced about him in a memoir, would invite him to join the Storm Society, a movement which, as we shall presently see, expressed better than any other the avant-garde ideals of the artists identified with Shanghai. Sanyu was Shanghainese neither by origin nor by residence; but, as the art historian Julia Andrews has written, 'To some of the most aggressively modern young oil painters in late 1920s Shanghai, Sanyu was the model.' On Pang and Zhang Xian (of whom more later), he exercised a decisive influence; he exhibited in Shanghai and his work was published there. He was in touch with Xu Zhimo, to whom he sent a picture of a female nude with legs swollen as though by elephantiasis, and he was in Shanghai to attend the wedding of Shao Xunmei, a

quintessential Shanghai figure whose contribution to Shanghai Style I will describe in another chapter.

Whether Sanyu had really had a portrait painted by Picasso, as Pang claims in his published reminiscences, we shall probably never know, though it is certain that the dealer who acted for him for a few years, Henri-Pierre Roché, 'knew everybody... and could introduce anybody to anybody.' The 'everybody' included Brancusi, Braque, Duchamp and Gertrude Stein, as Sanyu's biographer Rita Wong tells us. He was hard-up much of the time, not because no one bought his pictures, Pang Xueqin suspected, but because he was reluctant to part with them. At any rate, he was

Sanyu, *Lying Nude, Lifting One Leg*, oil on masonite, 1950/60. Yageo Foundation, Taiwan.

Sanyu, *Goldfish*, oil on canvas, 1930s/40s. Yageo Foundation, Taipei.

65

thought odd, not one to join groups or thrust himself forward. He never returned to China, but died down-and-out of what was probably accidental gas poisoning in his studio on rue de la Sabière.

Today he is regarded as a French artist rather than Chinese, and there is no doubt that a large part of his attainment rested on the support of standards which only Paris could provide. Yet seen in another frame, one which includes the other artists named in this chapter, he emerges as the very epitome of the modern Chinese condition they all embodied – betwixt and between, part Chinese and part Western. Like all these others, but more successfully and less self-consciously than them all, he produced modern artwork which let the Chinese past live on. If Matisse is in the nudes he so loved to paint, then so is the brush-trace of the Chinese calligraphy which, as a child, he had studied from a master in Sichuan. His own father, no mean painter himself, had taught him ink painting, and little imagination is needed to see the fingerprints of that experience in Sanyu's Parisian output. The art historian Jonathan Hay puts it best when he writes in the catalogue accompanying an exhibition of Sanyu's work at the Musée Guimet in Paris in 2004: 'Sanyu seems to have seen in modernism the possibility of dissolving any contradiction between a Chinese and a Parisian identity, with Paris here standing for the most up-to-date Western culture.'

After five years in Paris, Pang Xunqin returned to China, taking with him fond memories of the Parisian artistic life he had experienced in Montparnasse, where the Grande Chaumière, La Coupole café and other artists' haunts were located. In the meantime, quite a few artists had returned from overseas study, some from Europe like himself, but many more from Tokyo. Modern Japanese oil painting had developed under the influence of diverse European styles and movements, but of all these none had left as deep an impression as Fauvism; and it was styles emulating the Fauvism of Henri Matisse, André Derain, Maurice de Vlaminck and Albert Marquet, that the Chinese

students had absorbed in Tokyo and were now bringing back with them to Shanghai. To cite just two examples: *Hong Kong Harbour* (1942), a painting by Chen Baoyi, one of those returnees, is without doubt modelled on Derain's *Boats at Collioure*; while in the paintings of Ni Yide (1901-70) – low-toned views of a Shanghai street, a bridge – there is an echo of the moderation of Albert Marquet, who, when he lived in Paris, never tired of painting the Pont Neuf and the quays of the River Seine.

Still fresh from their years of study in Paris and Tokyo, these returnees considerably enlivened the modern art scene in Shanghai. But the efforts of artists of modernist inclination to press beyond mere tendencies to an actual programme and movement did not bear fruit until 1931. In that year Pang Xunqin initiated the first avowedly avant-garde art society in China: Juelanshe, which the members rendered as 'Storm Society' in English. It had a precursor in the Taimeng Painting Society (or Société des Deux Mondes in French, though with the exception of Pang all its members had studied in Japan, not France). Hardly had the latter announced its first exhibition than it ran foul of the authorities, who found the leftist radicalism of its public statement more than reason enough to shut it down. Most of its members joined the Storm Society, so the latter can be seen as a reconstitution of the earlier group.

There is no mistaking the new society's urge to crash through the art scene making a clean-sweep of

Hong Kong Harbour by Chen Baoyi (*left*). Oil on canvas, 1942. National Museum of Art, Beijing.

On the Banks of the Suzhou Creek by Ni Yide (*right*), oil on canvas, 1934.

all that was passé, stale and of low quality. Its Chinese name, Juelan, or a 'great wave,' tells us as much. So does its manifesto, which calls the local art scene mediocre, philistine, feeble-minded, shallow, decrepit and sickly. 'Let us arise,' it declares, 'and, with the fervour of a hurricane and reason of iron, create our world of intersecting colour, line and form.' Twentieth-century Europe burgeoned with Fauvism, Cubism, Dada, Surrealism...It was about time the Chinese art world did the same. They, the artists, could no longer wait for what was on its last legs to breathe its last but must, with all the life within them, go all out to give new expression to their charged-up spirit. Trailblazing was what they were about, Pang Xunqin was to remember years later, and, lacking the strength to do this singly, they did it collectively.

All in all, it was a declaration to make one sit up, inflated in language, it is true, but no more so than the

Pang Xunqin (*standing, first from left*) and Ni Yide (*standing, fourth from left*) with other Storm Society members, including Zhang Xian (*seated, centre*).

manifesto which the Futurist movement of Italy had distributed throughout the world in 1910, and which had appeared in a full Chinese translation in the journal of the Shanghai Art Academy in 1921. These young Chinese were after all no different from artists the world over – it is a common enough pattern, to become infected by missionary self-consciousness, to form groups and issue manifestos on the analogy of political parties, down to the denunciation of 'the other side.' One member of the Storm Society likened the other side to a wilderness of swaying, uneven weeds that, he implied, needed scything. Another spoke of crashing a wave against it to wash it clean of its 'intolerable stains.'

Book on art by Ni Yide, *Travels in the Garden of Art*, 1936. Cover reproduces painting by co-founder of Storm Society, Pang Xunqin. From Yao Zhimin et al, *Shu ying*, vol 1, Shanghai, 2003.

The manifesto was penned by Ni Yide, the society's co-founder. It first saw print in the pages of a tri-monthly magazine called *L'Art* (*Yishu Xunkan* in Chinese). Though *L'Art* became its house magazine, it wasn't the Storm Society which paid for it – it couldn't on its meagre resources – but the artists Ni Yide had rounded up from the Shanghai Art Academy. Ni was a graduate of the academy, where he had stayed on to teach before leaving for Japan in 1927 to further his studies. He would have stayed in Japan longer than a year if news of a violent clash between Japanese and Chinese troops in northern China hadn't driven him home in anger. He was just the person Pang needed to help him get his avant-garde group off the ground. The art historian Ralph Croizier sees in the coming together of Pang and Ni the convergence of 'the two main sources of influence on modern Chinese art, Paris and Tokyo,' in 'the centre of everything modern in China, Shanghai.'

Ni was something of an art theoretician, one of those people who straddled the visual arts and literature. Ni, who was as much critic as painter and who would leave behind him several books on Western art theory and practice, was a member of the Creation Society, a Shanghai-based literary group whose representative figures were returned students

from Japan. In style and spirit, these people were identifiably Romantic. In keeping with the Romantic manner, a story Ni wrote, called *Poor Scholar*, tells of a young impecunious art teacher who, feeling lonely in his bare room, falls asleep and dreams of the sweetheart he has left behind in the country racing to finish knitting a sweater for him. Ni was influenced by Yu Dafu, a Creation Society founder whose fiction was frank in portraying sexual frustration. And in an echo of Yu Dafu's self-representation as a 'superfluous' loner, Ni Yide styled himself 'a useless person without a single redeeming feature.' In founding their literary taste on nineteenth-century European models rather than on the avant-garde writing of the early twentieth century, Ni Yide, Yu Dafu and others of their kind showed that if there was a cultural time lag in the visual arts, there was a time lag still greater in literature.

Names cross borders more easily than the practices and spirit they imply, and nothing in Ni's own paintings suggests the influence of the Cubist, Dada and Surrealist movements mentioned in his manifesto. Instead one can detect, as has been earlier noted, an echo of Albert Marquet in some of his work. Like the French artist's views of the quays alongside the Seine in overcast weather, Ni's canvases incline to a dull misty atmosphere, with a sudden dash of primary colour relieving the low-toned shades of brown, grey and black in which the backgrounds are painted. The composition and perspective of Ni's *Shanghai's Nanjing Road*, an oil he painted in the 1940s, call up a painting of Marquet's in the State Hermitage Museum in St Petersburg, *Paris's Notre Dame on a Rainy Day* (1910).

By contrast, Pang Xunqin was a great deal more eclectic and experimental, grabbing at Cubism, Fauvism, Surrealism and other modern trends. At an exhibition in 1935, he showed a canvas, *Composition*, that is resolutely modernist, an adaptation of Cubist language that puts one in mind of the French painter Fernand Léger. The painting sums up the paradox of modernity: man stamped out by machine, humanity

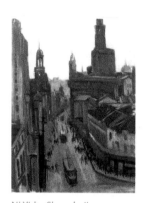

Ni Yide, *Shanghai's Nanjing Road*, oil on canvas, 1940s.

Pang Xunqin, *Composition*, oil on canvas (lost), 1935.

overawed by engineering. Pictured next to the head of a woman whose flowered headscarf points to her rural provenance is a robot's head with boilerplated face and cranium. It is a world which apparently has no further use for nature, exiled to only a corner of a canvas whose space is all but filled by a giant pneumatic drill, a hand gripping it of which only four fingers can be seen. The drill is apt, as is the architectural image of brickwork showing through behind it – for whoever could think of Shanghai without its construction booms (see Chapter 6)?

Shanghai is refracted in another painting that dates from that time. Named *Life's Riddle*, this is a collage which catches the blitz of fragmented sensations characteristic of urban living. Shanghai presents itself

Pang Xunqin, *Life's Riddle* (or *Such is Shanghai*), watercolour, 1931.

to him as a jumble of images in which the faces of three young women predominate. Its reference to the collages of Braque and Picasso is obvious, but his borrowing is selective. The forms are cursive, not geometricized. Far from being Picasso's physiognomic distortions, the faces have the verisimilitude and depthless clarity of poster images. The eyebrows thinned and drawn out in the fashion of the day, the eyes lightly shadowed and the lips painted, they betoken chic and artifice. And continuous with theirs is the mask-like maquillage of a *hualian*, a singer in the 'painted face' role of Beijing Opera. As for the rest, you recognize playing cards, a recurring motif in the still lifes of Picasso and Braque, part of the iconography of the bohemian life of the Parisian café and studio. The images overlap, but transparently, with one seen through the other.

A companion to *Such is Shanghai*, as this painting is also called, is *Such is Paris*, painted the same year. This, too, is a collage, with mainly women's faces, one of them black. It, too, has playing cards, but there is further borrowing in its inclusion of lettering, the words and word fragments of Cubist iconography. In this as in its companion picture, superimposed images suggest that what makes the city a city, its defining feature, is the simultaneity of the events that fill its space.

The city as patchwork is also how the French-educated critic Fu Lei (1908-66), one of the begetters of the Storm Society, represents it in an article he published on Pang Xunqin in *L'Art* in 1932. Called 'Xunqin's Dream,' it evokes the city by stringing together the things that spelled Paris, from ethnic mix, cafés, jazz, odious landladies and Montparnasse to secondhand book stalls by the Seine and Josephine Baker (the black American singer and dancer who so electrified Parisian audiences in 1925 and whose fusion of the primitive and the modern made her a Jazz Age icon). Paris and Shanghai were linked in Pang's imagination, not only because these were the two cities he knew best but because if Paris was what

Pang Xunqin's *Such is Paris*, watercolour, 1931.

Fu Lei aged twenty-six, 1934. From Ye Yonglie, *Fu Lei hua zhuan*, Shanghai, 2005.

you would use to take a modern culture-reading, then so was Shanghai. To a Chinese artist who was after modern subject matter and modern imagery, Shanghai sprang naturally to mind.

Influences from many sources appear in Pang's pictures, which display a wide acquaintance with modern styles while making no final commitment to any particular manner of drawing. In a 1934 portrait of Qiu Ti (1906-58), a graduate of the Shanghai Art Academy who became his wife in 1932, he paints her with an elegantly elongated face and figure in the style of Modigliani, but dressed in colours, pale blue and white, little like the earthy palette of the Italian artist. Both Surrealism and Cubism inhabit the same picture in his *Composition* (1932), where a seated woman bends her head to her book, faceless, only her long wavy hair identifying her as Qiu Ti. His *Son of the Earth*

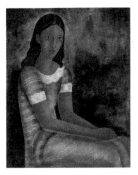

Pang Xunqin, *Portrait of Qiu Ti*, oil on canvas, 1934.

Pang Xunqin, *Composition*, 1932.

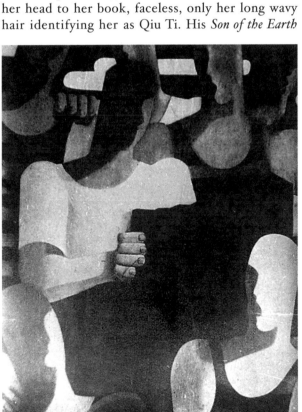

73

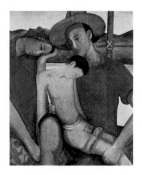

Pang Xunqin, *Son of the Earth*, 1934. Destroyed by his own hand during the Cultural Revolution, this survives in only a watercolour sketch.

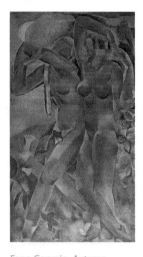

Fang Ganmin, *Autumn Melody*, oil on canvas, 1934.

(1934), which shows three drought victims – father and mother holding child's dead body – recalls any number of pietàs, and this is so even if we sourced the figures' elongation to Modigliani. In a *Still Life* painted in 1937, the floral patterns on a pot, bowl and fabric look back to his enthralment by the 1925 Paris exposition, to his initial urge to study decorative art, as well as forward to his future career in design. If ever a man was hard to pin down stylistically, it was Pang. He was an experimentalist, and frank enough about it – in an interview with the art historian Ralph Croizier in 1983, he said that he never did more than three paintings in the same style.

Did his pictures, all painted when he was still only in his twenties, begin what he would have done with his maturity had circumstances allowed? Would the various forms of stylization have settled into one style, his own? We shall never know, though one senses that the eclecticism was as essential to the man's identity as the liking for style and decoration. What is undoubted is the aesthetic pleasure his work can give. Pang related his own pictorial impulses to the language of modernism fluently and agreeably, in a way which makes for quick visual acceptance by the modern eye. In all this he perfectly fitted everybody's idea of what a Shanghainese should be, down to the cosmopolitanism and the weakness for styles.

His brief years of experimentation represent a climax in the history of visual modernism in China. Of course he was not alone in serving as a conduit for the art first generated in Paris. Before I return to the Storm Society I'd like to look at the work of seven other artists trained or active in Shanghai.

Fang Ganmin (1906-84) was born the same year as Pang and went to Paris to study art the same year he did. Of his paintings, two are particularly noteworthy. These are exercises in the Cubist manner. They give to their subject, both nudes, the geometrical and sculptural, but not the fragmented, effect of a picture by Braque. In jest, his fellow-students called his style *fang* ('square'), punning on his surname Fang, which also happens to be one of the characters of the Chinese word for 'cubic.'

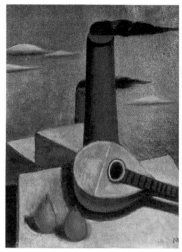
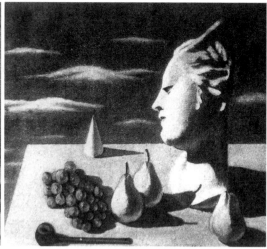

Yang Taiyang (b.1909), an enthusiastic member of the Storm Society, studied in Shanghai and, after the society dissolved, in Tokyo. Ni Yide has written of Yang's admiration for Picasso and Giorgio de Chirico, and the oils he exhibited at the Storm Society certainly show Cubist and Surrealist effects borrowed from these artists.

Liang Xihong (1912-82), a Cantonese who studied, exhibited and published art criticism in Shanghai, drew on Fauvism at one end (as he was bound to do, having had two years of study in Japan), and Surrealism at the other. Of the latter, he was a determinedly consistent advocate. His works have not survived but we can see something of his style from a reproduction of a mural he painted (jointly with an artist called He Tiehua, whose writings on modern art cites Cézanne, Jung and Chinese poets) for a secondary school in Hong Kong during his wartime sojourn there. Entitled *Nation Building*, the painting shows a man holding a book standing atop a flight of stairs against a tightly rendered city background of modern buildings, factories and bridges. It is not unlikely that before painting this picture Liang had seen a reproduction of Rudolf Schlichter's *Dada Rooftop Studio*, c.1920, itself deeply indebted to de Chirico.

Liang Xihong (with He Tiehua), mural, *Nation Building*, 1938.

75

Xu Xingzhi, *Hesitating Man*, oil on canvas, exhibited 1934.

Xu Xingzhi (1904-91) studied painting in Shanghai and Tokyo. From teaching art upon his return to Shanghai in 1929, he went on to author books on Impressionism and Post-Impressionism, Rodin's sculptures and Corot's landscape paintings; to publish poetry; stage plays and even direct movies. In all that he did a strong vein of leftism can be traced, one which drew him to the Proletarian Art movement in Japan and to politically engaged writers in Shanghai. While he did not repudiate French modernism in so many words, he would make it clear enough that he had no time for art that did not advance the cause of proletarian revolution, and put Paris-influenced artists like Liu Haisu and Lin Fengmian high on his hit list.

Distinct from these artists, but consistent with his politics, he dealt with the theme of alienation in his paintings. In his massive tome *A History of Art in Twentieth-Century China* (2006) Lü Peng writes that Xu Xingzhi's style inclines towards German Expressionism, and it is certainly true that the theme of the loneliness of the city runs through his *Evening Walk – Tokyo Street Scene* (1926) and *Hesitating Man*, the latter shown at a solo exhibition at the Shanghai YMCA in 1934. But to me the pictures have more of the 'emptiness' of an Edward Hopper composition and the dream cityscapes – piazza, arcades, shadows – of an early de Chirico. Their spaces are a state of

mind, with the architectural features in them, the deep-shadowed bays and façades of the buildings, expressing alienation and disconnection.

The fifth artist is the short-lived, French-trained figurative painter Zhang Xian (1901-36). Ni Yide wrote of Zhang in 1935 that he'd daub and daub his canvas with unhappy results until, too frustrated to continue, he left a second time for Paris. It is said that from studying Degas and Cézanne, he went on to find inspiration in Matisse and Derain, and in Picasso's figures in the latter's neoclassical period in particular. But actually he was interested, more so than others in the Storm Society, to find a style that combined French modernism and Chinese tradition. This might not be immediately apparent from the portrait he showed at the Storm Society's third exhibition in 1935 (and reproduced in the 111st issue of the popular periodical *Young Companion*), where he gives the sitter a wedge of a nose. Nor from a portrait, pictured below,

Zhang Xian, *Portrait*, oil on canvas, 1934.

Zhang Xian, *Hero and Beauty,* oil on canvas, 1935. National Museum of Art, Beijing.

Qiu Ti, *Still Life,* oil on canvas, 1931-33.

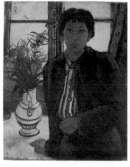

Pan Yuliang, *Self-Portrait,* oil on canvas. 1945. National Museum of Art, Beijing.

the magazine published in 1934 as part of its series on contemporary Chinese artists.

The wedge of nose he gives the sitter in the first, and the exaggerated neck, arms and hands he gives her in the second, are modernist distortions, maybe, but when we inspect a third work, *Hero and Beauty* (1935), we can't help but think of the seventeenth-century Chinese painter Chen Hongshou, a distinguishing mark of whose style is an exaggeration of face and figure. The link is reinforced by the flatness and the schematic drawing, which are owed as much to Chinese ink painting as to modern European art. The pencil and Chinese ink drawings of Sanyu, we're told by Pang Xunqin, were a source of influence on both Zhang and himself. A signed and dated canvas from a private collection which Lü Peng's tome reproduces (*Girl with Pet*, 1935) suggests how all those influences might have been assimilated into a distinctive style had Zhang's life not been cut short.

Now for two women painters. Qiu Ti, Pang Xunqin's wife, studied at the Shanghai Art Academy and in Japan. She won a prize at the Storm Society's second exhibition in 1933 for a picture of a potted plant which caused something of a storm in a teacup because it had red leaves and green flowers. She was only being true to her Japanese-Fauvist training, releasing colour from naturalistic constraint; but its viewers were bemused by it, and one imagines Ni Yide throwing up his hands when he exclaimed, as he did in an article in her defence, how backward China still was, how benighted it was of the viewer to expect natural colours from art when art didn't have to replicate external reality but could be expressive and decorative in its effect. On the whole, though, Qiu Ti's pictures – still lifes, flowers, a view from a window – are the sort to produce quiet pleasure rather than agitation.

Pan Yuliang (1899-1977) stands out from the crowd not because she was a woman, nor because, with her poor start in life, the odds against her flowering as an accomplished artist were great indeed, but by virtue of her true gifts as a painter. On the early death of

Pan Yuliang, *Flower Stall*, oil on canvas, 1940s. National Museum of Art, Beijing.

Pan Yuliang, *My Family*, oil on canvas, 1931.

her parents, she was sold into a brothel, but had the good fortune to be redeemed by a customs official whose surname, Pan, she took. Pan moved with her to Shanghai and put her through art school. He further supported her studies in Lyons and Paris, where she landed an Italian government grant to study painting and sculpture in Rome. She returned to Shanghai in 1928 and taught both there and with Xu Beihong in Nanjing, all the while painting and exhibiting her work before leaving for Paris for good in 1937.

One looks at her stern brooding self-portrait and wonders where else those mud-brown skin tones could have come from but the bodies of Gauguin's Tahitians? Yet a scintillating Fauve riot brightens up her other canvases, whose carmines, yellows, limes and

pinks seduce the eye without tiring it. When she made the female face and body a subject of exploration, she sometimes used her own as her model. Like Liu Haisu, one of her mentors, she attempted syntheses of oil painting techniques with Chinese ink brushwork, but generally these are the least satisfactory of her works, bland and lacking the world-weariness that distinguishes her oils.

In these artists we find the footings of modernism in China. Of course there could be no external influence except where internal conditions are ready for it. In China the backwoodsman is always with us; the past – older rules, older canons of taste – is always with us. But this was the generation that turned on its fathers; and Shanghai was the place, and 1930s the time, it could do this most effectively. There was next to no market for its work, but graphs of the growth of salons, art societies, and books and magazines on Western art trace a great spurt from about 1932. Regrettably the curve dived in 1937, and no one can have any glimmering of the sadness of modernism's fate in China who does not recognize the brevity of that time of unparalleled vitality. The modernists were trying to forge a new way out of the old at a time when Japan was spoiling for war, and when both war and the revolutionary doctrines of Marx and Lenin were so soon to burst upon them.

These obstacles faced the Storm Society from the very beginning. Its first exhibition had to be postponed for almost a year, until October 1932, because Japanese aggression in Manchuria in September 1931 was succeeded by the bombing of, and a full-scale attack on, Shanghai at the start of the following year. One of the places where artists and writers congregated was flattened when bombs fell on Chen Baoyi's airy studio in Jiangwan, to the north of Shanghai.

Afterwards, the Storm Society gave the impression of being beyond the political predicament, pressing on with its annual exhibitions and its monthly meetings. It had no lack of supporters in the local periodical press, and it must have been pleased to

see its exhibitions covered, and so consistently too, in the pages of the *Young Companion* pictorial – where better than in that most popular of general-interest magazines? Yet even were it possible for the artists to stay aloof from the political fray, they could not do so for long. In 1935, the society held what would prove to be its final exhibition. The Japanese had long been at the gates, and now, in 1937, they widened their incursions to face Chinese across the country with the violence and destructiveness of an all-out war. The modernist movement did not gutter out so much as it was snuffed out.

The crisis reinforced Chinese nationalism, and the anti-Japanese and anti-foreign feelings that were at the core of it. In that climate, whoever came along with an anti-imperialist message would get a hearing, and it is no wonder that the appeal of Marxism proved irresistible to so many young Chinese as a means for China to regain its pride and sovereignty. Among artists susceptible to revolutionary ideas, I have already mentioned Xu Xingzhi. Another was Zhou Zhentai, similarly a returnee from Japan. In the Storm Society's last exhibition in 1935, he entered a painting showing a worker in overalls repairing a machine. Ralph Croizier writes that the picture's style 'has more in common with contemporary American social realism than anything from the School of Paris,' but that its source was probably Proletarian Art in Japan.

Zhou was exactly the sort of person for whom Chiang Kai-shek's government kept a lookout – as well it might, for today's young radical was tomorrow's communist enemy, and, as we know from hindsight, it was at the hands of the communists that Chiang Kai-shek would one day be defeated. So the government was not taking any chances when it closed down the Storm Society's predecessor, the art group (Taimeng) which I said had Pang Xunqin for a member but which I forbore to say was radicalized by Zhou Zhentai.

A third was Huang Xinbo (1915-80), who studied at the Shanghai Art Academy and whose reputation now rests entirely on his woodcuts, an art which evolved,

as Japanese invasion, civil war and communism progressively overtook China, into a patriotic and leftist form of social propaganda, indeed as an art which the Communist Party would canonize and recognize for one of its own. Requiring only knife, ink and paper, the woodcut was an art that could be practised cheaply and quickly. Judging the medium to be appropriate to the times and circumstances prevailing in China, Lu Xun promoted a 'modern woodcut movement' through publishing European and Japanese examples, and organizing shows, talks and practical workshops for young Chinese artists like Huang. What is less well-known than Huang's dedication to the movement are the thirty or so oil canvases he painted in the five years between the end of the war with Japan and the communist victory. A widely held contemporary view was that oil painting and war didn't mix, and Huang's pictures, of which the Surrealist *Metropolitans* (1946) and *Seeds* (1949) have survived in reproductions, could have been intended

as a riposte to that view and an attempt to put modernism to political use.

In fact all the artists lived in the shadow of politics, even the least political of them. Pang Xunqin professed no political ideology, but when he exhibited *Son of the Earth*, to his alarmed surprise he received an anonymous death threat, no doubt because his painting was thought to be critical of the authorities. And as if this were not warning enough, Zhang Xian, his fellow in the Storm Society, was informed by phone that Pang would soon be arrested. In the event neither threat was carried out, Pang left Shanghai to lie low for a while, but intimations of danger were always to cling to *Son of the Earth*, and it was one of the paintings destroyed by the artist's own hand when the Cultural Revolution broke out in 1966. There would be no arguing with his accusers if they chose to use his past paintings as evidence against him, or to brandish them as proof of his ideological incorrectness.

By then he was Director of the Central Academy of Arts and Crafts in Beijing. One suspects that he had turned to the decorative arts with relief, if for no other reason than that they lent themselves less readily to politicization than avant-garde painting. In any case, his modernist phase was over, curtailed first of all by the war and, following closely upon the Japanese

(Right) Huang Xinbo, *Metropolitans*, 1946, one of perhaps thirty canvases he painted in the five short years (from about 1943 to 1948) he worked in oil before giving it up for printmaking.

(Left) Huang Xinbo, *Seeds*, 1946.

defeat, by the communist revolution. It came out years later that as the civil war neared its end, he and a number of other artists were jointly commissioned to paint portraits of Mao Zedong and Zhu De, the Red Army commander alongside whom Mao had fought, and that these portraits were then hung in the Great World, Shanghai's famous entertainment centre, in the flush of the communist victory.

So passed the modernist interlude in the art history of Shanghai. Aesthetics was co-opted into propaganda. We could safely expect no more Cubist nudes from Fang Ganmin, who went on teaching art but who, if he were ever tempted to paint anything avant-garde, would soon think better of it. From ignorance of his past attainments, suppressed with the execration of modernism, his students at the National Academy of Art in Hangzhou disdained and humiliated him, thinking nothing of parading him around the campus, all the while pouring ink over him, when the persecutions of the Cultural Revolution began. Ni Yide joined the Communist Party, which found additional uses for him, political and social. However, this did not save him from being punished in the Cultural Revolution for his interest in modernism, his sophisticated Shanghai manner and perhaps even for being well-dressed, offences meriting heavy and demeaningly filthy manual labour.

Fang Ganmin, 1930s.

Socialist Realism became the house style. Proclaimed as the guiding principle of Soviet art, Socialist Realism was comprehensible to the masses in a way which avant-garde art was not. With its uplifting content, heroic caricatures of muscle-bound workers, peasants striking thrusting poses and patriotic labour in idyllic sunlight, it isn't how anyone imagines the Shanghai aesthetic to be. Aiming to appear 'true to life,' it exudes an often repellent look-on-the-bright-side optimism which, combined with the didactic and the homespun, all too often ends up in being mere propaganda. It jars rather than jibes with a style and a spirit that in Shanghai grew out of big city life, commercial laissez-faire and the ambiguities of

modernity. It is a curious art, falling within the realist tradition yet requiring idealization of subject matter. Its triumph in China meant the triumph of realism, or the trumping of a Xu Zhimo by a Xu Beihong.

So visual modernism's promises were never ripely fulfilled. But then, it is one of the commonplaces of history that styles, movements and tendencies come and go, doing more or less violence to the received tradition and then going away again. Of course some might say, pointing to the small public for the kind of paintings the Storm Society exhibited, that Shanghai's soil wasn't fertile enough to begin with, and it is certainly true that these works would have found far more takers if they had been in the Chinese ink idiom. But to judge Shanghai's hospitality to modernism by the size of the public is surely to lose sight of the fact that experimentalism generally begins in a climate of apparent neglect, and that what there was of a modernist movement in China, however small, was generated and concentrated in Shanghai. There was more coterie acceptance of modernist painting in Shanghai than elsewhere in China, more debate and more critical recognition.

Of enormous importance to the extension of styles are the books, magazines and exhibitions through which they achieved their transmission and sought out their audiences, and it was Shanghai that produced these in the greatest number. Shanghai was at the centre of, and served as a focus for, even out-of-town art endeavours. Two examples will do for all. A photographic pictorial which set the pattern for art magazines to follow was the *Zhenxiang huabao* (*The True Record*), a tri-monthly periodical which started publishing as early as 1912. It was a Cantonese operation (its editor was Gao Qifeng, one of the two Gao brothers famously identified with the Cantonese school of painting), but its place of publication was Shanghai. Similarly, the Cantonese answer to the Storm Society, the Chinese Independent Art Association of avant-garde artists returned from Tokyo, held its exhibition in 1935 not where it was constituted,

namely Canton, but where artistic production was livelier, namely Shanghai The leading member of the Cantonese coterie, the fervent advocate of Fauvism and Surrealism Liang Xihong, was himself a graduate of the Shanghai Art Academy, a member of the Storm Society and the editor of two periodicals (*Meishu zazhi*, or *Art Magazine*, and *Xin meishu*, or *New Art*) published in Shanghai.

When cultural reaction against avant-garde art set in, Shanghai Style as a whole was hard hit. The style was the envelope of the modernist spirit, and those who accused Chinese artists of aping the West were but criticizing in small what those who stigmatized Shanghai's 'Westernized' culture were criticizing in large. In neither case, though, was it clear where the line was to be drawn, between copycat imitation on the one hand, and the artistic appropriation of a van Gogh (who took forms from Japan) or a Picasso (who raided Primitive art) on the other. There is no such thing as an artist who has escaped being influenced. Yet though the Chinese were as mingy in valuing their own artists as the next nation, when someone like Fu Lei, the French-educated critic glimpsed earlier in this chapter, complained in 1933 that some artists' enthusiasm for 'Cubism, Dada and Expressionism' was but a fad based on scant understanding, he was not being entirely unfair. That there was a genuine opposition to a dominant but exhausted art cannot be doubted. But that is just one kind of modernism. There is the modernism of new thought and new forms; and there is the modernism that takes to the new as to fashion. It was a characteristic of Shanghai Style that it was both.

STORM SOCIETY
90, RUE MARCEL TILLOT
SHANGHAI CHINA

M. Brunel
C qt Police
le 28.11.33

Changhai, le 24 novembre 1933

Monsieur le Consul Général,

J'ai l'honneur de vous faire savoir que notre société va fonder
une académie de peinture à notre siège social, 90, rue Marcel Tillot.
C'est une académie libre qui ne donne aucun enseignement, elle est tout
à fait dans le genre des académies parisiennes, telles que Julienne,
Grande-Chaumière, etc.

L'Académie ne comporte qu'un studio où nos sociétaires et les ar-
tistes non sociétaires admis à une certaine condition peuvent étudier
le nu, la nature morte en tous les genres--dessin, croquis, aquarelle,
peinture.

Je me permets donc de vous adresser ci-inclus les documents essen-
tiels sur la fondation de notre société et de notre académie. J'espère
que notre oeuvre ne commet en rien l'ordre de votre police ni les lois
de votre concession, nous sommes d'ailleurs à votre disposition de nous
conformer à tous les règlements en cas de besoin.

Veuillez agréer, Monsieur le Consul Général, l'assurance de notre
considération très respectueuse.

決瀾社
STORM SOCIETY
THE YOUNG CHINESE ARTIST SOCIETY

Secrétaire de Storm Society

87

3

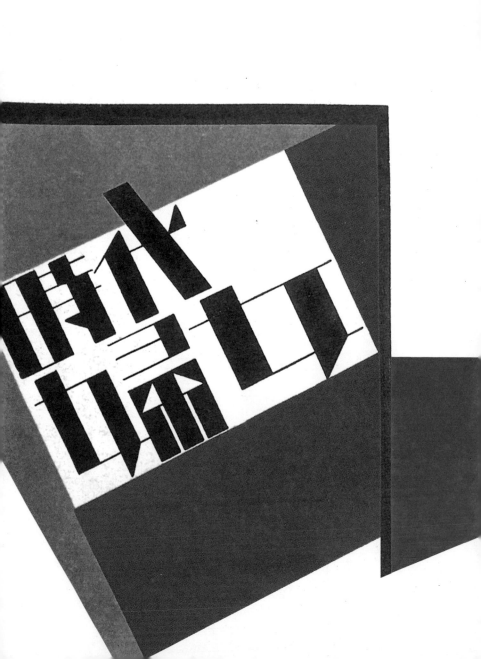

BOOKS & MAGAZINES

A quick way to get a sense of the change in visual culture brought about by the import of Western technology and Western designs is to place a Chinese book of the nineteenth century next to a Chinese book of the early twentieth century. The contrast strikes you even before you turn the first page. The front and back covers of the first book are made of plain paper, with the title in Chinese characters handwritten on a slip pasted onto the front cover. The book had been printed from wooden blocks, each carved with a double-page spread of text and, if the book is illustrated, with pictures. Its pages are of thin paper printed on one side only, then folded to form a verso and recto page with the printing on the outside. The raw edges are string-bound on the right, and you peruse the vertical columns of Chinese text, always read from right to left, by turning the pages from left to right – that is, in the opposite direction to that of a Western book.

(Opposite) Detail of magazine cover shown in full on page 116.

(*Far right*) Recto leaf of title page of *Xin xuebao (New Journal)*, September, 1897, with printing on verso page showing through the thin paper, Shanghai, September 1897. From Li Runbo, *Gu zhi yi yin*, Hangzhou, 2004.

Cover design (*bottom left*) by Feng Zikai of 1931 book (work by Gorky translated by Ba Jin) sets title in panel, deliberately evoking title slip of traditional string-bound book (*top left*) published also in Shanghai, 1930. From Jiang Deming, *Shuyi bai ying 1906-1949*, Beijing, 1999.

The second book opens in the same way, from left to right (doing it the other way round would come much later), but almost everything else about it is different. Glue has replaced string-binding; the title slip is gone, supplanted by typeset characters printed on the cover itself. Most strikingly of all, instead of plain paper the front cover is colourfully printed with a design, one based, what's more, on Western pictorial conventions. The Chinese characters, too, appear in shapes not seen in earlier typography. Times have clearly changed, and in the years it took for the first book to evolve into the second, two things had happened: lithographic printing had been introduced into Shanghai, and a new generation had come to manhood determined to invent its own symbols, judging the ones it had inherited too worn out and too hackneyed to be of use.

As we saw in an earlier chapter, it was the Jesuits and the Major brothers who brought the lithographic process to China. This technology had made possible

the printing of not only *Shenbao* and the *Dianshizhai Pictorial*, but lithographic editions of Chinese classics and reference works which, by buying up a number of Chinese book companies, Ernest Major was able to publish and sell in large runs extremely profitably. But a visual change is more than a technical advance accompanied by diminished costs; it is an overturning of past models in the interest of innovation. The early twentieth century in China is inconceivable without its inconclusive revolutions, one of which, the May Fourth Movement already discussed in the previous chapter, required jettisoning inherited values to make room for modernity. The design of book covers and illustrations as a conscious art and practice is conventionally traced to that movement.

As was indicated earlier, the movement was aimed at the modern makeover of all important aspects of Chinese culture in the image of Western civilization, the crux of which it thought to be science and democracy. To be an individual self unshackled by the Chinese past became a bracing intellectual imperative. Yet, much as the movement's intellectuals were fired by the West, deep down few believed that they must remake themselves as modern men and women to the point of deracinating themselves. They still cleaved, in one part of themselves at least, to inherited identity. Indeed, for all their conviction that their Confucian heritage was only there to be fought and left behind, they could not see how their country could achieve wealth and power without the national identity which pride in the intrinsic worth of its past cultural accomplishments could give it.

Making the arts and literature new required first of all that classical Chinese (termed a 'dead language') be replaced by the vernacular as the medium of written expression, and one of the bravest, most far-reaching projects of the May Fourth Movement's generation of intellectuals was the invention of a new written style to take the place of the classical language in which all serious works of literature were previously composed. Painted, powdered, obsequious, stereotyped, over-

1930 book (Chinese translation of Russian novel *In a Week*) still opens from left to right, but it is bound by glue rather than string and its cover carries illustration and printed typography. From Jiang Deming, *Shuyi bai ying 1906-1949*, Beijing, 1999.

ornamental, pedantic, unintelligible, obscurantist – by these words did Chen Duxiu, the May Fourth iconoclast already glimpsed in the previous chapter, describe literature written in the 'dead language.' The new language progressed in company with the quest for new literary techniques and styles – indeed for a New Literature, no less – for which the West was looked to for pointers. 'Is there any ambitious man in Chinese literary circles willing to become a Chinese Hugo, Zola, Goethe, Hauptmann, Dickens or Wilde?' Chen cried in the *New Youth* in 1917.

From the start the journal published translations of European fiction – Ivan Turgenev's *Spring Floods* in the first issue, and Oscar Wilde's *An Ideal Husband* from the second on. Chen himself wrote an article that described the broad stylistic phases of European literature of the eighteenth and nineteenth centuries as classicism, romanticism, realism and naturalism. China, he thought, remained still at the age of classicism and romanticism and the next step would take it to realism. At the time there was every sense, an apocalyptic sense even, that a modern era was dawning. There was every sense that a new stylistic age was at hand. But the romantic and realist styles were deemed modern enough for the New Literature. Modernism, the art which subverted realism and romanticism, may be the latest thing in the menu of modes from which the Chinese writer was making his selection, but it found only a small following, as we shall see, and that following confined almost entirely to Shanghai.

To all this, the design of book and magazine covers was a visual complement. Indeed, some of the May Fourth writers were themselves designers. Of these, no one looms larger than Lu Xun. Lu Xun fathered the movement to consider the look of a book and stimulated the work of the first generation of Chinese graphic designs who drew from European modernism. He found his vocation as a modern writer – by common agreement contemporary China's greatest – by way of a roundabout route that wound through

Lu Xun as student, 1904. Detail from group photograph with fellow countrymen in Tokyo.

family circumstances and an engagement with the fortunes of a China sunk to a low point in its history. His family having fallen on hard times, he took up a scholarship to study at a naval college. Denied the life of letters reserved for the scions of gentry families, he graduated from the School of Mining and Railways in 1902, then proceeded to Japan on a government scholarship to study at the Sendai Medical School.

There the famous slide incident took place. A projector normally used for showing slides of bacterial forms brought him face to face with an image which so jolted him that he abandoned Medicine for Literature. In the projected slide, an able-bodied Chinese man suspected of being a spy for the Russians (with whom Japan had been at war on Chinese soil) is about to be beheaded by the Japanese army while a group of his fellows look on. They do so impassively, with no apparent self-awareness, prompting what would turn out to be Lu Xun's lifelong, anguished question, 'What kind of people are we Chinese, to remain so unconscious of inhumanity?' It was as physician to the Chinese spirit, not body, that he decided he could most usefully live his life, and the medium most appropriate to this was writing.

Writing that could make its way to the reading public with the help of visual imagery. Lu Xun was interested from the first in pictures. As a child he'd rather draw than practise calligraphy, and it enthralled him to copy from illustrated popular romances and works on painting, flora and fauna, and above all ghosts, fantasy and mythology. It was Lu Xun the artist rather than Lu Xun the medical student who, in an anatomy drawing exercise, put a blood vessel in the wrong place out of aesthetic considerations. Pictures he'd seen are reproduced by his own hand in a book conjuring up the world of his childhood, *Dawn Blossoms Plucked at Dusk*. He was also an art collector, amassing such items of Chinese material and visual culture as illustrated books, classical paintings, and rubbings of ancient stone and bronze engravings. We saw earlier that when Cai Yuanpei made him responsible for art

and culture in the Ministry of Education, Lu Xun made it his business to develop museums, galleries, exhibitions, libraries and theatres as well as the preservation of ancient sites and monuments.

Though he wouldn't put it that way, the project on which Lu Xun was embarked, namely the transformation of Chinese consciousness, was actually modernity by another name. No true modernist, though, could find a way of becoming newer without re-ordering the older. It is in this light that we must see the long years he took upon his return from Japan to study the Chinese past. Textually, his studies included the history of Chinese fiction and the poetry of the Wei and Jin dynasties (third to fifth century AD), a period which spoke to the iconoclast in Lu Xun because its poets were the Bohemians and aesthetes of their day, crossing a threshold into more consciously artistic ways of seeing and feeling just as he himself did when he burst upon the Chinese literary scene with his unique brand of literary modernism. Visually, his energies as a researcher and classifier embraced the imagery of the Han (206 BC to AD 220) and the Wei-Jin ages – figures, mythical animals, decorative motifs of stylized clouds and waves found carved in relief on bricks or stone slabs in tombs and on memorial tablets. Of these engravings he assiduously acquired ink rubbings.

Out of the image bank thus formed came his design of the cover of *Peach Coloured Cloud* (*Taose de yun*), a translation of fairy tales he published in 1923. Across the top third of the space is a band of decoration, cloud scrolls in the colour of the title. I have sourced this to a rubbing in his possession of a carved decorative border he locates in the fourth rear chamber of an assemblage of structures dating to the Han dynasty, the Wu family shrines in Jiaxiang, in modern Shandong province. Another of his book cover designs, that adorning a 1926 publication entitled *Exploring the Heart*, adapts figures and motifs from Wei-Jin engravings.

To use archaic Chinese imagery might suggest

Exploring the Heart, 1926 edition of poetry and essay collection by Gao Changhong with uncut pages and cover design and typography by Lu Xun. From Yu Runqi, *Tang Tao cangshu*, Beijing, 2005.

that you were a traditionalist and not a modernist. But Lu Xun was very much the latter. To immerse yourself in the Chinese past and then to transcend it – that was the way to modernity. He sought models for new forms of Chinese expression in an international array of images, and far from stopping at China, his own taste in art ranged beyond it eclectically, to Japanese, English, German, Russian and other European cultures. This is more than obvious from his publications, his personal collections of illustrated books and prints, and from the pictures he hung on the walls of his home in Shanghai: woodcuts by Käthe Kollwitz and Lyonel Feininger, the German artist whose image of a cathedral serves as the frontispiece of the Bauhaus's first manifesto, as well as two nudes by Augustin Becher, *Eve and the Serpent*, and *Susanna Bathing*. Far from being a poor second to his knowledge of Europe's literary modernism, his acquaintance with and interest in its modern art and design paralleled it.

Eve and the Serpent (top) and *Susanna Bathing*, woodcuts by Augustin Becher decorating Lu Xun's house at Lane 132 Shanyin Road in Shanghai.

In the early stages of the evolution of Chinese book cover design, the connection between literary content and graphic image was often tenuous. Shanghai's publishing trade did not jib at putting a Western image – of a European woman, even – on a book whose characters and settings were entirely Chinese. The idea of keeping art independent of literature would not wash with many book illustrators today, but it was nothing unusual then. One thinks in this connection of the French painters Maurice Denis and Pierre Bonnard, for whom ornament was ornament and content was content, and illustration and text did not have to, indeed should not, be conceived together. In the covers created by Chen Zhifo (1896-1962) for and in conjunction with Lu Xun, it is as though the graphic pattern was all that mattered.

Chen Zhifo has been described as China's first professional graphic designer, though it was in woven textiles design that he had initially trained and specialized. His father owned a number of fabric

Chen Zhifo, Tokyo, 1922.

97

Chen Zhifo's cover design of *Experience of Creation*, 1933. The masking, by the ornamental pattern, of Lu Xun's title calligraphy makes this a less than successful design, but the attempt to create a modern composition out of a decorative scheme adapted from ancient Chinese bronzes makes it noteworthy.

Chen Zhifo's design for cover of *Literature*, vol 2, no 2, 1934, shows him keeping step with the high modernism of the 1930s.

dyeing workshops, and at the technical college where he studied in Hangzhou, Chen Zhifo learnt dyeing and weaving. Like many of the modernist painters referred to in the previous chapter, he had a stint in Japan in the early 1920s, enrolled in the Tokyo School of Fine Arts as its first foreign student in Design. He was in Tokyo at about the same time as Ni Yide, the co-founder of the Storm Society, and the artist Feng Zikai, with whom he became friends and of whom we shall hear more later.

Upon his return to China, he settled in Shanghai, where he started a commercial design studio, and taught and executed designs of not only silk and printed textiles but book and magazine covers. His book, *Pattern Composition ABC* (*Tu'an goucheng*, 1930), is believed to be the first on design to be published in China, and proved popular enough to be reissued half a dozen times. Far from being confined to Chinese motifs, its contents range widely, from ancient Egypt and Greece to Christian and Buddhist symbolism. To go by his use of ancient Egyptian figures on the covers he designed for the magazine *Eastern Miscellany*, his choice of subject matter for *Ancient Persian Design* (another one of his books) and the ancient Chinese decorative motif which adorns one of his best-known book covers (that of *Experience of Creation*, 1933, for which Lu Xun inscribed the title), he would appear to have a penchant for archaic imagery. And indeed he would one day be accused of being a 'traitor' to modernism, taking to painting in a realistic mode and in the traditional Chinese bird-and-flower style. Yet no designer in the Shanghai of his time could be without his modernist moments. Take the geometricized covers he designed for the magazines *Modern Student* (July 1931), *Creation and Criticism* (1934) and *Literature* (1934), and for the title *Collection of Short Stories from the Soviet Union* (1933), and see if he wasn't as alive as the rest of them to the fashionably modernist trends of the day.

How to make his graphic image suggestive of the character of the text exercised Tao Yuanqing

Cover design by Chen Zhifo of periodical *Modern Student* (*Xiandai xuesheng*), vol 1, no 8, 1931.

(1893-1929), another pioneer of graphic design. Lu Xun commissioned him to design a cover for his book *The Grave* (1927), a collection of essays in which the author makes his abhorrence of the old China, the China that 'devours' its people, more than apparent. Tao was struck by the book, indeed deeply depressed by it. How was he to represent visually the anguish of an author who tells you, 'It is true that I apply myself to dissecting others, but in fact how much more often does it not occur that I turn a much more pitiless scalpel upon myself'? It seems that Lu Xun was not fussy about the relationship between image and text, though he was fastidious about much else in book-making – the quality of paper and printing, the typography, the width of the margins and so on. In the

Tao Yuanqing in his bedroom, 1928.

Tao Yuanqing's design for *Worker Zweilov* (detail), translated by Lu Xun, 1927, alludes to ink rubbings of Han dynasty stone reliefs.

Tao Yuanqing's cover design for Lu Xun's *Wavering*, 1929.

end Tao Yuanqing did what Lu Xun had asked him not to, which was to evoke the tomb on the cover. The design is abstract, but you can make out the shape of a coffin seen head-on, with triangles representing burial mounds and elongated cones for trees.

Lu Xun was pleased enough with it though. In fact, he had nothing but praise for not only Tao's designs but his paintings. Of the latter, which Tao executed in the Western manner he had learned at art school, Lu Xun has written, 'He uses fresh forms and especially fresh colours to represent his own world' even as he stays true to the Chinese national character, while keeping up with the times and with the international currents of the day. Tao Yuanqing is Chinese and modern at once, Lu Xun continues, and it is only by seeing him as one of those who harbour a wish to operate in a worldwide frame of reference that you get the full measure of his art.

The two collaborated closely, and we have the first editions of several titles, original works by Lu Xun as well as translations, to show how concerned they both were to renew and update traditional Chinese imagery. Tao's designs for *Selected Tang and Song Stories* (1927) and *Worker Zweilov* (1927) draw from the image bank of Chinese antiquity, but he has modernized the look of ancient bas-relief figures and motifs by making them more cursive, more angular and even more flattened, a tendency taken further still in what is perhaps his best-known cover design, that for Lu Xun's short-story collection *Wavering* (1929). In this last design, Tao has taken a ruler to his picture surface, and from its straight lines and pointed forms the viewer derives a sense of the angular tendencies of visual modernity as well as Lu Xun's comfortless, hard-edged sensibility. To me the stiffness of the figures in Tao's design is the rigor mortis of death, Lu Xun's analogy for the Chinese tradition he could only think of as decayed, even putrid. The rigidity of the figures conjures up the man himself, taut with the fear of uncaging his demons lest they wreaked damage.

For the covers of two of Lu Xun's numerous

translations, *Symbols of Mental Anguish* (1924) and *Out of the Ivory Tower* (1925), originally Japanese works by the literary critic Kuriyagawa Hakuson, Tao sketches a nude female figure. Coming so late to life drawing, Chinese artists were being avant-garde when they painted nudes. But Tao no doubt took his cue also from the influence on Kuriyagawa of Freudian theory, which eroticizes life and art and subjects reality to symbolization. The modern world is a world changed and reinterpreted by Freud, and Lu Xun would not have been the modernist he assuredly was if Freudian ideas of psychological trauma, symbolism and dream didn't enter into his creative writing.

Tao died young, aged only thirty-six, but there was nothing transient about his legacy. One on whom he had a lasting influence was Qian Juntao (1907-98), the most prolific and accomplished of all Chinese graphic designers. The two were roommates when Qian was studying art and music in Shanghai, and their paths crossed again when they found themselves teaching – Qian, music; Tao, art – at the same school in Taizhou, a town to the south of Shanghai. Starting out in music – which he not only taught but composed and published – Qian was to become successful in many other endeavours, as graphic designer, writer, calligrapher, ink painter, seal-engraver, publisher, art collector and even businessman. His energy seemed boundless, and it really did look as though he was a great all-rounder who could put his hand to almost anything.

Large as it was, his oeuvre would have been greater still had he not been robbed of more than a decade of his life by the merciless persecutions of those political terror campaigns that culminated in the Cultural Revolution. His having been an entrepreneur and made money from the publishing business in the 'bad old days' before China's 'proletarian' revolution would return to plague him. Grievous harm was done to him personally and professionally, and it is extraordinary to find him bouncing back after the Cultural Revolution ended in 1976 with his appetite

Tao Yuanqing's cover design for second edition of *Symbols of Mental Anguish,* translated and first published by Lu Xun in 1924. From *Tang Tao cangshu,* Beijing, 2004.

Qian Juntao as a young man.

Concision and simplicity of line in Qian Juntao's sketch reflect his search for the greatest economy of expression. From *Xin nüxing* (*New Women*), vol 2, no 17, 1927.

for work undiminished. He is remembered today by a memorial museum in his birthplace in Tongxiang, Zhejiang province – a repository of not only his own paintings, calligraphy and seal engravings but those of the masters he had collected over the course of his long life.

Qian Juntao's career as a graphic designer was inextricably intertwined with the growth of Shanghai's Kaiming Shudian, literally 'enlightenment bookshop,' a progressive publishing house for whose music and art lists Qian was given editorial responsibility. Composing music, writing lyrics and designing covers all came naturally to him, and he would prove again and again that his eye was no less developed than his ear. Indeed, for Qian, the one informed and enriched the other, and he would later write that, 'I tried as much as I could to apply what I know about melody, harmony, rhythm and timbre to the design of book covers.' In his time he designed something like 1,700 covers, which included all of Kaiming's titles as well as a stream of commissions received from other Shanghai imprints. If authors could choose, they'd all have their books designed by him, and many famous ones did – Lu Xun, Yu Dafu (see previous chapter), Mao Dun and many others – far more, in fact, than Qian could singly handle, so that he had to draw the line at titles whose contents did not deal with art and culture.

Looking back on those years, he recalled half a century later that the designs of the 1920s and 1930s were still at the stage of being 'immature, dull, motley and repetitive.' Only if illustrations escaped being 'superficial, revealing, sweet, ingratiating, shrill and brittle,' he claimed, could they succeed, and only by being restrained could they achieve that meaning beyond word and picture with which the very best of them are imbued. Stylistically, they were varied enough, as befitted the mood of experimentation spawned by the May Fourth Movement, and as a creature of his time Qian was as open as any Chinese artist to the Western design vocabulary. If, as many say, modernism is less a style than a search for style, then

Cover designs by Qian Juntao, 1928-1937 (*clockwise from top left*): *Peach Orchard*, short story collection published by Kaiming, Shanghai, 1928; *Soviet Russian Stories* in special issue of *Literature Weekly* (*Wenxue zhoubao*), 1929; *Literary and Artistic Front* (*Wenyi zhendi*), periodical prompted by start of Sino-Japanese War in 1937, vol 3, no 2; special commemorative publication marking tenth anniversary of Shenshi Telecommunications, 1930. Despite considerable differences in detail, there is a continuity of feel to Qian's designs: no other graphic artist used typography with greater innovativeness and clarity, and none achieved a more balanced composition in their use and division of space. From Jiang Deming, *Shuyi bai ying 1901-1949*, Beijing, 1999; Xie Qizhang, *Fengmian xiu*, Beijing, 2005.

Qian exemplified it – his graphic oeuvre, as we shall see, is an anthology of references to Europe's avant-garde movements. Perhaps better than any other Chinese designer, Qian showed that Shanghai was part of the internationalism integral to modernism.

Like many another Chinese artist of the time, Qian came by European modernism via Japan. As an art student, he learned much from the collected works of Sugiura Hisui (1876-1965). The latter was, among other things, head of design at Mitsukoshi, the famous department store. Mention Japanese Art Deco and everyone thinks of Sugiura, who introduced it and other modern styles from Europe and America

to his own country, if not through the graphic design magazine he founded, *Affiches*, then through the influential design compendium he helped to edit, *The Complete Commercial Artist*. For mentors, Qian also had two gifted Chinese trained in the fine arts in Tokyo: Li Shutong, the painter-turned-monk; and Feng Zikai, the artist I mentioned in passing earlier. Yet another point of contact with modernism was a Japanese-owned bookshop in Hongkou, a neighbourhood with so high a concentration of Japanese residents that it was called Shanghai's Little Tokyo. The proprietor, Uchiyama Kanzo, was no ordinary bookseller but the provider of a safe house for clandestine leftist meetings, a channel for Japanese publications and materials, and a bridge to Japanese academic and art circles. Lu Xun was a close friend and Qian, who had an account at the store and would drop by periodically to browse and buy books, would on occasion run into Lu Xun there.

Lu Xun had made it his business to introduce Western printmaking to Chinese audiences, and he and five friends who called themselves the Morning Flower Society were publishing anthologies of European woodcuts and etchings. He and Qian would have talked about these, just as they would have talked about how art might be simultaneously modern and Chinese (or 'international' and 'national'), a question which did exercise Qian, but less urgently than it did Tao Yuanqing. If Qian, whose mastery of classical Chinese arts like calligraphy and seal-engraving is beyond dispute, showed himself to be true to his Chinese self, it wasn't by wearing his classicism like a badge, appealing to Han imagery or going out of his way to bring about a fusion of Chinese archaism and Western modernism. Yet though he knew well enough that in modernism art turns from the real and the material towards style and spatial form, his arguments against verisimilitude in book design are couched not in terms of 'abstraction versus realism' but in a language more familiarly Chinese, as the opposition between *xu* (virtual) and *shi* (real, material), with the

implication always that the former is to be preferred to the latter.

He was not alone in his receptiveness to the modernist trends reaching him from Europe and Japan, and in what follows I will look at how he and other Chinese graphic artists refashioned for their Chinese audiences the variety of imported styles that coexisted in Shanghai. At times the graphic trends running side by side converged, not always to happy effect, it has to be said, resulting in pure pastiche. However, in the hands of the more skilful practitioners the incongruity could be transcended and a new aesthetic created.

Aubrey Beardsley's black and white drawings, displaying many characteristics that would come to define Art Nouveau, held a fascination for Chinese artists and writers, and continued to do so long after interest in them had ebbed in their country of origin. Because of the cultural time-lag involved in stylistic transplantations, Shanghai's artistic and literary circles did not take him up until the late 1920s, about thirty-five years after he famously published *J'ai baisé ta bouche* ('I kissed your mouth'). This print illustrated Oscar Wilde's *Salomé*, and along with the others supplied by Beardsley it formed a watershed for the Aesthetic and Decadent movements.

We are told that Lu Xun, who was to die of tuberculosis, would not read books or papers when he was ill but would solace himself with a little picture he put by his bed, taking a look at it every now and then as he lay there quietly. Though it was probably a coloured woodcut by a Soviet artist, it was no revolutionary image but a picture of a woman in a long skirt running along with her hair streaming out behind her in the wind – what sounds, in fact, 'like some pre-Raphaelite vision,' to cite his biographer David Pollard. Why this picture and not the scores of others he had in his possession? His common-law wife did not know, but surely the high decorativeness of the Becher woodcuts I mentioned earlier provides a

Illustration of Wilde's *Salomé* from Lu Xun's *Selected Pictures by Beardsley*, Morning Flower, 1929.

clue? Scholars of Lu Xun make much of his admiration for Käthe Kollwitz, the German printmaker whose depictions of suffering, poverty, wretchedness, war and death certainly spoke to his evangelical wish to see Chinese art serve the ends of social criticism and political protest. Yet his gaze would just as soon be consoled by feminine beauty and leafy vegetation. Asked why he liked the one of Susanna bathing, he said it showed the female subject in an unusual pose – baring her back to the viewer. That may be so, but his fondness for the two pictures is also of a piece with his great liking for Aubrey Beardsley, the supreme Decadent artist to whom he devotes an issue in his Morning Flower series, though without looking back to the English artist's Pre-Raphaelite antecedents or associating him with Art Nouveau or the 1890s Aesthetic Movement in England. He wrote of the grace of line in Beardsley's drawings, and thought that as a 'decorative artist' the latter had no equal. So just when you thought you had Lu Xun pegged as someone of whom it could never be said that he was not hard enough on himself, you are faced with his taste for an epicene style of art.

This could have come from the deep well of collective aesthetic memory. Behind the Art Nouveau aesthetic lies the European encounter with Oriental art, the art of Japan particularly, but also that of China. 'The East,' writes the Dutch Art Nouveau artist Jan Toorop, 'is the foundation of my work! This wonderful, half-Chinese décor...[was] my first contact with beauty.' The aesthetic debt to Japan is widely acknowledged, to China much less so, partly because of a European inability to distinguish between the two (so that the Chinese influence is frequently lumped with the Japanese under the rubric 'Oriental'), and partly because its contribution was indeed attenuated and secondary, based mainly on its being the ultimate source of much Japanese art. In their liking for the Art Nouveau style, it might well be that the Chinese artists were irresistibly called back to their own decorative traditions, finding in the new,

self-consciously modern art a misty evocation of the Chinese past.

If, for example, they had stepped into the Peacock Room designed by James McNeill Whistler for the London home of a wealthy English entrepreneur in 1876-77 (and now in the Freer Gallery of Art in Washington DC), they would have recognized much of what was on display – certainly the blue-and-white Chinese porcelain collection displayed on the gold spindle shelving, and probably the peacocks based on a Japanese print painted on to the walls. The Peacock Room, one of the world's most celebrated interior design schemes, symbolizes the Aesthetic Movement, a begetter of Art Nouveau. Whistler was part of the circle of artists and writers who made up that movement, along with Aubrey Beardsley, Oscar Wilde and Walter Pater (the Oxford don whose writings on 'the love of art for art's sake' helped shape the Aesthetes' dandyish lifestyle and decadent non-conformity).

In Shanghai, no one pursued that style more eagerly than the writer, illustrator and bibliophile Ye Lingfeng (1905-75). Indeed, Ye came to be known as the 'Oriental Beardsley,' he was such a devoted fan of the English artist. A playwright, Tian Han, was probably the first to introduce Beardsley to a Chinese audience: his translation of Oscar Wilde's *Salomé* reproduces the English artist's famous illustrations, while the covers of a magazine he ran, *The Southern Country Weekly* (*Nanguo zhoukan*), sport Beardsley's drawings. It was through these, as well as through an article by the writer Yu Dafu, that Ye came to know of Beardsley. Yu Dafu's article introduced Chinese readers to *The Yellow Book*, the English magazine of which Beardsley was art editor. Bowled over by Beardsley's graphic style, Ye Lingfeng bought an edition of Wilde's *Salomé* and began to copy the English artist's black and white drawings. Years later he would write of his longing for a print of Daniel Gabriel Rosetti's *The Lady Lilith* (1868) to hang on his wall, so well did he like this painting, and this is exactly as you would

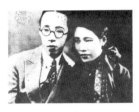

Ye Lingfeng with fiancée, 1928. From *Shanghai Sketch*, Nov 10, 1928.

expect from looking at his attempts to draw in the Beardsley manner, which owes something to Rosetti and other Pre-Raphaelite painters.

Ye Lingfeng even aspired to the sleekness of an aesthete himself, wearing his initially tousled hair glossily slicked back. He has written of how, to show himself off to a fashionable young woman he espied on a tram, he took a handkerchief scented with Houbigant (a French perfume) out of his pocket and wiped his hands with it, then looked at his own fingers, slender and pointed, with the nails gleaming under a fresh coat of Cutex nail polish. It went with this persona that he was an avid collector of books, bookplates and rare editions – a prized item was a copy of the seventh edition of James Joyce's *Ulysses* published by the Shakespeare and Co of Paris, a find from a secondhand bookshop named Tianfu on Sichuan Road.

Ye Lingfeng had learned to paint in the traditional Chinese way by copying from manuals, but had gone on to study Western painting at the Shanghai Art Academy. It was not long, though, before his pictorial interests gave way to his literary aspirations, and he began to publish fiction and essays even as he drew magazine covers and illustrations. He fell in with the writers of the Creation Society, the literary coterie of which Yu Dafu and other Chinese alumni of the Tokyo Imperial University were founding members and for whose publications the young Ye worked at first as a general dogsbody. It was through doing this that he found his métier as a book and magazine man.

Some of the periodicals he worked on (the *Deluge*, *Literary Pictorial*, *Mirage*, *Gobi*) were as ephemeral as such things tended to be in the Shanghai of the 1920s and 1930s, when the government would come and shut you down if you showed leftwing sympathies. In fact the Creation Society pursued a Romantic style of writing in its early phase, and did not turn to 'proletarian literature' until later. Yu Dafu's idol was a Decadent, Ernest Dowson; while the foreign writers every literary type worth his salt had to have read were Baudelaire, Dumas *fils*, Hugo, Romain Rolland

(French authors topped the long list of European works translated into Chinese during the May Fourth period), Byron, Keats, Shelley, Goethe, Nietsche and so on. One task Ye Lingfeng later reminisced about was bringing out a new edition of the Chinese translation of Goethe's sensationally popular *The Sorrows of Young Werther* by the Creation Society co-founder Guo Moruo. How he went about it says something about him and about the Shanghai of the time. He took pains over the cover, layout and choice of paper, and to include some illustrations from an original German edition, he made a trip to a German bookseller near the Sichuan Road Bridge across the Suzhou Creek (probably the Tianfu named earlier) to borrow a copy. Because Werther's dress, which was widely imitated by the novel's devoted following, consists of a blue frock coat, buff leather waistcoat and breeches, Ye used two colours, blue and buff, on the cover, which he further livened up with a decorative symbol of the frock coat and breeches.

Far from wanting to bend art to radical social application, in the Creation Society's earlier years the members found the Aesthetic Movement's motto 'art for art's sake' to be the more appealing – indeed more glamorous – slogan. It was in such a milieu that Ye developed his enthusiasm for Beardsley. His borrowings from Beardsley (and, as we shall see, from the Japanese artist Fukiya Koji and other styles) were a visual parallel to the writers' literary gropings after a modern aesthetic. Both were experimental, superficial. As much as they were moderns of new thought and new forms, it has to be said that these people were moderns who responded to the new as to fashion. If Ye Lingfeng famously became the butt of Lu Xun's renowned invective, it was not only because he had used low humour to decry *A Call to Arms*, the latter's collection of short stories, but because Lu Xun scorned faddishness and imitation. In acerbic print, Lu Xun jeers at the 'self-styled Chinese Beardsley' as he has scoffed at Wu Youru, the artist of the *Dianshizhai Pictorial*; indeed he lumps the two together, as men of

Ye Lingfeng imitates Beardsley in his illustration of a femme fatale with dress modelled on *The Peacock Skirt* and streaming hair (a good pretext for creating the curving, tendril-like lines beloved of Art Nouveau style). It must be supposed that the jars are there to hold alcohol, the title of the illustration being *Intoxication and Woman. Chuangzao yuekan (Creation Monthly)*, April 16, 1926.

the same ilk, tainted alike by that seam of Shanghai society for which he uses 'hoodlum' as a shorthand. Surely, Lu Xun implies, there must be something phoney about a fellow who 'swallows' Beardsley one minute and 'rips off' Fukiya the next?

Actually, if Lu Xun meant to suggest that Ye was nothing but a copycat, he was being unfair. Ye Lingfeng did see beyond the graphics to what lies behind Beardsley's style. He has written that somehow, Beardsley reminds him of the poetry of Li He (791-817), the singular Chinese poet known to many as the 'demonic genius,' and Ye wouldn't have done this if he didn't see something in Beardsley that called up the morbidity, darkness, aestheticism, violence and voluptuousness of Li's poetry. Both died young, the tubercular Beardsley before his twenty-sixth birthday and the Tang dynasty poet at roughly the same age. Both distort, exaggerate. And, as the sinologist Angus Graham has observed, Li He reminds many readers of Baudelaire, the very poet the French Decadent movement glorified. The crossover points overlap, Beardsley and Decadence with Baudelaire and Li He, and of this Ye did have intimations.

Ye was not alone in his admiration for Beardsley; nor Lu Xun in publishing his illustrations – a collection of Beardsley's pictures was brought out by a publisher in Shanghai in 1929, while an anthology of his poetry and pictures was compiled and published in the same year by the poet Shao Xunmei (1906-68) under a pseudonym. Shao, who had studied at Cambridge University, England, was the image of the man of letters who was also a man of the world. The first could have been produced by any place in China, but the man of the world that Shao Xunmei was could only have flourished in Shanghai in its noon hour. Born privileged, he was part of the city's *beau monde*, incarnating Shanghai's cosmopolitan qualities. He wrote poetry under English and French examples; but more importantly for my purposes, as a publisher of illustrated periodicals he helped shape the city's popular visual culture (see next chapter).

A Collection of Beardsley's Pictures, Heji Educational Materials, 1929. From Yao Zhimin et al., *Shu ying*, vol 1, Shanghai, 2003.

Shao Xunmei in London, 1925. From *Sheng Peiyu, Shengshi jiazu, Shao Xunmei yu wo*, 2004.

Shao named a journal he published the *Golden House Monthly* to echo *The Yellow Book*, the quarterly in book form of which Beardsley was the art director. Walter Pater appears in Chinese translation in the inaugural issue (1929) of Shao's journal. The latter declared kinship with *The Yellow Book* by sporting a plain yellow cover, while another Chinese literary journal, *The Crescent Moon* (1928-33), imitated its squarish shape and general appearance if not its colour (blue instead of yellow) because its designer Wen Yiduo (1899-1946) was so thoroughly enamoured of Beardsley's style at the time. Wen Yiduo, a May Fourth activist who had studied at the Chicago Art Institute, Colorado College and Columbia University, co-edited the journal with Xu Zhimo, he of the 'Two Xu's Controversy.'

Shao Xunmei's publishing company Golden House Bookstore distributed *Sphinx*, a Shanghai magazine Shao had first come across during a trip to Singapore. He liked it so much that he would seek it out on his return home and help to produce it. Just the title is enough to explain why: like the temptress Salomé, the oriental, enigmatic and dangerous sphinx was one of the guises for the *fin-de-siècle* femme fatale, a recurrent theme in the Aesthetic and Decadent movements

Crescent Moon with uncut pages, sized 21.5 cm x 20 cm to resemble *The Yellow Book*, March 1928. From Xie Qizhang, *Chuangkanhao: fengjing*, Beijing, 2003.

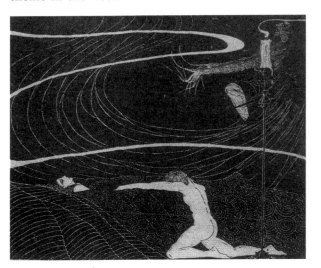

Lu Shihou's Beardsley-inspired femmes fatales in *Sphinx*, no 8, Oct 16, 1928. Death is linked to desire in *fin-de-siècle* imagery in Lu Shihou's illustration and in a poetry collection by Shao Xunmei (1929) in which this reappears – one entitled *Hua yiban de zui'e* (flower-like evil) in deference to Baudelaire and his *Les Fleurs du Mal*.

and in Art Nouveau, and an object of fascination to Shao and his circle. Shao would have been drawn to the artist Lu Shihou's illustrations in the magazine, conjuring as they did the death and desire thematized in Decadent literature and *fin-de-siècle* art, as well as the latter's taste for eroticism and dream imagery.

The femme fatale finds visual form too in pictures by Ye Lingfeng, the French-trained artist Lin Fengmian and the portrait painter Jiang Zhaohe (1904-86). Jiang Zhaohe, who had arrived in Shanghai from the hinterland as a poor sixteen-year-old but who would one day become Professor at the Central Academy of Fine Arts in Beijing, is down in the history books as a realist painter in the manner of Xu Beihong. His portraits are certainly lifelike. But different times and different circumstances extracted different things from him. Self-taught, he learned Western-style painting on the job, making a living from portraiture; creating backdrops for photographic studios; and producing fashion designs, commercial art and advertisements for the Sun Sun and Sincere Department Stores in Shanghai.

A picture he created during his time with those department stores, one with Art Nouveau features entitled *Consolation*, survives in only a printed reproduction in the periodicals *Shanghai Sketch* and *Young Companion*. Others in the same curvilinear vein were cover designs for the periodical *Art and Literature Monthly*. To suggest that they're not quite art, Jiang's Chinese biographer Liu Xilin (2003) calls these images 'decorative pictures' (*zhuangshi hua*), apparently unaware of their debt to Art Nouveau. It is to the latter that Jiang owes the use of slender, sinewy female nudity, the dreamy sensuality and slightly grotesque imagery. The rest strikes the native eye as familiarly Chinese: those feather patterns on the two magazine covers, for instance, could have come just as well from the phoenixes and cranes of ancient and medieval Chinese ornamentation as from Beardsley or Whistler, while nothing could be more immemorially Chinese than the cloud forms painted in silver on the

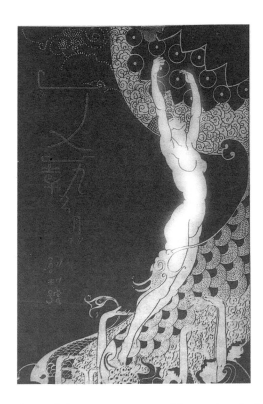

Jiang Zhaohe's femme fatales cover for *Wenyi (Art and Literature Monthly)*, August 15, 1930.

first of the two covers, and heaped and clumped in *Consolation*.

It says something for Chinese artists' receptivity to changing trends in Europe that Art Nouveau was only a phase in their earlier career, one they outgrew as other styles came their way. In any case, the Chinese adoption of the Art Nouveau style was never wholesale, seldom without a local inflection. The local inflection may itself be a style, one which the artist might well have first seen in ancient Chinese textiles, engraved tiles, bronze mirrors and pottery, and dredged up from the depths of the collective memory. What's more, the Chinese artist may simultaneously borrow from several European sources at once, in what the art historian Ellen Johnston Laing has aptly described as a 'scattershot approach to Western art.' This is the approach making for the pastiche of a very early image, the cover of a collection of stories

Whiplash curve on cover of *Xinhua mi ji (The Secret Records of New China)*, 1918. From Yao Zhimin et al., *Shu ying*, vol 1, Shanghai, 2003.

Deco doe, zigzags and locomotive in Chen Zhifo's design for cover of *Wenxue (Literature)*, vol 1, no 4, Oct 1933.

published in 1918 (*The Secret Records of New China*), which reproduces that most quintessential of Art Nouveau lines, the whiplash curve, but combines it with a lion that is out of character with it.

Art Nouveau's sinuous, organic patterns were geometricized into Art Deco as the machine aesthetic increasingly entered European art. Repeating, overlapping images expressed this fascination with machinery, as did, in the 1930s, streamlined forms derived from the principles of aerodynamic design. The various styles to which the label 'Art Deco' has been attached were first showcased at the Exposition Internationale des Arts Décoratifs et Industriels Modernes, last seen in these pages as stopping Pang Xunqin in his tracks when he caught it on his arrival in Paris in 1925. Since 'Art Deco' was not coined until the 1960s, elements of the style prevailed in 1930s Shanghai without anyone putting a name to it, and it was as a modern look that the Chinese took it up. Not just modern, but glamorous too: as a style of the Roaring 20s and the jazz-baby flapper in Europe and America, one that was propagated across the world by Hollywood cinema, Art Deco trailed a glamour better suited to commercial art than serious literary media; and was, for this reason, not all that pronounced in the latter in Shanghai.

While much of the book-cover design produced at the time was immune to its influence, there is no doubt that some of it was not. Chen Zhifo's cover for the October 1933 issue of *Literature* (*Wenxue*) shows three of the trademark motifs of Art Deco: the leaping doe, zigzags, and locomotive. The magazine *Silver Express* strikes an Art Deco note on its back cover by virtue of the modern look of the three girls it depicts, the trademark Deco tresses they sport and the modernistic disc-shaped earrings they dangle from their ears.

It can't be emphasized enough that the Chinese designers could no more name this new visual language than their counterparts in Europe or America. One reviewer of the Paris exposition applies labels first

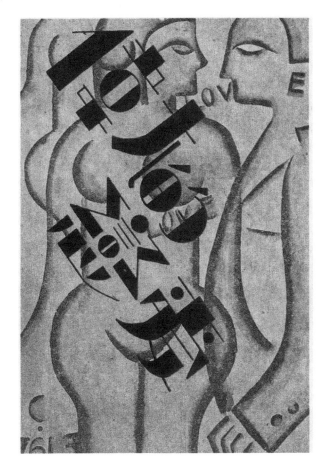

Silver Express (Yinse lieche) on cover of two magazines in one, Shanghai, 1935. From Xie Qizhang, *Chuangkanhao: fengjing*, Beijing, 2003.

Designs of book and magazine covers by Qian Juntao showing Cubo-Futurist influence: *A Great Love*, (left), c. 1930; and (top) *Xin shidai yuekan (New Era Monthly)*, 1931. From Scott Minick and Jiao Ping, *Chinese Graphic Design in the Twentieth Century*, London, 1990; and Xie Qizhang, *Chuangkanhao: jianying*, Beijing, 2004.

developed in the fine arts to the new style, describing how, on entering the exhibition, one comes upon 'a cubist dream city,' its 'cubist shapes and futurist colours... looking like nothing so much as a Picasso abstraction.' We know, as the Chinese designers could not, that movements like Cubism and Italian Futurism were sources for Art Deco. We might detect, as these Chinese could not, the migration of the imagery of avant-garde artists like Fernand Léger and Robert Delaunay to Art Deco. At the time nobody in Shanghai thought of it as a style unto itself. That is why, when Qian Juntao spoke in 1980 of the cover designs he created in the 1930s, it is Futurism that he

For his cover design for *Literature and the Great War in Europe*, 1928, Qian Juntao says he borrowed ideas from Dadaists – appropriately so, since it was at the height of the war that Berlin Dadaists like George Grosz (a figure much admired by Chinese artists) began mixing texts and fragments of newsprint with found images and photomontages. From Jiang Deming, *Shuyi bai ying 1906-1949*, Beijing, 1999.

Qian Juntao's design of *Modern Woman (Shidai funü)*, 1933.

said he learned from, rather than Cubism or Art Deco. In fact, it was ultimately from Kazimir Malevich, and particularly this Russian artist's 'convex' Cubo-Futurist style, that Qian borrowed for some of his cover designs.

While they were decidedly influenced by the Western modernist movements spilling over into the 1930s from the decades before, many designs show no single, readily identifiable style. It has been observed of graphic design in Japan that a style which historians term 'Japanese Modern,' one compounded of elements derived from Russian Constructivism, Art Deco, Bauhaus and, for want of a better term, 'Proletarian Graphic,' prevailed in the interwar era. It may equally be said that a 'Shanghai Modern' existed, and that it mingled many contemporary pictorial cultures, though not exactly the ones characteristic of 'Japanese Modern.'

Of all graphic artists Qian Juntao came closest to creating that synthesis of pictorial cultures which we recognize as modern Chinese design. Like other modernists he liked to 'cleanse' his designs of the figurative, going beyond representation to pure pictorial form in some of his most striking covers, graphic compositions using only geometric shapes and typography. Designing letterforms with the stripped look of sans serif typefaces enhances the modernist feel of the covers, especially the Chinese characters for the title, *Shidai funü* (*Modern Woman*), where Qian's achievement is to press the typography to an extreme of geometricization without making the words illegible (see Chapter 5). Arranged diagonally, all but one of the character strokes, the right-falling one in *dai*, are plotted vertically or horizontally or at forty-five degrees – giving to the composition a rectangularity characteristic of De Stijl, the Dutch avant-garde movement exemplified by the abstract paintings of Piet Mondrian.

Knowledge of the latest design trends came from several sources. Not the least of these was the American magazine *Vanity Fair*, that glamorous

'Kaleidoscope Review of Modern Life' where the Russian-born art director Mehemed Fehmy Agha brought Parisian chic and German experience to bear on the task of revolutionizing magazine design, and where the Italian Futurist Fortunato Depero spent part of his New York interlude (1928-30) designing covers. From the reminiscences of their contemporaries, we know how avidly the magazine was studied by the likes of Ye Lingfeng, the illustrator Zhang Guangyu (see next chapter) and Shao Xunmei, the publisher of the *Golden House Monthly*.

The illustrator and cartoonist Ding Cong recollects how he would scour the secondhand bookshops in the Old Chinese City, Henan Road, Hankou Road and the lanes round about for back issues of Western pictorial magazines; and how a foreign-run bookstore below Sichuan Road Bridge (probably the Tianfu noted earlier) sold secondhand copies of *Vanity Fair* with their mastheads torn off. Priced at 1.20 yuan unused, they were now a bargain at 20 to 30 cents a piece, cheap

Style of cover design of *Chrysanthemum Fragrance* (*Ju fen*) mimics that of Italian Futurist Fortunato Depero, probably studied by Chinese designer from covers of *Vanity Fair*, 1928. From Yao Zhimin et al., *Shu ying*, vol 2, Shanghai, 2003.

'Taking a bit from here and a bit from there': Ye Lingfeng does this in cover design for own novel *A Girl of the Times*, 1933. From Yao Zhimin et al., *Shu ying*, vol 2, Shanghai, 2003.

One of twelve illustrations by Fukiya Koji which Lu Xun selected and published, together with his translation of the poems they accompanied, in his Morning Flower series, 1929.

enough certainly for Ding Cong, who would clip their illustrations to fill his scrapbooks. The *New Yorker*, *Esquire*, *Harper's*, the *Saturday Evening Post*, *Vogue* – these were all available in 1930s Shanghai. Depero's designs for *Vanity Fair* and *Vogue* certainly had their imitators in Shanghai, as you could tell by looking at the cover of *Chrysanthemum Fragrance*, a novella published in 1928 (see figure on previous page).

Another source these artists drew on was the cinema. Zhang Guangyu is said to have learned composition from the frames and imagery of American and German films – in a book he compiled in 1932 on the applied arts, he reproduced stills of the cityscapes of Fritz Lang's *Metropolis*. In the visually arresting sets of this movie, Zhang wrote, modernist art was absorbed more fully and powerfully than in any other film. 'We'd watch movies and commit the camera angles to memory,' Ding Cong recalls. Ding admits to raiding movie magazines, to 'taking a bit from here and a bit from there,' but 'digesting it' all so thoroughly that 'you can't tell,' probably not even he himself, 'where any of it came from.' It was not outright copying, he claims. Nor could it be, since in crossing borders any foreign language of forms necessarily undergoes translation, adjusted to the native representational code and audience.

Shanghai's artists had access to not just American or European models, but Japanese ones too. Ye Lingfeng had other models besides Beardsley – notably Fukiya Koji (1898-1979), a Japanese illustrator (particularly of girls' magazines) much given to portraying dreamy Japanese beauties in a delicately wistful style. Ye's two volumes of the artist's work, itself influenced by Beardsley's, had come from Uchiyama Kanzo's bookshop in Hongkou, a gift from a writer friend recently returned from Japan. Ye was someone who took styles and motifs from a wide span of sources and used them unapologetically. Adding the Japanese illustrator to his repertoire drew Lu Xun's scorn, as we saw, and it was to show how far short Ye and other Chinese imitators had fallen, how far they had strayed

from Fukiya Koji's line, that Lu Xun reproduced a selection of the original pictures in his Morning Flower series in 1929.

Another Chinese designer to have learned from Japanese artists was Qian Juntao, who has named Sugiura Hisui as an influence. Sugiuru was last named in these pages as the founder of *Affiches*, a magazine that helped channel modern European and American design to Japan. As the chief designer of the Mitsukoshi Department Store too, he helped steer the modern movement in Japanese commercial graphics away from the tendrilled style of Art Nouveau towards greater stylization and clarity. Yet Qian was never one to imitate anyone consciously, and if he acknowledged Sugiuru as a source of influence, it must have been an indirect and diffuse one, for any trace it may have left on his work is hard to find, much less any direct quotation from it.

Both Qian and Ye were eclectic, experimenting with and, in Qian's case, internalizing and synthesizing the styles that came one's way in Shanghai. The only artist to remain true to one style throughout his life was Feng Zikai (1898-1975). Feng Zikai is identified to this day with the form the Chinese call *manhua* and the Japanese *manga*, a term which, as Feng himself has explained, could cover anything from a Chinese-style impromptu sketch to a Western cartoon or caricature. But he was also, like his mentor Li Shutong, a writer, a musician, a calligrapher and a woodcut artist. For all his versatility though, his style, once found, stayed distinctively his own.

Feng Zikai on his return to Shanghai from Japan, 1921.

It was while studying in Tokyo in 1921, and rummaging through the books of a secondhand book stall, that Feng Zikai stumbled upon the 'soundless poetry,' as he calls it, of the art of Takehisa Yumeji (1884-1934), a pioneer of Japan's commercial graphic art and an illustrator of numerous children's books, book covers, sheet music covers and posters. A collection of the latter's brush sketches, titled *Spring*, so appealed to Feng that he bought it and took the worn copy home with him to study. Takehisa Yumeji's

illustrations, on which the native *ukiyo-e* tradition, the Arts and Crafts movement in England, and socialist and Christian thinking have all left traces, synthesized East and West in a way which spoke to Feng Zikai. His strong blacks, his simple compositions, his lyrical quality, his fondness for depicting women and children engaged in everyday activity and for including a caption or some verse, all came to characterize Feng's pictures too. An example of Feng's captions is the one in a classroom scene in which a student cheats by reciting his lesson from a text which, unbeknownst to the teacher, is pasted on the back of the pupil sitting in front of him. The caption, 'Reciting from memory,' is a pun on 'reciting,' the same word being used for 'back' in Chinese.

Although some of his illustrations, particularly the more decorative ones he did for book and magazine covers, have something of Fukiya Koji about them, there is no question that the overwhelming influence was Takehisa Yumeji, down to the pastoral feel of his figures and settings. It is as though he did not live in Shanghai, did not publish mostly in that city's media, as though he were a habitué of the age-old teahouse rather than the café and cabaret. Like the Japanese artist, he seems to have located himself in a time and place impervious to industrial change and metropolitan experience. This is why labelling it as 'almost Haipai,' as the contemporary Beijing-based writer Zhou Zuoren has done, and dismissing it as 'slick, superficial, ignorant of humour,' seems to me to be wrong. Feng's extensive body of work may include some pictures of the 'modern girl' with permed hair, but by and large his imagery is the sort to resonate with a yearning for timeless, Eternal China. While it was ubiquitous enough to be part of Shanghai's visual culture, seen in as widely distributed a medium as *Shenbao*, the leading newspaper, his imagery doesn't easily fit the category 'Shanghai Style,' at least not in the sense it is most commonly understood.

Unusually for Feng Zikai, 'Picking shepherd's purse' was composed in the *gongbi* style of traditional Chinese painting, one characterized by fine brushwork and close attention to detail. In this he said he took a leaf from Fukiya Koji, who sometimes employed this technique.

That 'slick' and 'superficial' are attributes of Haipai was implied by its detractors in the Beijing vs Shanghai slanging match reported at the start of this book. To suggest that modern Chinese literature would be well rid of Haipai, one of these detractors said that it was only the Saturday School by another name – the kind of writing, in other words, published in the popular periodical *The Saturday (sic)*. Much of this writing was sentimental fiction, a genre named after two traditional Chinese images for lovers – Mandarin Duck and Butterfly. To an intellectual snob and especially to a modernist, Saturday School writing is light reading of the worst kind: old hat, hackneyed, commercialized, pandering to a lowbrow taste for love stories and comedies, and for tales of detection and knight-errantry.

Yet Haipai is not just one mode, passing for the

Its early date and visual style (particularly the modelling of the face) declare the cover painted by Ding Song as Early Haipai: *The Saturday*, Oct 1914. From Jiang Deming, *Shuyi bai ying 1906-1949*, Beijing, 1999.

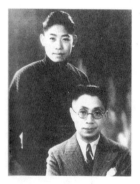

Ding Song *(right)* and son Ding Cong embody Early and Middle Haipai, early 1930s. From Li Hui, *Ding Cong*, Zhengzhou, 2001.

exact same thing in 1910 as in 1930. If it is hard to avoid linking its earlier phase to Mandarin Duck and Butterfly fiction and *The Saturday* magazine, it is just as hard to think of its later incarnation without reference to the modernism of literary journals like *Les Contemporains*. And the contrast is as clear in the visual arena as in the literary.

Consider the two leading vehicles of Mandarin Duck and Butterfly fiction: *The Saturday* (inaugurated in 1914) and *Violet* (first published in 1925). If writing of *The Saturday* and *Violet* type is Early Haipai, then so is their visual style. In keeping with their specialization in romances, they had pretty girls on their covers, ones with, moreover, a whiff of the boudoir about them. These girls were foreshadowed by a genre of figure painting called 'female beauties' in the traditional medium of ink and colour on silk or paper. By convention the latter are dainty women, with melon-seed-shaped faces and narrow sloping shoulders. Silk and paper paintings apart, lithographed illustrations sold in booklet form under titles like 'One Hundred Celebrated Beauties' portrayed them. The look of these, and the style of their delineation, linger in the cover girls of *The Saturday* and *Violet* in their earlier years of publication.

The girls' attire, hairdo and demeanour grew more modern as time passed and fashions changed – pigtails were replaced by permanent waves, for example – but the painting style remained conservative, representational, never out of range of the realistic convention. There was no violation of expected continuities. Large numbers of them were painted by an illustrator named Ding Song (1891-1969), the father of Ding Cong, who naturally came to be called Ding Junior when he started to follow in Senior's footsteps. Ding Senior had been a sometime teacher at the Shanghai Art Academy as well as a commercial artist producing advertisements for BAT (British American Tobacco).

In literary histories Middle Haipai is commonly represented by the writers associated with *Les*

Contemporains (1932-35). The editor of this periodical was Shi Zhecun (1905-2003), who is nowadays much studied by PhD students in Europe and America. He and his fellow-writers were widely read in Western literature, and kept themselves abreast of the latest literary and artistic trends in Europe and America by their avid perusal of journals like *Vanity Fair*, the *Dial*, the *Bookman*, the *New York Times*, the *Times Literary Supplement*, *Le Monde* and *L'Humanité*. The Harvard literary historian Leo Ou-fan Lee, who came by a selection of Shi's large library of Western-language books from a bookseller in Shanghai in 1994, tells us that they are in English and French and published in London, New York and Paris. Shi himself studied at l'Aurore, the Catholic university founded by French Jesuits, and fellow-students there, particularly Liu Na'ou and Dai Wangshu, would write, translate and interpret European writing for *Les Contemporains* and join him in turning it into a journal expressive of the modernist, cosmopolitan and metropolitan seam in Shanghai's culture.

Articles on such trends as Neo-Romanticism, Dada, Surrealism, Futurism and American Imagism bring home the message of modernity. The journal, its contributors meant the readers to understand, had intuited the quality of experience peculiar to

its day, the 'modern times' or the 'contemporary age' of the title *Xiandai*. The graphics on the cover of the inaugural issue told one as much. With their quality of abstraction, what a world away they were from those of *The Saturday* and *Violet*. The contrast with what the Futurist Filippo Marinetti called the 'mythological greengroceries' of Art Nouveau decorative style is similarly marked. The shapes of the Chinese characters, which were to remain constant throughout the life of the magazine, look as though the calligrapher's brush had been ousted in favour of the ruler.

The covers of five numbers of the fifth volume (1934) were designed by Qian Juntao. The use of straight lines and blocks of colour (which changes with each issue), and of the rectangle as the basis for laying out the lettering of the French title, evokes the rigour of the De Stijl avant-garde movement of the Netherlands. Even when not geometric, cover designs remained modernist, a clear example being the Cubist figure of the November 1933 issue. From the signature, we know the artist to have been Pang Xunqin, since 'Hiunkin' was how 'Xunqin' was spelt in Paris, the nursery of Pang's modernism. It could be said that the Storm Society he helped to found and *Les Contemporains* were products of the same urge, to enact – in the one case on canvas and in the other

on the printed page – a break from old patterns and familiar conventions into fresh forms and expressions, and to do so on Western and Japanese models.

The two worlds, art and literature, overlapped to a degree all the greater for the fact that some of the writers were themselves illustrators – I have already named Ye Lingfeng and Wen Yiduo – and for the frequency with which the artists and writers mingled socially, every one a habitué of places like the Sunya Cantonese Teahouse on Sichuan Road and the Dongya Restaurant on Nanjing Road. When one reads of Shi Zhecun, the poet Dai Wangshu and the designer Qian Juntao repairing to the Peach Hill Ballroom to dance after they had finished dinner at the Sunya, one may easily imagine the cross-fertilization. Earlier we heard Qian Juntao acknowledging the influence on him of Futurism. Qian was by no means alone in his interest, for even before he embarked on his travels in Europe in 1932, Dai Wangshu, the translator of French poets like Paul Valéry, had written about Filippo Marinetti, and translated an interview he had read of the poet-founder of Futurism in what was probably a French newspaper.

It required a modern city like Shanghai to offer teahouses and dance halls as crossing points of modernism, a style of art which is particularly urban, not only because the city is the locale of the modernist artist (as well as of his publisher, bookshop, coterie and magazine), but because it is his modern material, and the generator of his modern experience and modern point of view. Middle Haipai writers, particularly Mu Shiying, author of the decidedly urban stories *Shanghai Foxtrot* and *Five Characters in a Nightclub*, had a tendency to encapsulate, indeed exoticize, experience within the city. In this they were influenced by Japanese 'neo-sensationists' and the then-popular writer Paul Morand. Japanese 'neo-sensationism' was a stream of ideas, some strongly influenced by Futurism, that flowed to Shanghai through Japan-educated writers like Liu Na'ou. Its preoccupation with urban glamour, eroticism and

Caricature of Mu Shiying by Huang Miaozi, published in *Xiaoshuo (Fiction)*, no 7, Sept 1934.

Guo Jianying's cover for *Les Contemporains*, vol 4, no 4, Feb 1934. Shanghai Library.

Guo Jianying's illustration of 'Murder Unaccomplished,' Liu Na'ou's story published in *Art and Literature Pictorial (Wenyi huabao)*, vol 1, no 2, Dec 1934.

decadence finds an echo in Shanghai's Middle Haipai writers, by whom all the temptations of city life were worked into fiction, down to Shanghai's answer to the Japanese *moga*, short for *modan gaaru*, or 'modern girl.'

When it came to representing all this graphically, these writers could find no better illustrator than their friend Guo Jianying (1907-79), whose fluid artwork graces the cover of one issue of *Les Contemporains*, (February 1934, vol 4 no 4). To suggest these writers' cultural affinity with Guo's visual style, Mu Shiying's 1933 story 'The Man Treated as Leisure Goods' has the heroine mentioning 'Liu Na'ou's novel language, Guo Jianying's sketches and your [Mu's] rugged prose' in the same breath. Guo loved to portray the modern girl as seductress, the 'hot baby,' as Mu calls her in his story 'May' (from the *Saintly Virgin's Feelings* collection, 1935), and in this Guo's pictures complement Mu's prose imagery, itself inspired, one guesses, by fashion and product advertisements and the Hollywood films which Shanghai's movie houses showed almost as soon as they appeared in America. To judge by his sketches, of which more in the next chapter, Guo Jianying would certainly have agreed with the remark Liu Na'ou made in a letter to Dai Wangshu in 1926, to the effect that while there may be 'no romance' in the contemporary experience of modernity, 'We do have thrills and carnal intoxication,' and 'That is what I mean by modernism.' Guo illustrates some of Liu's stories (see figure).

As is clear enough from reading him, 'hot baby,' Camel cigarette, nightclub and the things he calls by their original English names in his writing – jazz, saxophone, café, cocktails, cabaret, kissproof [lipstick], elevator, Studebaker – spell modernity to Mu Shiying. The illustration of his 1934 story 'Camel, Nietzschean and Woman' by Ye Qianyu (of whom much more in the next chapter), of a modern girl in high heels puffing away at a Camel cigarette held in a heavily lipsticked mouth, is 'modernist' in the same vein. Mu, who died aged only twenty-nine, was a habitué of dance halls, living as he did in a city and a time

known for its conspicuous consumption, loucheness and reckless excitements. An impoverished farmer in his story 'Country Scenes' (*Art and Literature Pictorial*, February 1935) dreams of going there: 'Shanghai!' he wishfully thinks, 'Shanghai is a golden city, a city beyond the imagination'; it is his hope of 'consolation, of happiness,' signifying 'all that is bright, warm and strong.' His fantasies elide its flip side, the squalor and misery which Mu remembers in the opening line of his *Shanghai Foxtrot* (1933) – the oft-repeated cliché about Shanghai being 'a paradise built upon hell.'

Ye Qianyu's illustration to Mu Shiying's 'Camel, Nietzschean and Woman,' 1934.

'Country Scenes' is accompanied by the pictures of Liang Baibo (1911-70), the only woman illustrator to be working in 1930s Shanghai, or China, for that matter. Cantonese in origin, Liang had studied oil painting in Hangzhou and put in some time teaching Art in an overseas Chinese school in the Philippines before her move to Shanghai. In the next chapter I will discuss her comic strip and cartoons; here I confine myself to her illustrations of fiction and poetry. These are modernist in a conspicuously higher key than any other illustator's. Nine illustrations to a 1930 poetry collection traced to her many years after they were published (Lu Xun, who kept the original manuscript, had mistakenly attributed them to the poet himself), show figures standing alone in empty, friendless space. Liang was a member of the Storm Society, the coterie formed in Shanghai to further the cause of modernism, and it showed. As if sketched in shorthand, her images convey unease, loneliness and alienation, with something of a surreal dream world about them. Years later her contemporaries recalled Liang as an artist who stood apart, a free spirit and a loner. That she became unbalanced and, it is said, schizophrenic in her late years would not have greatly surprised those who had known her in Shanghai.

Liang Baibo's illustration to 'Country Scenes,' *Wenyi huabao*, Feb 1935.

Liang Baibo's illustration to poetry collection *Haier ta (Child's Pagoda)* by Yin Fu, 1930. From Wu He (ed): *Zhishang jingling*, Beijing, 2003.

In any account of the next stage of Shanghai's literary history, Late Haipai, the name of the precociously gifted novelist Zhang Ailing (1920-95), better known in English as Eileen Chang, will figure prominently. In Zhang's love stories (and they are mostly love stories),

we recognize the everyday life of 1930s and 1940s Shanghai.

Today's readers have never known and could never know this life, but they 'recognize' it from the way she transfigures it in all its ordinariness and strangeness. And the prose style in which she does this is altogether unique, at once traditional and modern. Yet, singular as that style is, it is also typical of a tendency in the Late Haipai period. This was the war period, 1937 to 1945, when heightened patriotism returned many writers, artists and intellectuals to Chinese tradition. Zhang Ailing's work cannot be facilely subsumed under any category of political or cultural allegiance, nor could its psychological realism be anything other than modern European, yet her admiration for traditional Chinese fiction, even of the Butterfly school, is well-known and unequivocal, and her own use of its conventions quite deliberate. She was emotionally held still by the old styles that the modernists wanted to change or abandon. But she achieved what no other Chinese writer had before her, which was to reintegrate them with modernity on a higher level of insight, inwardness and complexity.

'Late Haipai' has a more than chronological significance. There is about it the sense of an ending, not only of the earlier surge of modernist experimentation not answering to any contemporary political and social demands, but of the world from which modernism was receding. In Zhang herself and in her writing, the awareness of what was passing was far more acute than the awareness of what was to come. 'An individual can wait,' she has written, 'but time is in a hurry... it is in the midst of destruction, with the greater destruction still to come; and our civilization, be it sublime or superficial, will one day become a thing of the past. And if the word I most frequently use is 'desolation,' it is because I feel this indefinable dread at the back of my mind.' In a review of a published story of hers, Fu Lei, the critic mentioned in connection with the Storm Society, gives visual form to the atmosphere she evokes, coming up

Zhang Ailing (1920-95) with Fatima Mohideen (*left*) on roof of Zhang's home in Shanghai, August 1946. From *Renditions*, no 45, Hong Kong, 1996.

with the image of 'a gigantic hand beyond one's vision, opening its palm and crashing down from nowhere on everyone's heart,' an image printed, what's more, 'on low-quality newsprint with its lines and black and white contrast all besmeared.'

We may be sure that though it was a close friend, Fatima Mohideen, the half-Chinese daughter of a Ceylonese jewellery shop owner in Shanghai, who designed the cover of one of her story collections – the 1946, enlarged edition of *Romances* – Zhang, another one of those writers who also drew, would have had some say in the choice of imagery, for if it produces disquiet (or 'indefinable dread') in the viewer, this is 'precisely,' she writes in the preface, 'the atmosphere I had hoped to create.' If the giant ghostly figure in modern hairstyle looming over the balustrade were self-referential (as seems likely when compared with Zhang's self-portraits), then the picture could have been of the observing artist, the imagined spectator of an Early Haipai world, here made to look like something straight out of the *Dianshizhai Pictorial*. Her writing is in double relation to that world, simultaneously continuous and discontinuous with it. In fact it was from the *Dianshizhai Pictorial* that the designer took the vignette, one cropped from a picture Wu Youru produced for the periodical, and subsequently anthologized in his collection *One Hundred Beauties of Shanghai*.

For today's Chinese readers, some of the pleasure of reading her work is nostalgic, for a time and a place erased by revolution. She herself quit the city, and in her space-time exile in America she wrote little original fiction of equal quality. Since the 1970s she has acquired a cult following in Hong Kong and Taiwan. A generation too young to have known the Shanghai of her time, these readers are learning nostalgia at second hand.

Zhang Ailing's self-portrait, 1940s.

Cover of *Romances* (*Chuanqi*), expanded edition, 1946.

4

COMICS & CARTOONS

A wedding photograph of the poet Shao Xunmei and his bride made it to the cover of the popular magazine *Shanghai Pictorial* in 1927. During his vacations from Cambridge, England, where he had gone to study as a seventeen-year-old, he had put in time at the Ecole des Beaux-Arts in Paris, and the Chinese art students he had befriended there attended his wedding celebrations in Shanghai – Sanyu and Xu Beihong, to name just two. Liu Haisu and Ni Yide were at the reception too, and so were artists and designers like Ding Song and Zhang Guangyu. Shao's artistic connections were wide and strong, and to dwell only on his literary side, as most accounts do, would be to portray him incompletely, giving the part he played in addressing Shanghai through pictures and images less than its due.

It is as a poet turned publisher that Shao wins

(Opposite) Detail of Guo Jianying's cover illustration for *Ladies' Pictorial (Furen huabao)*, no 23, November 1934.

133

Shao Xunmei as bridegroom, January 15, 1927. From Sheng Peiyu, *Shengshi jiazu, Shao Xumei yu wo*, Beijing, 2003.

his place in our story, a story begun in the previous chapter with the launching of the *Golden House Monthly*. In 1934 he founded the Modern Book Company and financed a string of illustrated magazines under its imprint, from *Modern Cinema* to *Modern Sketch*. The word I've translated as 'modern,' *shidai*, is normally rendered as 'era,' but in the usage of the time *shidaihua* meant 'of the day,' 'up-to-date' or 'modern' (-*hua* being a suffix added to a noun to turn it into an adjective); this being the case, I've chosen to understand *shidai* in the same sense. A new generation of artists and writers found in these papers an outlet for their enthusiasms and talents. Magazines are crucial vehicles for setting trends and establishing new tastes, and it was through Shao's that the evolving thinking and practices of this group of Shanghai artists achieved their transmission, found their audiences, gained commercial acceptance and therefore wider stylistic resonance.

'Sketch' translates *manhua*, a loanword from the Japanese *manga*, or 'comics.' The word was first used in 1925 of Feng Zikai's impromptu, lyrical pictures, but these poetic brush paintings were something of a one-off, not quite what people ordinarily understand by the term 'comics' or, as *manhua* is also sometimes translated, 'cartoons' or 'caricatures.' The people discussed in this chapter were more nearly comic and cartoon artists. They were a remarkable group, young, eager and open, many of them gifted and extremely prolific. They worked at a time when the intensifying atmosphere of visual and commercial expansion culminated in a golden age of print culture. By the mid-1930s, no fewer than nineteen *manhua* magazines were being published in Shanghai.

Of these, Shao Xunmei's *Modern Sketch* (1934-37) is considered the best, not least because it was produced by more advanced printing technology. At great cost Shao had imported, as no one had before in China, the newest rotogravure press to ensure print quality. He was still reaching the public through the printed word, but as publisher, not poet. That he considered this the lesser vocation comes through in a conversation (thinly

disguised as fictitious) recounted by Emily Hahn, an American adventurer-writer who wrote about him in fiction, memoir and autobiography, and whose lover he became:

'Are you the Chinese Cocteau, for instance?'

He took these words seriously and considered, 'Cocteau? No. I will not say that. I am not a poet any more, and even when I was a poet, I was something like Swinburne, but not Cocteau.'

'...Well who are you, then?'

'The Chinese Northcliffe,' he said solemnly [referring to the founder of the *Daily Mail* and other papers in Britain]. 'I publish magazines and newspapers. Popular ones. You are disappointed?'

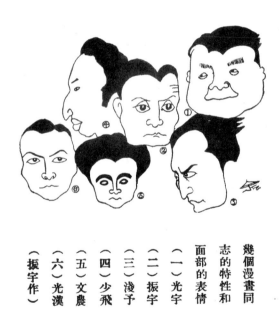

幾個漫畫同
志的特性和
面部的表情

（一）光宇
（二）振宇
（三）淺予
（四）少飛
（五）文農
（六）光漢
（振宇作）

Six cartoonists: Zhang Guangyu (1), his brother and fellow-cartoonist Zhang Zhenyu (2), Ye Qianyu (3), Lu Shaofei (4), Huang Wennong (5) and Zheng Guanghan (6). *Shanghai Sketch*, 100th edition, Mar 29, 1930.

Yet Shanghai's print and visual culture would have been the poorer had he not given work to so many of Shanghai's illustrators and cartoonists. The most influential of these, Zhang Guangyu (1900-65), designed the cover of the inaugural issue of *Modern*

135

新詩庫第一集第一種

瑋德詩文集

方瑋德著

上海時代圖書公司發行

Cover illustration by Zhang Guangyu of poetry collection (by Fang Weite) published by the Modern Book Company in 1936. From Jiang Deming, *Shuyi bai ying 1901-1949*, Beijing, 1999.

Sketch. Until 1934 Zhang worked in the advertising department of BAT (British American Tobacco), but he had been a contributor to comics and pictorial magazines since he was eighteen. Indeed, while his work experience ran the gamut of commercial art, from set designs, advertisements, cigarette cards and calendar posters to interior decoration, it is as a *manhua* artist (indeed, pioneer) that he is best remembered.

A younger contributor to the periodical has said of Zhang that he marks a turning point both in his contemporaries' evolution into 'modern Chinese,' and in the development of Chinese design and

illustration. In 1933, Zhang Guangyu was one of the people in his circle who met the celebrated Mexican artist, caricaturist, anthropologist and collector Miguel Covarrubias (1904-57) when the latter visited Shanghai. Together, the two would frequent the antique shops and flea markets around the Temple to the City God. Covarrubias drew a caricature of Zhang, as he did also of Shao. Both Zhang and Shao knew and admired the Mexican artist's strikingly modern cover designs for *Vanity Fair*, the favourite reading, as I have earlier mentioned, of Shanghai's artists and writers. Zhang's peers have remarked on his stylistic debt to Covarrubias, and there is certainly something of the latter's signature clean lines in the flat and simple feel of Zhang's illustrations. Yet Covarrubias's was only one of a range of Western styles to have inspired Zhang – in the previous chapter I mentioned his interest in film and in particular Fritz Lang's *Metropolis*, and in Chapter 6 I shall touch on his knowledge of the latest furniture designs in Europe. Viewed as a whole, his large output can be seen to be receptive to the appeal of both modernist stylization and Chinese folk culture, a characteristic noted also by Covarrubias, who liked his work and said as much to Shao Xunmei.

Shao Xunmei caricatured after a dinner at Zhang Guangyu's home by Miguel Covarrubias during the latter's second visit to China in 1933. The sketch accompanied a report Shao published of their conversations in one of his own magazines, *Shiyue tan*, no 8, Oct 20, 1933.

He designed the covers of both the first and hundredth edition of an earlier and equally remarkable magazine, *Shanghai Sketch* (1928-30). The reader will have seen *A Cartoonist's Dream*, the hundredth cover (which incorporates the first), in the illustrations to the prologue of this book. This weekly paper, which he had a hand in founding, was produced by a handful of young artists writing the copy and drawing the pictures themselves, paying for its expenses out of their own pockets. In a foreword penned in high-flown language, they urge their readers 'to feel' – feeling is all, they say, and it is in feeling and expressing 'the greatness and richness in the treasure trove of life in Shanghai' that they aim to direct their efforts.

Much foreign material accompanies the local content, and this is taken from motley sources – Hollywood films, Western periodicals like *Punch* and

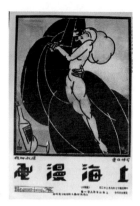

Terrifying Love, cover by a very young Chen Qiucao (1906-88), who would become Director of the Shanghai Art Museum in 1955. The macabre subject matter and the dramatic block of solid black are probably inspired by Beardsley. *Shanghai Sketch,* Sept 22, 1928.

Reproduction from *Morte d'Arthur* in *A Selection of Beardsley's Works* compiled for the Morning Flower series by Lu Xun, 1929.

the *London Illustrated News* and notably a German book comparing physiques across the world (reproducing illustrations from which allowed the editors to run nude pictures in the magazine, and caused them to be prosecuted, but let off, for pornography). The editors no doubt extracted material that was of visual interest to them, but their selection also hints at the styles that might have influenced their own artwork. In the second issue, editorial comment on three stills reproduced from a film which had just opened at the Olympic Theatre in Shanghai draws attention to the spectacle of 'beautiful' figures and sets. The film is of dance performances by the Folies Bergères in Paris, and one of the stills is of a semi-clad Josephine Baker doing her famous Charleston, while the other shows her mimicking the sphinx, her back arched, her haunches protruding, the whole doubled, kiss curl and all, in the mirroring surface on which she perches. In the third, a tableau of curlicues and fountain imagery reminiscent of Edgar Brandt's metalwork screens forms the backdrop. Both Josephine Baker and Edgar Brandt are embraced by the vogue today for Art Deco, though at the time they would simply have impressed their Chinese audiences by their chic modernity.

Many of the covers of *Shanghai Sketch* titillate, and this is as you would expect, but what is unusual is their suggestion of the grotesque and the macabre. Encoding desire, danger, death and dismemberment, the *fin de siècle* themes that were also permeated by those of evil and corruption and the erotic and emasculating femme fatale, these covers link their authors to the Aubrey Beardsley and Baudelaire fans of the previous chapter. Invoking, like Salomé, the femme fatale, the sphinx embodies men's worst fears over modern women. Franz von Stuck, who co-founded the Munich Secession (Art Nouveau), painted her, as readers of *Shanghai Sketch* discovered when they opened the July 21, 1928 number. On a page entirely devoted to von Stuck, this painting is reproduced along with six others, one of them the Surrealist canvas *Sensuality*. It is hard to see the giant

boa constrictor coiled around a nude in Ye Qianyu's cover drawing of *Serpent and Woman* for the May 12, 1928 issue without suspecting its inspiration to be von Stuck's *Sensuality*. Ye Qianyu (1907-95), only twenty-one at the time, was the magazine's editor and publisher. Ye, who has made an appearance in these pages already, with his illustration of Mu Shiying's 'Camel, Nietzschean and Woman,' had arrived in Shanghai from neighbouring Zhejiang province as an eighteen-year-old in 1925. He found employment selling fabric in a shop on Nanjing Road and fell to painting its advertising hoardings. Sooner or later everyone came window-shopping on Nanjing Road, Shanghai's busiest shopping street, if not at the Wing On Department Store then at the Sincere. And so it was that Ye found himself studying the Sincere's advertisements, discovering only decades later that they were by Jiang Zhaohe, the painter whose youthful borrowings from Art Nouveau the reader may remember from the previous chapter.

Ye Qianyu, c.1930.

As with his peers, the jobs that came his way included painting stage backdrops, illustrating books, and designing printed textiles and even fashion. However it was in *manhua* that he came into his own, and by getting some published in the local magazines he got to know Zhang Guangyu, as he was bound to, and came to be included in the circle that eventually cohered around the Manhua Society of Shanghai: people like Ding Song, Zhang Zhenyu (Guangyu's brother), Lu Shaofei and Lu Zhixiang.

Success came quickly to Ye Qianyu, whose creation of *Mr Wang*, surely the most popular of all comic strips to appear in Shanghai, held up to ordinary Shanghai citizens a mirror in which they saw themselves and their foibles, comically exaggerated as is proper to the genre, yet truthful and familiar too, as satire can disconcertingly be. The series debuted in *Shanghai Sketch* but migrated to other papers when the former ceased publication in 1930.

At first Ye had wanted to call his strip 'The Shanghainese,' and though he plumped for 'Mr Wang'

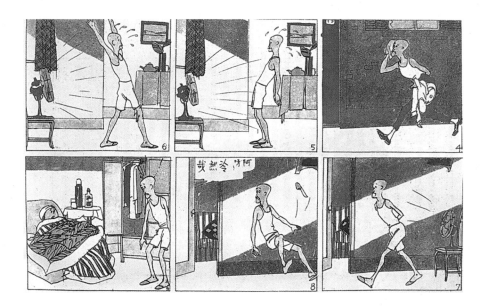

Mr Wang. Comic strip (read from right to left) by Ye Qianyu. *Shanghai Sketch,* July 6, 1929.

in the end, his intention of creating characters, situations and scenes his fellow-townsmen could recognize and even identify with is still there for all to see. The people who could identify with them the most were the petit bourgeoisie of Shanghai, that part of the urban population which, if transposed to, say, England, would be seeking distraction in Bingo, football matches or the bookmaker. Much in the strip struck a chord with these people: the wish to shake off social handicaps; the weakness for gambling, particularly mahjong; the predatoriness of creditors; the corruption of officialdom and the bullying of police officers. For as long as ten years, and until the Japanese attack in 1937 put paid to the strip, Shanghainese were entertained to the doings and misadventures of the four characters around which the strip revolved: the bald, stick-like Mr Wang; his fat, scolding wife; their alluring daughter Miss Wang; and the squat, bespectacled Young Chen, a government functionary showing all too many characteristics of the breed.

So popular did the strip become that filmmakers believed they could make money adapting it to the

silver screen, casting the Chinese Laurel and Hardy in the two male roles. And make money they did, as remakes and sequels – *Mr Wang's Secret, Mr Wang's New Year, Mr Wang Goes to the Country, Mr Wang's Way to Prosperity, Mr Wang and the Secondary Landlord* – came out one after the other, turning the henpecked husband into a household name.

When war began and Shanghai was besieged, Ye and fellow illustrators lost no time in organizing themselves to use cartoons, caricatures and photographs to spread patriotic messages of resistance and 'national salvation.' Publications apart, they employed open-air exhibitions in street and park. As the Nationalist forces retreated to the southwest of China, ending up eventually in Chongqing, Ye and the rest of the Shanghai propaganda team followed.

Ye sketched mostly in pen and ink, and occasionally pencil. In his memoirs he wrote that he got the idea of carrying a notebook about him to doodle in from Miguel Covarrubias. This is not to say that he emulated Covarrubias's style of caricature, however. His style was eclectic, and as a source the cinema was as much grist to his mill as American comic strips like *Popeye the Sailorman* (who debuted the year after Mr Wang) and George McManus's *Bringing Up Father*, all of which were readily available in Shanghai at the time. In fact, *Bringing up Father*, which tells the story of Jiggs, an Irish-American bricklayer who comes into sudden money and who resists the efforts of his social-climbing wife and his beautiful daughter to 'bring Father up' to his new social position, was what put the idea of a henpecked husband into Ye Qianyu's mind. Poor chubby Jiggs, at whose skull his frequently irate wife throws rolling pins and smashes crockery, was not Ye's model for the stick-thin Mr Wang, but he knew that the humour latent in the domestic situation would ring bells of recognition among the Shanghainese, as it would anywhere in the world, for that matter.

Another influence on him was Liang Baibo (1911-70), whom I named in the last chapter as the

Liang Baibo sketched by Wan Laiming, 1930s. From *Lao manhua*, Jinan, 1999.

only woman cartoonist to be working in Shanghai. Born Cantonese, she met Ye Qianyu when, arriving in Shanghai in 1935 from the Philippines, where she had put in some time teaching Art at an overseas Chinese school, she appeared at the *Modern Sketch* office to see if she could get one of her pictures published. It was a case of love at first sight, though it couldn't have been for her looks, which were ordinary enough, that the handsome Ye felt so attracted to her. She took the initiative of asking him out, knowing full well that he was married with children; but such was the 'romanticism' abroad in the 1930s, Ye recalls in his autobiography, that she couldn't care less, 'so much more daring was she than I, and so little time did she have for social convention.' 'I felt like a bird released from its cage,' he continued, 'savouring in full the heaven that is its birthright.' Her style of living (which could only be called Bohemian), the way she thought about art, her attitude to life – 'it was all new to me,' he writes, 'alluring, and quite irresistible.'

They quickly became lovers, and in the few years they lived together it was as if his imagination 'had grown wings.' He thought his *Mr Wang* comic strip the better for the effect she had on his imagination. He says that her artistic consciousness – he describes it as 'poetic' – rubbed off on him. During their time together a book that never left her side was the Chinese translation of Isadora Duncan's autobiography (1927). There was something about the dancer's courage and idealism, her passionate belief in complete emotional, spiritual and sexual fulfilment, that spoke to Liang (just as she did to Bloomsbury Bohemians in London).

Little wonder that the one comic strip character Liang created, the wasp-waisted and large-bottomed Miss Bee, behaves as though it were not a pre-permissive world full of confining prohibitions she lived in, for what Chinese woman would, on being introduced to her friend's dashing boyfriend as Miss Bee is in one episode, help herself to him? In one strip, a beggar ingratiates himself to Miss Bee by

Miss Bee being eyed by Mr Wang and Young Chen. Sketch by Liang Baibo, c.1935.

B 老不走。

叫 C 来吧。

气走他!

这样就可以和 A 去玩了。

Comic strip by Liang Baibo ran for twenty-five days in newly launched paper *Libao*, 1925. Captions to consecutive frames read: 'B won't go. Send for C. B clears off fuming... Leaving me free to go out with A.'

Zhang Leping as a young man in Shanghai, 1930. From *Zhang Leping huabi xia de sanshi niandai*, Shanghai, 2005.

Three Hairs restores hair to bald father. One frame of a comic strip by Zhang Leping, 1930s. From *Zhang Leping huabi xia de sanshi niandai*, Shanghai, 2005.

wishing her good fortune, long life, and numerous sons and grandsons, but she gives him the brush-off, and instead it is his imprecation 'May you have many [illicit] lovers' which brings out the Lady Bountiful in her. When Ye wrote decades later that the comic strip reflected Liang's own ideals, one guesses he was thinking of the store she put by sexual liberty. In 1938 she left Ye Qianyu for a Nationalist Airforce pilot she met while travelling with the anti-war propaganda brigade, and eventually moved with him to Taiwan, where she died in 1970.

Another serial from the 1930s, truly a golden age for cartoons in Shanghai, was Sanmao, 'Three Hairs,' by Zhang Leping (1910-92). Everybody, children and adults alike, knew Three Hairs, the little boy who lives by his wits and whose street encounters bring him face to face with the allure, inequalities, indifference and squalor of the modern city. Begun in 1935 and interrupted by the war, the strip famously reappeared in a leftwing paper (*Dagongbao*) under the name *A Chronicle of the Adventures of Three Hairs* in 1948, by

'Dovecote' was how Shanghainese alluded to overcrowded tenement living, with a whole family to a room. Cartoon by Zhang Leping, a keen observer of the Shanghai scene, 1930s.

Schiff sketched by Sapajou, 1930s.

which time the rich-poor contrasts of the streets had become wider and sharper than ever, and Shanghai itself closer to the ideologically charged, post-1949 stereotype of the city as sink of iniquity.

An exact contemporary of Zhang Leping was Georgii Avksent'ievich Sapojnikoff, a White Russian refugee whose artistically accomplished and keenly observant cartoons appeared under the nom de plume Sapajou in the *North China Daily News*, the leading expatriate – many would say heavily British – newspaper in Shanghai. Sapajou was a White Russian lieutenant invalided out of the Russian Imperial Army after severe wounding in the First World War. Evening classes at art college had prepared him for a second career when, five years after he landed in Shanghai in 1920, the English-language paper took him on and started publishing his cartoons. Some fifteen years'

worth of these, plus several albums of his sketches of Shanghai life and illustrations to various books on Chinese subjects, are what he left behind him when he died in 1949.

The audiences for *North China Daily News* and for those which carried *Three Hairs* belonged to separate worlds, but imagery crosses language barriers more easily than text, and it is hard to escape the impression of stylistic similarities between Zhang Leping, Sapajou and another European cartoonist working in Shanghai at the time, the Austrian Friedrich Schiff (1908-68). We can claim a stylistic parallel between Zhang Leping and Sapajou (or Schiff) if we agreed, at the same time, that there was also one between them and some contemporary American cartoon art. The art of all three has a purchase on the imagination of those of us who feel a nostalgia for the vanished world of prewar Shanghai, and this is not least because they appeal to us along the strand of a common period style.

Cartoon of Shanghai shop window by Friedrich Schiff, 1930s. Caption reads: 'The teachings of Western civilisation.'

I've already mentioned *Popeye* and *Bringing Up Father*. There were others. *Katzenjammer Kids, Mutt and Jeff, Polly and Her Pals, Blondie, Prince Valiant, Dixie Dugan* – all these American strips were familiar to the Shanghainese, who read them under their Chinese names in magazines like *Funnies Weekly, World Comics, West Wind, Friends of Comics* and so on. Not always translations of the originals, in some cases the names reflected Shanghainese perceptions – *Dixie Dugan*, for example, appeared under the title *Modeng Girl*.

The look of life in these cartoons was available to all Chinese comic strip artists, and vaulted across the gap between continents to be transformed, with adjustments of course, into Shanghai's. A look which nowadays many identify with Shanghai Style is that found in the art of Zhang Yingchao. It is in fact a simulacrum, a Shanghai mythologized. He was much published in *Modern Sketch*, where, to represent Shanghai Modern, he tapped into the image repertory of the hedonistic pleasures and glamour of the Jazz Age. The girl-about-town Polly, the early Blondie and the flapper Dixie Dugan, a showgirl inspired by

the silent movie star Louise Brooks, were all part of that repertory, as was the art of two of America's best known Jazz Age illustrators, John Held Jr (1889-1958) and Russell Patterson (1894-1977).

One of Zhang Yingchao's contemporary cartoonists has said of him that he derived his technique and mood from Russell Patterson, who was all the rage at the time. Certainly, looking at Zhang's improbably leggy Chinese women, the reader is left in no doubt that they are modelled on Patterson's stylishly elongated flappers, perhaps Mamie, his famous syndicated comic strip character. The same commentator has said of Zhang that it is around 'the hysteria of the metropolis,' (by which he probably meant frenzy), 'female fashions, the temptations of wine and women and jazz' that all his art revolves. That these were signs and symbols of the *modeng* no doubt heightened his appeal for many. Enthralment, frenzy and sensuality were what spelt modernity, just as Liu Na'ou has said (recall that the neo-sensationist writer is quoted in the last chapter as defining 'modernism' by 'thrills and carnal intoxication'). 'Wine and women are one,' says Zhang Yingchao in one of his contributions to *Modern Sketch*, 'think of one and you think of the other.' In his pictures they drink and dance in style, the men in tuxedos and the women in evening gowns, bent on pleasure all, and high on sensation.

If modernity was fizz, no artist captured it with more flair than Guo Jianying, whose last appearance in these pages was in the company of Liu Na'ou and Mu Shiying, authors whose enthusiasm for

Japanese writers of the neo-sensationist school he wholeheartedly shared. Guo had studied at a missionary university, in his case St John's, where he majored in Political Science. His father was for a time Second Secretary at the Chinese Legation in Japan, and Guo himself served in the Chinese Consulate in Nagasaki in 1935. He was there for only two years, however, and though from his writings and sketches you would not think he would last long in a bank, it was as a banker, both in Shanghai and in Taiwan (to which he repaired in the 1940s and where he ended his days) that he made his living. In his spare time he wrote, drew, and contributed an illustrated column to *Ladies' Pictorial*, a magazine he subsequently edited.

He was a better artist than Zhang Yingchao, more his own man, less derivative. Yet he also embodied his time in his openness to Japanese and Western examples. His were line drawings, as befits cartoons, but were he to apply flat colours in the way Sugiura Hisui did, some of them would recall the Japanese graphic artist's designs. At the same time there could be no Shanghai artist as enamoured of drawing women as he who was not inspired by images in the 'smart' American magazines too. Without those long-legged women, would his pictures be as beguiling? Definitely, no. Today they provoke unabashed nostalgia. The world about to be swept away by war and revolution is preserved in the elegant, ankle-length *qipao* (Chinese gowns) of these women, in their marcelled hair (drawn in some cases in the zigzag Art Deco style) no less than in the period flavour of his captions and epigrams.

Cartoon by Guo Jianying with caption reading: '*He*: If your mother saw us dancing in a place like this, she'd disapprove. *She*: But there she is – she's dancing here herself,' 1930s.

He gave his contemporaries the illusion that they too were urbane, modern – an illusion reinforced by the use time and again of words like 'metropolitan,' *modeng* and 'trendy' in his captions And what defines this modernity? What are its emblems? The sprinkling of English words in his texts, in either their original form or in Chinese transiliteration – rendezvous, cocktail, absinthe, chic, saxaphone, romantic, erotic, Gary Cooper, Rudy Vallee, Garbo, Dietrich, the

Caption reads, 'An evolved dog – a *modeng* species of a famous Shanghai speciality' on signed cartoon by Guo Jianying, 1931.

Charleston – points his reader to the Shanghai of popular stereotype, summed up by 'Joy, gin and jazz,' as a 1934 guide to Shanghai describes it. Guo, then, was a stylist with a natural subject, that cultural moment when Western diversions titillated Shanghai and Hollywood provided dream worlds for its middle classes.

He remade the Chinese woman in a new image. He draws her in a state of complete or partial undress, with breasts and thighs showing through negligée or lingerie, free from the nuisance of modesty. In one caption, the question 'Has your new maid from the country adapted to life in Shanghai?' is answered by, 'More or less. She hasn't even worn her bodice in the last couple of days.' He shows the Shanghai woman sunbathing, because in the eyes of a 'modern boy' in 1929, the 'bourgeois style' of beauty is passé and what defines you as modern is the 'naturalness' and 'savage rawness' of the primitive. And if not exposing flesh Guo shows the Shanghai woman androgynously cross-dressed in suit and tie (or cravat), as though staking out territory that had hitherto been reserved for men. In the battle of the sexes, how are men to stand a chance against her, her desirability makes him her slave? Not for her the bookish, *shendimentuo'er* ('sentimental') lover either, but a 'well-built and tall' man like Gary Cooper. She is knowing, arching her eyebrows and casting sidelong glances, and in place of the amorous gaze which Chinese poets of old have called 'autumn ripple,' she winks. She glows with self-confidence, and while she is not hard-bitten she isn't a bit starry-eyed either. What's more she is too sophisticated and sceptical to buy into the myths of matrimony. The caption appended to a sketch of two young women talking reads:

'I hear your brother got married last month.'
'Yes.'
'Then when is he preparing to get divorced?'

In truth, though, Chinese women that much

in advance of their time were to be found more frequently in the artist's imagination and fantasies than in reality. But then Guo belonged to the modernist set, and what was a modernist who didn't rewrite the rules? Of course, the idea of the 'Modern Woman' was familiar enough from the way she had been culturally constructed and mass-circulated by the popular media of the day. And as for love and sex, 'What is the new sexual morality?' was a debate aired as far back as 1925, when the *Ladies' Journal* devoted a special issue to the question, to the wringing of hands on the part of the traditionalists. All this is true; yet quite apart from the fact that the survival of the old and the emergence of the new are always confounded, with the past persisting in the present, you can't elevate a cartoon to the status of a historical document – the question to be asked of it is not how true a reflection it is of life as it was really lived. Veracity is not the issue, style is. What I mean by this is that in eroticizing the Modern Woman and glamorizing her, Guo Jianying, Zhang Yingchao and others created an aura that has come to be identified with Shanghai.

Their imagery fits in with the cliché of Shanghai as a site of pleasure catering to the desires of all those who came in search of gratification or, to echo its detractors, as Sin City or the capital of modern vices. In an earlier day, so celebrated a focus of these desires and pleasures was the brothel in all its guises, from the upmarket courtesan house to the flophouse, that if you were a well-heeled male tourist you could no more leave Shanghai without some acquaintance with one (even if it was only by reading about it in a guidebook) than you could leave Paris, say, without seeing *Mona Lisa*. In a cartoon by Zhang Leping, the creator of Three Hairs, sex and sightseeing are conflated: a gaping old man from the country looks on while a curvacious tour guide bares her bosom to him, pointing out, 'Sir, this is the breast, this is...this is...'

To the traditional houses of pleasure hundreds of dance halls and cabarets were now added, introduced by Westerners to begin with but naturalized and made

'Sir, this is a breast... this is... this is...' Country bumpkin has sites mapped out for him by female tour guide at Huangpu Hotel.

thoroughly their own by Chinese. As time passed the 'world of flowers' of courtesans lost ground to the more modern 'world of dance,' with photographs of and gossip about dance hostesses and song-and-dance stars encroaching upon the spaces once devoted to courtesans in the tabloids and in lore. This trend was paralleled by the emergence of movie actresses in the late 1920s and their propulsion into stardom by the film magazines that proliferated in Shanghai in the 1930s. Celluloid now abetted the printed page in circulating images of women, intensifying them as objects of interest. Between the two worlds, cinema and cabaret, there was not so much a line as a blur, with the screen idols of the one shading into the icons of the other. Nor, when all is said and done, could you clearly separate these women's sexy allure, glamour and fashionability from the way people then and in the years to come conceived of Shanghai's metropolitan attractions and, by extension, of Shanghai itself.

Shanghai had a short career as 'the Paris of the East,' the kind of city which people thought of as glamorous, but even after its metamorphosis into a straitlaced communist citadel after 1949, its reputation as a hedonistic playground offering sexual excitement persisted. Decadence and dissoluteness would seem to be stamped into its prewar identity, never to be erased. 'Shanghai is truly more demonically sensual than Paris,' remarked a Japanese author, Sakai Kiyoshi, in a book he published in 1938 called *A Guide to the Red Light Districts of Paris and Shanghai*. The cover is a picture of Josephine Baker, the iconic black dancer who personified eroticism for 1920s and 30s Parisians. In this way Shanghai and Paris are linked, with Baker's eroticism, so modern in its blend of exoticism and primitivism, serving to symbolize both cities. Guo Jianying too annexes Baker in a cartoon he contributed to the inaugural issue of *Modern Sketch* (1934), montaging a cut-out figure of the dancer in her trademark banana skirt above a line drawing of a praying mantis piercing its prey with its pincers – a metaphor for the castrating female perhaps.

Guo's visual style implies an urbane, sophisticated viewer. Zhang Yingchao, whose women look like models in fashion magazines, mythologizes the city in a style consistent with his own bourgeois, moneyed background. Theirs was a different world from that of Zhang Leping, whose early experience of Shanghai had a harshness similar to the treatment meted out to Three Hairs in his wanderings around the city. Vary the class angle at which the urban landscape is refracted, and a different Shanghai emerges. This is immediately apparent from the work of Cai Ruohong (1910-2001) and Lu Zhixiang (1910-92), a pair of young cartoonists with more in common than the fact that Shao Xunmei gave both exposure in his magazines. What united them too was their emulation of the Berlin Dada caricaturist George Grosz.

Grosz's communist politics, no less than his graphic style, inspired both Cai and Lu. The style is unmistakable, and Grosz comes to mind every time one sees a smug, sottish, fat and thick-necked German in a beer garden. His ferocious social caricature was of post-World War I Germany, the crumbling Weimar Republic and rising Nazism; but Chinese counterparts to the people he portrayed in his drawing collections – capitalists, militarists, lechers, prostitutes (whose other guise is the socialite wife), poor factory workers and the unemployed – could with little difficulty be found in Shanghai, where the disparities between rich and poor were wide enough to provide plenty of raw material for the kind of politics Berlin Dadaists espoused. The latter's emphasis on radical communism marked it out from Dada's manifestations in Zurich, Paris and New York, and enhanced its appeal to Grosz's left-leaning followers in Shanghai. His drawings were widely reprinted in the Chinese periodical press, and Lu Xun used six of them to illustrate *Little Peter*, a collection of children's stories he translated and published in 1929. 'George Grosz was the vogue in Chinese radical art circles,' reports the Shanghai-based English-language periodical *T'ien Hsia Monthly* in 1937.

While Cai Ruohong is 'seeking his themes from

Caricature of Cai Ruohong, 1930s.

George Grosz's drawing 'Kissing' reproduced in *Modern Sketch*, Feb 1946.

Pencil drawing by Cai Ruohong captioned 'Sucking each other.' *Arts & Life,* no 22, Jan 1936.

Chinese reality,' the article continues, 'his vision is still heavily influenced by the great German satirist.' Though he had studied oil painting at the Shanghai Art Academy, one of a few cartoonists to have had formal training, he sought his models, the article notes, 'in the streets rather than in the studios.'

With a pointed pen similar to Grosz's, and a nod to the Berlin Dadaist stereotypes of capitalist, cop and Prussian officer, Cai shows us the streets of his Shanghai: its policemen, Black Marias, Russian bodyguards, fat capitalists, the labouring poor, small-time crooks and hookers. One of his best known pictures is the one entitled *Picnic*: in it the contrast could scarcely be starker, between the gross couple gorging on their spread and the starving paupers scrabbling at plants and bark. But though the graphic style is derived from Grosz's, the emotional content of Cai's images is more diluted, showing less anger and pain than the German's.

Picnic. Cartoon by Cai Ruohong. From Zhou Limin and Wang Xiaodong, *Manhua shenghuo,* 1934.

Cai's communist sympathies may be divined from his departure in 1939 for Yan'an, the Red base area and headquarters of the Chinese Communist Party, there to head the art department of an academy named for the late Lu Xun. This became the spawning ground for the revolutionized artist, and for propaganda art. After the

communist victory in 1949, Cai became director of the People's Art Press and later Art Editor of the Party organ, the *People's Daily*. He would have continued to support all that Shanghai stood for before the communist victory – an openness to the West, to experimentation, artistic diversity and modernism – were all this not made to yield, by Maoist decree, to an aesthetic confected of Chinese folk art styles and the idealized look-on-the-bright-side realism favoured by socialist officialdom.

There is more grace of line in Lu Zhixiang's sketches than in Cai's, but Lu borrows no less than Cai from Grosz. Perhaps the picture that comes closest to showing that borrowing is the one (published in *Modern Sketch* in 1935) in which Lu depicts what he calls 'sub-colonials' in one of Shanghai's foreign-governed areas (the International Settlement, in all likelihood). The police constable and the prosperous-

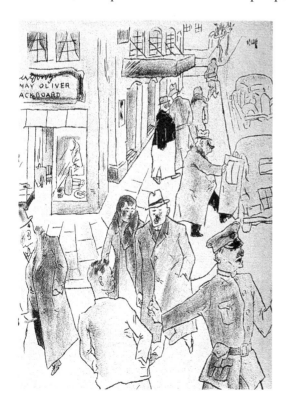

Shanghai caricatured by Lu Zhixiang. *Modern Sketch*, Jan 1935.

Lu Zhixiang caricatured by Zhang Guangyu, 1930s.

Cartoon by Lu Zhixiang, *Modern Sketch*, Dec 1934. Caption reads: 'Businessman A: Stock's in hand. Just pick what you like. Businessman B: What I'd like is a trial run first.' Colour added to reproduction in Bi Keguan, *Zhongguo manhua shihua (History of Chinese Cartoons)*, Tianjin, 2004.

looking men in the picture, particularly the one seen stepping into a motorcar, are as swinish as Grosz would have made them, bearing smudges that hint at a pig's snout instead of noses.

However, on the whole the Dada element is less pronounced in Lu than in Cai, if Dada is understood as disgust for bourgeois values and cultural politics or, as has been said of its Berlin variant, as Bolshevism. Tired, hungry, hollow-cheeked labourers do appear in Lu's pictures, which do convey some of the harshness of quotidian reality; but while he satirized the overfed moneyed class in the Grosz manner, he threw down no open challenge to it, nor did he commit himself to any scheme for the betterment of man. Unlike Cai, he had no truck with party politics, and at no time in his life did he seek or hold any official or teaching post or engage in any political debate. This may have to do with the fact that he was deaf from birth and could lip-read speech only if it was in the Shanghai dialect.

His sketches were not of the comic kind and did not come with any gags. They are more a slice of Shanghai life, an insider's glimpse into a city at work: crowds awaiting their turn in hospital, bank, post office and railway station; coolies bearing shoulder-poles; boat people cooking; barbers cutting hair and shaving. That his art, and so much of the art of his peers, should show a deep engagement with Shanghai is perhaps inevitable. Before war and revolution had begun to do their worst, Shanghai was the foremost generator in China of that modern Chinese sensibility of which both cartooning art and its audience were popular manifestations. Those images were not conceived out of thin air, but drawn from a specific body of cultural capital: the shared yearnings, experiences, outlooks, prejudices and imaginations of their target audiences.

That engagement shows itself in another way in the work of Hu Kao (1912-94) Today, whenever we think of the Shanghai of the pre-communist era, we cannot avoid thinking of the figures he caricatured in his series on the 'Shanghai Types of the 1930s.' Shanghai's folk memory

today is full of the Shanghai gangster, the gangster's moll, the hood, the brothel-keeper, the playboy, the dance hostess, and the Shanghainese girl (or the 'Shanghai Miss,' as she was known in her day), all figures his drawings parodied and propagated. He caricatured politicians too, Nationalist government figures such as Chiang Kai-shek and the quintessentially Shanghainese T.V. Soong, the American-educated Finance Minister. Instantly recognizable, Hu's style is more consistent than that of most other contemporary cartoonists and, in its strong tendency towards stylization, more consciously modernist.

Whether it is the modern Shanghai Miss coming home in the morning from dancing all night, or the poet plagued by an ever-lurking sense of not looking sickly enough, the Shanghai types Hu caricatures are compellingly urban. There is no doubt that Shanghai was the urban focus for that period of high cultural intensity in which Hu's generation flourished. The Sino-Japanese war and the revolution which immediately followed it did not bring this intensity to an immediate end, but they shifted that generation's focus and impelled it to assume a political and social responsibility that bent art towards patriotic practical application. Fitting in with that politicization, and with the increased awareness of international issues, not least Fascism, was the example of the greatest political cartoonist of the twentieth century, David Low. Born in New Zealand in 1891, Low practised his art in England, famously in the pages of the *Evening Standard*. He was the inventor of the plump, pompous, walrus-moustached reactionary Colonel Blimp, a character who epitomized everything Low disliked about Britain and who reflected its temper in the 1930s and '40s.

Just one cartoon will suffice to reveal Low's hatred also of Fascism: in a rendezvous between Hitler and Stalin, the caption goes, 'The scum of the earth I believe?' (S to H) 'The bloody assassin of the workers I presume?' Dawei Luo, the Chinese name by which Low came to be known to the cartoonists of wartime China, exerted a powerful influence, one enhanced no

Hu Kao's Shanghai types *(from top to bottom)*: dance hostess, gangster, hoodlum, 1930s.

doubt by the resonance which his portrayal of Japanese brutality in China had for those who directly suffered or witnessed it. Te Wei (b.1915), who had started out drawing advertisements but who was later to make a name for himself in animation, was a particularly ardent follower. For large numbers of Chinese it was a crisis-ridden time with which Low's satire seemed especially in tune. That some of Te's targets overlapped with Low's – Hitler and Japanese militarists, for example – virtually doomed him to be derivative, but like his fellow-artists Te was exposed to many other sources of influence, and no comprehensive style marks his cartoons and book illustrations.

'Voices of denunciation [by American citing international law and Briton echoing him] cannot be heard above the sound of [Japanese] cannon.' Cartoon in bimonthly *Kangzhan manhua (War of Resistance Cartoons)*, Jan 1, 1938.

←谴责的声浪是掩不了炮声的
特　伟作

What he and his generation of artists represented was perhaps more a Zeitgeist than a style. That spirit rose to a peak in 1936. Symbolic of that climax was the enormous successs of the First National Cartoon Exhibition, an event organized that year in Shanghai, but drawing on the talent of the entire nation, by Zhang Guangyu, Ye Qianyu and Lu Shaofei, the Editor of *Modern Sketch*. Few as yet could see the breach in consciousness to come. Just a year later, and that exhilarating notion of modernity they enjoyed as a group would begin to shrivel. An outward sign of

this was the demise in June 1937 of *Modern Sketch*, the longest-running of all cartoon magazines. But all that still lay ahead. Experimentation, borrowing and assimilation were on a scale as never before. From Russell Patterson to David Low, all were sources from which the Shanghai artists blithely quoted.

There was a debate – as there always is in China – on whether cartooning's purpose was to entertain or to educate, and whether, in pandering to the mass market's taste for titillation and pleasure, its practioners had sunk too low, producing erotica instead of social art, thereby encouraging hedonism and debauchery. Visual treats like female nudes or exposed thighs and breasts were greatly enjoyed by some and roundly condemned by others. The latter would rather the cartoons were socially conscious propaganda, revealing injustice, the plight of the downtrodden and the depredations of militarists and imperialists. But what was distinctive about the period in question is that the one kind of picture did not preclude the other, and the same artist would often produce both. This is true, for example, of Ye Qianyu, who could not help drawing nubile young women even as he responded to the times by producing political satire.

Eclecticism was a feature of their style, a style they and their peers varied as need arose. At the same time, the urban setting in which they all worked offered them an inexhaustible supply of prototypes and themes, as well as wide opportunities for experiment, innovation, excitement and discovery. All around them the experience of modernity was happening in the street, the home, the shop, the factory and, eventually, on the battlefield. Theirs was a promiscuous style consonant with modern experience and fertilized by American and European influences of the early twentieth century, the age of the modern movement. It was a style, in other words, for whose point of culmination it is not hard to find a clear place and time: Shanghai in the years between 1934 and 1937, the lifespan of Shao Xunmei's *Modern Sketch*.

5

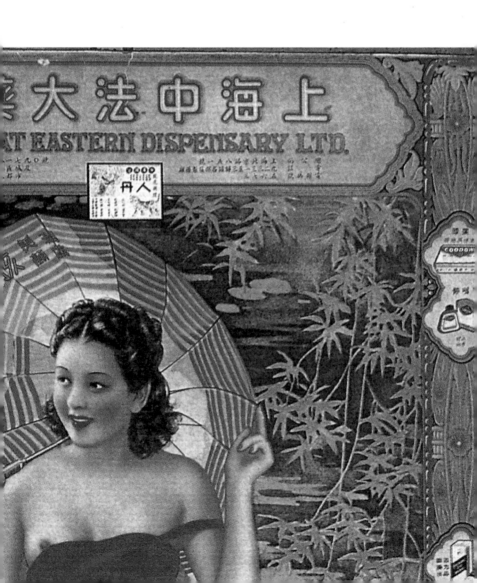

ADVERTISING

Another strand of Shanghai Style grew from a juncture of consumer desire, film and fashion. By the early decades of the twentieth century, many had grasped that for a mechanized and urbanized society like Shanghai, the secret of successful business lay in mass production for a mass market, a notion that had been pioneered by America. In Shanghai the advertising business had already been introduced in response to the same opportunities, and with it the mass entertainment industry. The consumer's experience of visual content in text and image was appearing in multiple forms and media – popular journalism, cinematography, billboards, calendar posters, cigarette cards, shop window displays. All these embodied the mingling of visual culture with consumer culture. How this mingling in turn contributed to Shanghai Style is the subject of this chapter.

When we look at physical artefacts, we may see connections between their appearance and the circumstances of their production and consumption. Why one look prevailed over another at a particular moment had everything to do with the technology,

(Opposite) Detail of illustration on page 178.

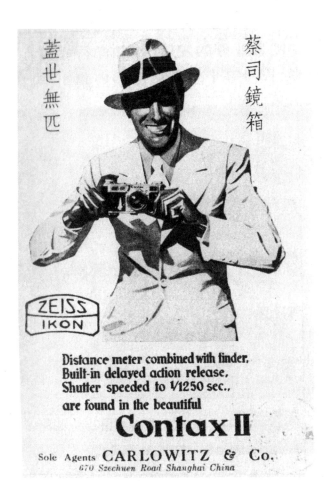

蓋世無匹

蔡司鏡箱

ZEISS
IKON

Distance meter combined with finder,
Built-in delayed action release,
Shutter speeded to 1/1250 sec.,
are found in the beautiful
Contax II
Sole Agents **CARLOWITZ & Co.**
670 Szechuen Road Shanghai China

Artwork of ad for German camera Zeiss Contax II, introduced in 1936, was not originated in Shanghai.

purchasing power and sensibility of the time. In Shanghai's case, it had to do with these factors not only as they prevailed in China but in places as far-flung as Britain or the US, for even if the artefact were manufactured and consumed locally, its being a thing-in-itself, its type, design or style could have been British or American. To this day, for example, the words for matches and umbrellas, both nineteeth-century imports, carry the prefix *yang*, for 'Western,' in the Shanghainese dialect. And if the product was Western, the style of the visual which advertised it was likely at first to be generalized from its country of

origin too, to be indigenized perhaps at a later stage. There could be no doubt that the style of Shanghai's commercial art grew from direct exposure to Western material and visual culture.

Underlying that art, then, were the changes that redefined the individual as a consumer. And since advertising can be either literal, identifying a product by brand, logo, packaging or description, or symbolic, using associations – with a type of person or lifestyle – to enhance the product's appeal, the consumer had to be so portrayed as to be the incarnation of communal desire. In representing her – for it was more often a she than a he – commercial artists evolved an iconography that has come to be thoroughly identified with Shanghai, so much so that the Shanghainese writer Cao Juren, for one, has made 'the modern girl' a synonym for Haipai.

Whatever may be her other attributes, she is the personification of Shanghai-style material life and consumption. To put her in context, let us imagine ourselves strolling down Nanjing Road in, say, 1928. We look in on Sun Sun, a department store that had opened two years before, to compare its eye-catching display windows with those of its two predecessors, Sincere and Wing On, glittering palaces of desire that made Nanjing Road the city's shopping mecca. We then step inside Wing On to find shoppers

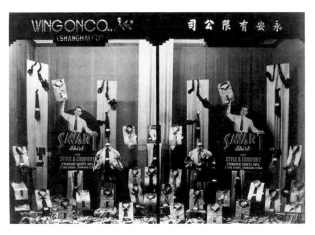

Shanghai-made Smart-brand shirts displayed in window of Wing On.

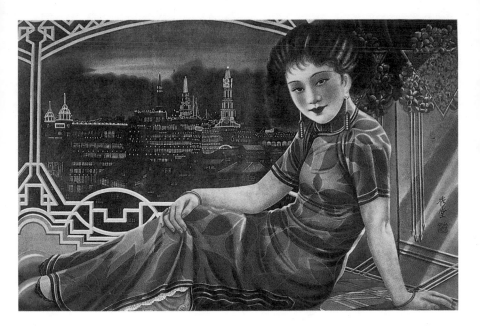

thronging the miles of aisle that separate displays of alluring goods from New York, London and Paris, all showcased in glass cabinets to feed the eye and tickle the appetite of shoppers. In their merchandising the owners of Sincere and Wing On were nothing short of revolutionary, sending buyers to those cities to source the latest fashions and to sign up exclusive rights to sell them in China even as they were getting their own in-house designers, technicians and textiles mills to produce the-look-of-the-year colours and patterns. More than retail outlets, these stores were also places of leisure and entertainment, boasting hotels, restaurants, nightclubs as well as rooftop gardens.

All these, abetted by advertising and sales techniques that would be called 'lifestyle marketing' today, spurred the growth of a style of consumption which emphasized taste, modern living and whatever was the coming thing. Those department stores were trendsetters, and where they led the rest of the nation followed. A figure of Shanghai fun was the country bumpkin up for the day gawping at all this, the

goods no less than the lights, signs and décor around them. He gawped with shock and wonder. He had seen nothing like it. It was enough to stop him in his tracks to see on the roof of a building, as the opening passage of *Midnight*, a famous 1930 novel by Mao Dun, has it, 'a gigantic NEON sign in flaming red and phosphorescent green: LIGHT, HEAT, POWER!' If 'Shanghainese' became a proud self-designation for the residents of this city, it was partly because whatever was newly introduced to China would make its first appearance there, whether it was neon lighting or the latest mode in the West. It was because Haipai implied *shimao*, 'fashionable' and *modeng*, 'modern.' What was more, those who liked novelty had the means to buy it. Postwar prosperity was in full swing in Shanghai. World War I, as we have seen, had ushered in an economic miracle and a burst of affluence.

To see how up-to-date Shanghai was, one had only to look at the Hollywood movies showing at its cinemas. All the larger motion-picture producers

Painters produce blown-up version of photograph (hanging from bamboo ladder) of Hollywood movie star Greer Garson on Shanghai street hoarding of Lux ad, 1949. Photo by Sam Tata.

in the US and Europe had agents or distributors there, and 'the best pictures produced anywhere are released in Shanghai,' a report by the US Department of Commerce tells us in 1930, 'almost as soon as they are in the country of production.' In addition to advertisements in the daily papers and movie magazines sold in the cinemas, a host of visual ephemera – posters and billboards on trams and buses, neon and other electric signs and displays, postal notices of new pictures – insinuated the look and idioms of America's dream factory into the lives of the Shanghainese. Film was not the only medium of the modern age but it was the most powerful.

Through it, as through pictorial print media and advertising visuals, what was in vogue in the West was transmitted to Shanghai. In this way the aesthetic of the Roaring Twenties, the flapper fashion type and the new American designs which the cinema was helping to turn into a worldwide mass style, was metabolized into a strand of Shanghai Style.

But it has to be stressed that insofar as advertising visuals were concerned, it was no more than a strand. Unlike the other graphic forms I've dealt with, advertising was mass communication, aimed at people from many more walks of life and in many more places than book covers and illustrations or even caricatures and cartoons. Take cigarette advertising. This penetrated corners of China of which the Shanghai city slicker would have barely heard. For advertisements to speak to urban and rural Chinese at once, they had to be, if not dumbed down exactly, at least reduced in modernist and foreign content. This is why, of the various graphic forms looked at in this book, pictorial advertising was on the whole the most conservatively Chinese.

To find evidence of this, one need look no further than the ubiquitous, widely sought-after colour-lithographed calendar poster (or, if it came without the calendar, 'hanger'). Given as New Year gifts to customers, such posters were also sold by street vendors. No avant-garde artist worth his salt would

be caught dead painting in the style of the *yuefenpai*, as such posters are known in Chinese, often derogatorily, it has to be said. His modernist tendencies, chief of them an anti-representationalism, would set him against it, quite apart from the accusations of vulgarity such art attracted. Yet, retrograde as the *yuefenpai* manner was thought to be, ironically this is what most people identify with Shanghai Style nowadays. If it's nostalgia for a bygone era you're after, the quickest shortcut to it, it seems, is a calendar poster picture.

But not the poster picture showing traditional Chinese subject matter. Broadly speaking, the scenes and figures portrayed may be dated by dress, appearance and décor to two eras, the imperial past in the one case, and the Republican (1912-49) present in the other; and it is not with the first kind that people identify Shanghai Style. The first kind shows scenes and figures drawn from Chinese history, legend or literature – the classical novel *Dream of the Red Chamber*, for example. The painters who executed them had assimilated certain European painting

Figures and setting historicized in artwork by Hang Zhiying Studio advertising a Chinese medicine for children made by Hongxing Drugstore, 1930s. Hang and contemporary artists judged historical pictorial narrative appropriate for ads for traditional Chinese medicine.

techniques – among others the use of perspective to suggest recession into space, and chiaroscuro to produce volume and mass in figures – but this could only have been apparent to the few who understood painting *qua* painting. Besides, the unequivocally Chinese thematic source and subject matter of the pictures swamp any feeling of their being the technical mongrel that they are. Aesthetically, there is an incongruity about them that arises perhaps from the imperfect, even awkward, fit between the Western realistic representational style of painting and the Chinese subject matter and imagery.

To Shanghainese of a later day, the second type of poster more nearly exemplifies Shanghai Style. To their eyes, what could be more quintessentially Shanghainese in style than the woman dressed in, not the flowing robes of the imperial past, but the figure-hugging *qipao* (or cheongsam) of modern Republican times, with her hair marcel-waved in the mode of the day, and her feet shod in leather heels? Didn't Cao Juren say that the 'modern girl' was a synonym for Haipai? Painting her was certainly the stock-in-trade of most of the best-known commercial artists of the day.

But the modern Shanghai Miss stands in a long line, and her representation winds back to roots in the past. She is adumbrated in a nineteenth-century staple, the 'female beauties' genre of Chinese painting, and if Shanghai stakes any claim on her it is because she found a natural habitat there. She owed her modern incarnation to the unique confluence of technical, artistic and commercial factors that took place in the city in the closing decades of the nineteenth century and the opening decades of the twentieth. Technically, there was the elaboration of printing methods from the traditional Chinese woodblock print to imported lithography and photography (at first colour lithographs could not be printed in China, but this changed in 1906 and 1907, when two of Shanghai's publishers invited Japanese technicians to come and work at their presses).

Artistically, there was the tide of metropolitan migration that concentrated talent and application in Shanghai, a place offering not only metropolitan opportunities but hospitality to foreign tendencies. Commercially, there was the lively market for goods and services, and a critical mass of distributors, advertising agencies, publishers and, not least, the latter's in-house art departments where not a few of the Shanghai Miss's creators first cut their teeth as commercial artists.

The artist credited with remaking her in a new guise is Zhou Muqiao (1868-1923), the first painter to represent her as a modern woman in an advertisement poster. Zhou was Wu Youru's colleague on the *Dianshizhai* and *Feiyingge* (Flying Shadow) pictorials, the latter set up by Wu on his own and handed over to Zhou to run in 1893. Two posters he painted for BAT (British American Tobacco) in 1914 encapsulate that remake. Between these and his other pictures of contemporary Shanghai women, there is a noticeable break. The women wear what a law in 1912 had

Zhou Muqiao's calendar poster *Woman Standing by A Rock* for Xiehe Trading Company *(left)*, 1914, compares unfavourably with his picture in Wu Youru's style. From Ng Chun Bong et al., *Chinese Woman and Modernity*, Hong Kong, 1996; and *Wu Youru huabao*, 1908.

dictated as formal dress for Chinese womanhood, hip-length high-collared jackets with side-fastenings over long pleated skirts (trousers in one case), but the feet they walk or stand on are natural-sized and shod in Western-style shoes, not bound and deformed into 'golden lilies.' But what is also striking – and this is particularly so when the stiffly posed and maladroitly rendered single woman pictured next to an ornamental rock is compared to the lithe figures Zhou drew with such skill earlier – is that in making her new Zhou also made her awkward, as though he, at least, were not accustomed to her modernity. Besides, her face looks so mannish you could be excused for thinking it was based on a male model or, as the art historian Ellen Johnston Laing thinks, a photograph of a female impersonator of Chinese opera. Laing, the author of a book on calendar posters, *Selling Happiness*, certainly sees hints of the photography studio in Zhou's poster, the setting it shows looking more like a landscape backdrop and props than real scenery.

But to reiterate a point made earlier, advertising visuals tended to be more conservative than other kinds of print. The modern woman may be appearing for the first time in BAT's advertising poster, but her like was already cropping up everywhere in comtemporary media.For instance, on the covers of *The Saturday*, the magazine that gave its name to the school of writing we also know from Chapter 3 as Mandarin Duck and Butterfly romance fiction. Magazine illustrations apart, there were images offered for sale or as giveaways with various purchases under rubrics like 'Beauties.' These showed women going about their domestic tasks in a manner that would have appeared quite modern. To go by their look, these pictures belong to the Early Haipai mode. In Early Haipai images, the women wear high-collared tunics slit at the hip; their hair is kept long and plaited in a pigtail beribboned at the nape of the neck. There is no separating body and hair from fashion, and to follow the work of our next *yuefenpai* artist, Zheng Mantuo (1888-1961), is to see representations of

the female figure evolve in tandem with changes in couture and coiffure.

One wouldn't hesitate to describe his *Girl with Fan*, a poster he did for the Nanyang Brothers Tobacco Company, as Early Haipai; one has only to look at the subject's clothes, hairstyle and demeanour. One could date the poster, too, by the 'weeping willow' bang falling down the centre of the girl's forehead. Contemporary photographs, such as the one taken in 1922 or 1923 of Sheng Peiyu and her fiancé Shao Xunmei, tell us that this was the vogue in the early 1920s. By 1928, when Zheng's poster for the Hong Kong cosmetics company Kwong Sang Hong (Guangshenghang) was painted, girls had chopped off their tresses, and each of the two in the picture wears a bob that matches to a nicety the one Louise Brooks sports in a film of the same year.

The *qipao*, one day to be iconic, makes an

Sheng Peiyu with fashionable bang photographed with husband Shao Xunmei (see Chapters 3 and 4). From Sheng Peiyu, *Shengshi jiazu, Shao Xunmei yu wo,* Beijing, 2003.

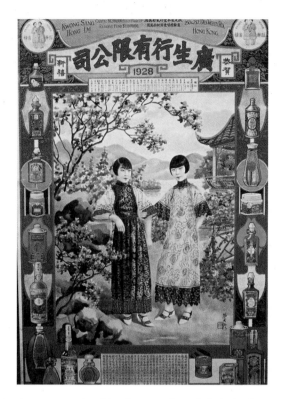

appearance in this picture, though it is in the straight, loose, A-line form that it does so, and not in the later slim-fitted version that outlines feminine curves to such grace and advantage. The style, derived from the Manchu robe, is still at an early stage, and new on the fashion scene when Zheng painted it. In an essay on the history of apparel the writer Zhang Ailing dates its emergence to 1921, only she starts by calling it the *changpao*, the 'long gown' worn by the Chinese male at the time, to bring out her point that women donned it to be more like men. If this was indeed the case then it would have paralleled the emergence of the flat-chested *garçonne* or 'boyish' look of the flapper in Europe, a fashion which reflected the new woman's desire to emulate men and to be empowered by her 'mannish' look.

By common agreement Shanghai was the *qipao's* place of origin. And for any style of garment to

win popular acceptance in the rest of China, it was enough that it was 'in' in Shanghai. Thus whoever thinks of the *qipao* as being expressive of Shanghai Style has every reason to do so. Shanghai certainly dictated the variations it underwent according to fashion, whether and by how much the hemlines, side-slits and collar heights should rise or fall, the sleeves lengthen or shorten, and what kind of fastenings to use besides press studs, whether frogs or knotted loops or the so-called 'flower buttons.' Indeed, just trendiness was enough to define Shanghai Style. There is a cartoon by Ye Qianyu where the editor of a 'New Woman' pictorial magazine holds up a set of photographs observing that they are out of date, only to hear a fellow-editor answer, 'Just put them away for now and we'll run them in a special issue next summer.'

Ye Qianyu's 1935 cartoon of editorial office of *New Woman* magazine. Caption has one editor saying, 'These pictures are out of date,' and the other, 'Just put them away for now and we'll run them in a special issue next summer.' From Bi Keguan, *Guoqu de zhihui (The Wisdom of the Past)*, Shandong, 1998.

In the mid-1930s hemlines dropped down to the ankle or even to the feet, but they rose to mid-calf by the decade's end. In winter the *qipao* would be either fur-lined or wadded, or else it would be made in a woollen fabric instead of silk. The silks ran the gamut of weaves and finishes, from gauze and brocade to crêpe and chiffon, with satin favoured for piping, while imports of both natural fibres and synthetic textiles extended the gown's range of materials, colours and patterns. Besides plain Indanthrene-dyed cloth, striped, checked and tartan fabrics were very popular, and it was while wearing these designs that the film actress Ruan Lingyu (1910-35), who was to China what Greta Garbo was to the West, appeared in some of her most memorable scenes.

Of course, it mustn't be supposed that advertisements were a mirror of society in every instance and that the fashionable attire they depicted was what women were actually wearing, for it could have been what women were shown wearing in the Western magazines from which the artists copied. Take Zheng's advertisements for Nanyang Tobacco Company and Wuxi Maolun Silk and Satin Factory, both of which show figures dancing – the Charleston

Ruan Lingyu, 1930s.

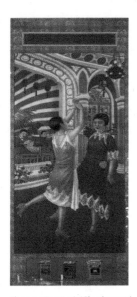

Zheng Mantuo's 'Charleston,' ad for Nanyang Brothers Tobacco Company, 1927.

Xie Zhiguang's calendar poster *Fun By the Pool*, 1930s.

in the first case and the tango in the second. The attire of the two same-sex couples is, as Ellen Johnston Laing puts it in her book *Selling Happiness*, 'a compendium of French high style current between 1925 and 1927.' The girls are fashionable all right, but in Parisian not Shanghainese terms. Zheng was being faithful to the prototypes shown in the Western images that came his way and not to any fashion seen on the women of Shanghai.

Some of the women in the posters have their hair shingled all around the head à la the Eton crop, a style which came into fashion in 1926 in the West and which exposed the ears for long drop earrings to be displayed to good effect. Others have tight, finger waves covering the crown of the head, and spit curls over the cheek like Josephine Baker. Cropping hair that short allowed the close-fitting cloche hat, so redolent of the flapper era, to be worn. As contemporary photographs attest, the cloche did find its way to Shanghai, though it was far from being the Roaring Twenties icon there that it was in the West.

Zheng was in great demand as a *yuefenpai* artist and commanded enormously high fees, though it is difficult to see why when we look at his highly uneven work, the earlier examples of which are gauche and ill-proportioned to the point of crudity. But his place in commercial art history is assured because he brought something new to the advertisement calendar: he perfected the 'rub-and-paint' technique for producing coloured pictures, and he introduced the partial nude and half-length figure. 'Rub-and-paint' is a technique in which you gently rub carbon into the paper to create shadow in those parts of a figure (flesh or fabric) where volume and mass are desired before applying water-soluble pigments to the drawing layer by layer. This allows your picture to achieve a heightened sense of realism and a suggestion of three-dimensionality. As for nudity, that would have been nothing new in other printed media, but exposing flesh to the degree Zheng did in advertisement posters was a 'first' – advertising art tended to be more old-fashioned, as noted earlier.

The pin-up girl gained in curvaceousness as the years progressed, and as the *qipao* slimmed down to a closer-fitting, more revealing sheath that restored to the female body the physicality that had hitherto been hidden from view. The new style carried the girl from nubile inexperience and virginal innocence to sexual explictness and sophistication, fitting her for a world where sexuality was harnessed to selling ever more overtly. In what may be regarded as the Middle Haipai period, her figure emerges fuller, her cheeks redder; and even her eye brightens and meets yours. Indeed the 'come hither' message beamed at you by her pose and gaze is unmistakable. You can't miss it in the advertisements of men like Xie Zhiguang (1900-76), Ni Gengye (dates unknown) and, above all, the shortlived Hang Zhiying (1900-47).

Xie was unusual in having had formal art training at the Shanghai Art Academy. He worked for a time for Carl Crow, an American resident of Shanghai who opened the first Western advertising agency in China and who famously authored *400 Million Customers* (1937), a bestseller in its day. Xie's career was inextricably linked to the growth of cigarette advertising in China, the scale of which was so massive it practically left no corner of the country untouched. Just how massive may be seen from the size of BAT's annual advertising budget for late 1910s China – almost half as large as the entire annual education budget of the Beijing government. That urban surfaces were blitzed with cigarette ads, which became unavoidable even in inland Chinese towns, meant that commercial artists like Xie were kept busy. It got to a point where you could scarcely light up a Meili ('beautiful'), a brand of cigarettes called My Dear in English, without imagining it held between the lips or fingers of Xie's luscious ladies.

Times had changed and so had eyes. Neon lights no less than advertising had inured them, attuning them to a new key of brightness and intensity. Ni Gengye, whose ads for BAT's Hatamen cigarettes are among the most beguiling to come down to us, was another

Hang Zhiying's ad for Monkey brand mosquito coil, 1930s.

artist to endow smoking with frank sexual allure. The spectator of his poster for Ruby Queen cigarettes does not need to know the title, *Always Thinking of You*, to detect the invitation to intimacy, so plain for all to see is how completely and tantalizingly the back half of the woman's *qipao* falls open from the thighs, revealing the white lace-bordered slip beneath. As is characteristic of Ni's women, she stares at you directly and intently, daring you with her eyes. You could tell Ni's paintings by that penetrating stare, so distinctive is it of his style. If his women are not exactly brazen, there is nothing coy about them either, and though fewer than a dozen years separate them from Early Haipai women, they are a breed apart.

In the hands of Hang Zhiying, they took on still more facets. Hang may or may not have studied, as some have supposed, at the painting school for orphans which the Jesuits ran at Tushanwan, but the cultural eclecticism of his training is not in any doubt, for he attended the Commercial Press art department school, an important cradle of commercial art in Shanghai, and for teachers there he had both Chinese and foreigners. In about 1922 he took on trainees and established his own commercial art studio, and by 1928 he had done well enough for his wedding photograph to be published in *Shanghai Sketch*, with a note to the effect that he was a 'famous artist.' Certainly his

posters and hangers were much sought after, not only in Shanghai but in Hong Kong and overseas Chinese communities in Singapore, Malaya, Vietnam and Indonesia. His studio was turning out artwork at the rate of 200 pieces a year, a volume hardly conducive to the steady maintenance of quality, though who exactly was responsible for which formal lapse is now impossible to tell, so often were the pictures collective endeavours, with only the final touches put in by Hang, though they are all signed 'Zhiying.' Nevertheless, there is a recognizable Hang Zhiying look that still comes across as distinctive.

One aspect of that look is glamour. The vehicle for this is fashion, which in Hang's hands assumes greater prominence than in other artists' advertisements. Many of his pictures are like fashion shoots, with the women looking improbably long-legged for Chinese. They are Chinese versions, Ellen Johnston Laing says, of the American 'Yard Long Girl' calendar, the source of the posters' tall, narrow format no less than

'Generic' calendar posters such as this were churned out by the Hang Zhiying Studio, to have brand names and calendars added to them to suit the individual firms that bought them, 1930s.

the figures' elongation. That creaminess of skin helps of course, that peachiness which Hang so delighted in painting and which appeared on face after face, regardless of whether it was ingénues he was depicting or mothers with children. The latter was a new theme in which his studio led, following Nationalist government programmes aimed at encouraging modern women to become nurturing mothers and domesticated homemakers, this for the ultimate good of the state.

Another subject was the newly fashionable outdoor, sporty type of woman. To be thought a modern beauty for your athletic looks posed a sharp contrast to the time, a mere six, seven years ago, when you had to be willowy and delicate to be deemed feminine. Political design had something to do with this change in standards of female beauty, the government having got it into its head to correlate physical fitness with the strength of China as a modern nation, and so was promoting sports, gymnastic exercises, swimming and ball games through directives and the media. This was a gift to the commercial artist, who could now represent legs, arms and torsos revealed by scanty sportswear without risking accusations of pornography. In an advertising poster for the Great Eastern Dispensary, a girl in a canoe is pictured gliding across a lake in a swimsuit with one strap pulled down to reveal a breast and nipple.

Hang and his colleagues would not have had any sitters for such images, so they took them from Western paintings and photographs. Another way of producing portraits was to paint copies of photographs published in the local papers. These would be of celebrities in the entertainment world, an arena where the cinema, Chinese opera, the theatre and the cabaret overlapped, and where men and especially women rose to fame on the back of the explosive growth in the pictorial press and other mass media. In the Early Haipai period it was denizens of 'the world of flowers,' as the Chinese called courtesan culture, who appeared on posters advertising soap, toothpaste

Advertising poster for the Great Eastern Dispensary from the Hang Zhiying Studio showing girl in outdoor setting, 1930s.

and beauty products, and it was courtesans too that served as cover girls on the *Saturday*-type publications that Ding Song's generation illustrated. Courtesans were also much photographed, the pictures helping to advertise their charms to their male customers, who, if not presented them by the courtesan herself, could buy them directly from the photographic studios. Such prints united two kinds of fashion: the still novel art of photography, and the subject's modish attire.

Elegant woman, probably Chen Yunshang, promoting Indanthrene in poster named *Happy Young Woman*, also by Hang Zhiying Studio, 1930s.

But 'the world of flowers' had yielded to modern media figures, and it was likenesses of cabaret and cinema stars that now conferred allure on goods. One of Hang's clients was Indanthrene Textiles (Indanthrene, Yindanshilin in Chinese, was a colour-fast dye invented by Germans and imported into Shanghai for use in locally woven cloth). Chen Yunshang, a movie star pictured seated in an apricot-coloured *qipao* in one of Hang's best-known advertisements, was one of several to lend her likeness, and it may be her likeness too that was used in one of the loveliest of all posters to be painted, an advertisement showing a svelte woman standing with her arms folded, her long, Indanthrene-dyed royal-blue *qipao* buttoned all the way down one side, set off by green piping and accesorized with three strands of pearls at the base of the collar.

An even more familiar face was that of Hu Die, whose English name Butterfly came of the pun it makes on the compound formed by the two characters of her Chinese name. Hu Die was a big star, made bigger in 1933 by being crowned China's very first 'Movie Queen.' One advantage she had over other actresses was that she had spent enough of her youth in northern China to be a good Mandarin speaker, and this fitted her well for the talkies. In 1934 Shanghai was agog with the news of her grand tour of Europe, lapping up the media coverage of her progress from Moscow, where she was a guest of the International Film Festival, to Berlin, Paris, London, Geneva and Rome. Borne on a wave of publicity, she travelled again to Europe the following year, this time with

Hu Die, her glamour enhanced by car, 1930s.

179

Mei Lanfang, the legendary Beijing Opera female impersonator. She was the picture of glamour as, swathed in a fur coat, she posed for photographs with Mei. In London she was photographed with Charlie Chaplin and Paulette Goddard, and when the pictures reached Shanghai they naturally burnished her star still further. In fact, so iconic did she become that one wonders if the round faces of the women in Hang's pictures were not inspired by the film star, whose chubby dimpled cheeks were such a departure from the 'melon seed' and 'goose egg' shapes idealized in an earlier day.

Hu Die's face was used to endorse a variety of products, Lux soap and Sincere Department Store perfumes among others, and there was at least one brand of cigarettes named after her, the packaging of which had her portrait and the name 'Miss Butterfly' for a trademark. In Shanghainese dialect 'butterfly' also puns with the word 'peerless,' and it can't be mere chance that a range of beauty products, face creams, powder and fragrances, was marketed under that name. Celebrity sells, and Hu Die was not the only name and face to be used as an identifying label for a product: Mei Lanfang, for example, was both the

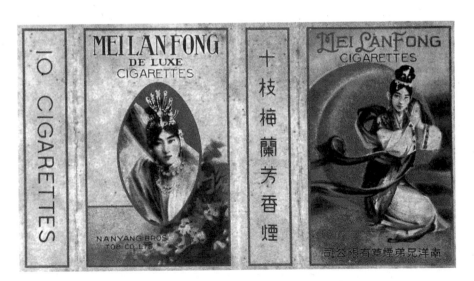

greatest of all Beijing Opera performers and the name of a brand of cigarettes.

Hu Die sought refuge in British Hong Kong when Shanghai was imperilled, escaping life under Japanese occupation. Things did not grind to a halt – Chinese film makers still found ways to produce the dream substitutes that movies were, and fans collected glamour portraits of their favourite movie stars with no less avidity – but the war sealed the fate of the *yuefenpai*, dealing a blow to the genre from which it would never really recover. Late Haipai, as it now was, was a style past its prime. In commercial art as in other arenas, an appeal to patriotic sentiments and resistance to enemy invasion took the form of a reversion to Chinese roots. It was historical costume melodramas that people watched in the cinema, and it was age-old Chinese themes recycled from traditional woodblock prints that they saw in the advertising visuals. For the rest, the bright sexiness of Middle Haipai degenerated into outright pornography, while artists of standing like Hang preserved their self-respect by forsaking poster girls for the plum blossoms, bamboo, and other familiars of Chinese brush painting.

When Japanese surrender impended, Hang, Xie Zhiguang and eight other artists collectively painted a poster called *Mulan Returns in Triumph*. Hua Mulan, whose story every Chinese knew, was a famous woman warrior who defended China against foreign invasion in place of her frail father, and who was exactly the sort of heroine and symbol to appeal to the patriot and nationalist that the war had brought out in so many Chinese (*Mulan Joins the Army*, a 1939 film version of the story starring Chen Yunshang, who was last seen in these pages endorsing Indanthrene fabrics, turned out to be one of the highest-grossing of all Chinese movies). By and large, though, and in contrast to such other forms of graphic art as caricature and cartoons, advertising did not lend itself easily to political propaganda, especially with the Japanese on the lookout for signs of resistance to suppress. Yet

many were the Chinese-owned cigarette companies that brought out politically charged cigarette cards – these were sets of colour-printed pictures serving as stiffeners for the soft packs of cigarettes – in the wake

Patriotic cigarette card downplaying sex difference, late 1930s. From Chen Chaonan and Feng Yiyou, *Old Advertisements and Popular Culture*, San Francisco, 2004.

of Japanese attacks, cards with titles or slogans like 'The Nineteenth Route Army fights heroically against Japanese invaders,' 'Better to die fighting than to be enslaved by foreign conquerors,' and, as in the card reproduced here, 'In the face of the national crisis, of what matter is gender?'

The calendar poster would have an afterlife after the war ended and after the communists took over, though in an altogether unforeseen way. It goes without saying that the sexy advertising poster girl would have no place in a world that disallowed private property, but at least two of her creators, Li Mubai (1913-91) and Jin Meisheng (1902-89), both of

them contributors to the Hang Zhiying look, would successfully transfer their skills to the execution of propaganda posters. Pigtails would take the place of permed hair, and rustic honest-to-goodness work clothes (loose shirt and baggy trousers), the shapely and urbane *qipao*. But in the propaganda poster we see the artist's compulsion to repeat what he had learned, and we are reminded that among the familiar things we can read into pictures are other pictures – in this case the advertisement poster that had ironically been so much a part of the Shanghai marketplace.

An advertisement visual is of course much more than a space enclosing one or, as was often the case with the calendar poster, two figures (presumably because two women are better than one). Quite apart from the setting in which the figure is placed, whether a landscape or an interior, there are graphical components like the surrounding design or border and, most crucially, text or type.

For the design of both artistic borders and typography, the Chinese calendar poster artists drew from the native decorative base but, more heavily, as Ellen Johnston Laing has shown, from the vocabulary of the Western advertising visual. The hybrid thus formed was very much in the style of 'Shanghai Modern,' the modernity consisting of the insinuation of foreign elements into the core of an ancient pattern, which makes one re-read and redefine the new whole thus assembled.

Indigenously Chinese border patterns may be found in woodblock-printed products like popular prints and illustrated books. Of the examples that have come down to us, the earliest is a twelfth-century print preserved in the Hermitage in St Petersburg. Four opulently dressed and adorned female historical figures are enclosed in a narrow patterned border of squared volutes. Above and below these are wider borders, bands of spiralling leafy vines which, in the one at the top, curl around two phoenixes. Traditional hanging Chinese scrolls are customarily mounted

Four Beauties, earliest extant example of the genre of woodblock prints Chinese call *nianhua,* or New Year Picture, twelfth century. Hermitage, St Petersburg.

Border with Art Deco motifs surrounding *Beauty Seated by a Stream: The Movie Star Ruan Lingyu*, 1930.

Geometric motifs decorate border of Xie Zhiguang's ad for the Central Agency, 1930s.

with a perimeter of fabric or paper patterned with repeated floral motifs, diaper, medallion or other geometrical designs, and it would be natural enough if such ready-made decorative schemes migrated to the advertisement poster border. The squared volutes, lattices, discs bearing felicitous Chinese words and pomegranates (symbolizing fertility as it is full of seeds) which you may recognize in this or that poster are indeed no more than you would expect, knowing the hold which the common stock of traditional motifs possesses. Yet while Chinese tradition was given its due by Shanghai's commercial artists, it was Western examples that they largely followed.

These examples could have come from any number of sources, from actual advertisements and visuals appearing in Western periodicals to pattern books of the kind that were published in Shanghai in 1922 under the collective title *Compendium of Classified Pictures in the New Style of Art*. The latter offered images in such profusion that an object would have to be an unusual one indeed for its picture to be omitted from it. Objects, figures and scenes apart, the student using the manual could ransack its design section for Western patterns, whether geometric, floral or Art Nouveau, just as he could raid it for Chinese geometric motifs.

Art Nouveau was an Early Haipai fashion, and when tastes changed in Europe and the style yielded to Art Deco, it was the latter that Shanghai's artists took on board. Here we must turn again to Zhang Guangyu, who was a commercial artist employed by BAT as well as a cartoonist. At BAT he specialized in designing borders, and for some of these he drew from the Art Deco vocabulary — curlicues and deer in a border framing Ni Genye's painting of a girl with a parasol (1928); and discs, arcs and bars in the one surrounding a picture of the movie star Ruan Lingyu seated by a stream, a calendar poster for Hatamen cigarettes (1930).

A textile design of cones and other geometrical forms, worn by a girl holding up a spool in a poster

advertising the Central Agency, a British maker of threads, is even more obviously Art Deco, as is the background – of blue and black arcs of circles and, at the top, two yellow triangles – against which the artist has set his painting. The artist, who turns out to be Xie Zhiguang, could very easily have borrowed or adapted these motifs from contemporary Western magazines, since there is no such thing as an artist who does not copy, and there were plenty of Art Deco images around to which he could help himself. Xie moved easily between styles, being one of those artistically ambidextrous painters who would produce a scene from Chinese legend in a hanging-scroll style one minute and a modern girl smoking a My Dear cigarette in a Lucky Strike ad style the next.

The lettering of the Central Agency's Chinese name is in a typographical style which, were one to compare it to Western fonts, one would call sans serif (a serif font would be one where a horizontal stroke finishes off with a hook or a triangle at the top right corner). Sans serif faces (misleadingly and incorrectly called 'gothics' in America) were created in the nineteenth century and used in the West for posters and promotional materials, but it took the development of cleaner, more mechanical-looking design at the end of World War I for such typefaces to gain wider popularity. Sans serif typefaces were favoured by De Stijl, the influential Dutch avant-garde movement whose magazine was laid out with the square as the basic unit, with pages that became ever more minimalist and purist. And it was a sans serif alphabet with no capitals, the Universal typeface, that Herbert Bayer designed for the publications of the Bauhaus, the German-based group that was the single most important influence on modern typographical design, and whose principle, 'form follows function,' may sound familiar enough today but was revolutionary then. It is no doubt because it aspired to a modern graphic style that the Central Agency poster used sans serif lettering for the Chinese name.

Horizontal stroke of Chinese character formed in a way (with hook) that may be called 'serif.'

abcdefghi
jklmnopqr
s tuvwxyz

Universal typeface designed by Herbert Bayer.

Lu Xun's handwriting on cover of *Lu Xun's Self-Selected Collection*, 1933.

Because lines of Chinese characters can be composed both vertically and horizontally, and from left to right or from right to left, the Chinese script has a design flexibility that in some ways surpasses that of the Latin alphabet. Furthermore, the supreme aesthetic value it has for its readers is unparalleled in any other of the great literate civilizations. To call the Chinese art of writing 'calligraphy' by analogy with a minor Western decorative craft is to overlook its exalted place in the visual arts of China. It is the pre-eminent art form, ranking higher even than the ink painting with which it shares the brush. Inevitably, it plays a part in the development of printed lettering, and for their titles countless book covers have resorted to calligraphy – on a number of Lu Xun's publications, for example, the titles are in his own, instantly recognizable handwriting. Only under the influence of Art Deco, Bauhaus and Proletarian Art, notes Martin J. Heijdra, who has studied the development of modern typography in China, Japan and Korea, did interest in the design of Chinese characters 'liberate itself somewhat from the restraints of the rhetoric of calligraphy.'

This occurred chiefly, he goes on to note, in the design of title, logo and trademark or book and periodical covers – that is, in what was called 'lettering' rather than in body-text typefaces. The latter is another story, one in which Christian missionaries, sinologists and Japanese type designers loom large. Publishers in China had been woodblock-printing their books since the early Tang dynasty (618-907), but metal type-cutting or casting Chinese, a non-alphabetic language with some 40,000 characters, presented almost insuperable difficulties. The first people to attempt it were Europeans, particularly missionaries keen to print Christian books and tracts for proselytizing in China; and the first places to which European printing technologies were transferred were, inevitably, Macao, Hong Kong, Canton, Shanghai and other treaty ports where Westerners had a foothold. In none of these places, however, did the technology

'take' so well as in Shanghai.

Those early years saw the Baptist missionary Joshua Marshman beavering away at cutting fonts for the Chinese New Testament and his *Elements of Chinese Grammar* at the Mission Press in Serampore, India, between 1805 and 1810; while away in Malacca and Macao, Robert Morrison, of the London Missionary Society, produced a complete Chinese Bible in 1824, using hand-cut type, and his famous *Dictionary of the Chinese Language* with the support of his one-time employer, the East India Company.

In Europe, Chinese type was produced for sinological works in Paris by Marcellin Legrand in about 1834 with the help of Chinese students, and in Berlin by Beyerhaus in about 1850. Meanwhile, the *Matai chuan fuyin shu*, or, in English, *The Gospel According to St Matthew*, was published in Shanghai in 1850, printed in the so-called Hong Kong typeface, which was produced

大 美 國 印 書 館 上 海

Fonts created by *(from top to bottom)*: Dyer, 1843; Beyerhaus, 1859; Marcellin Legrand, 1834/44; Cole, 1851; and Gamble, 1959, this last called Meihua or Song. From *Chinese Recorder* 6, 1875.

by Samuel Dyer of the London Mission in Penang and the American type maker Richard Cole, the latter redeveloping and adding to it in Hong Kong after Dyer's death. Cole founded the American Presbyterian Mission Press (Meihua in Chinese) in Macao, then moved it to Ningbo as soon as the US gained the right to establish itself there following China's defeat in the first Opium War by imperial Britain.

None of these efforts to produce modern Chinese type were longterm propositions, since cutting the thousands upon thousands of Chinese characters

187

Gamble's American Presbyterian Mission Press fonts. From Gilbert McIntosh, *The Mission Press in China, Shanghai*, 1895. Reproduced by Christopher A. Reed, *Gutenberg in Shanghai*, Hong Kong, 2004.

needed for just one set of type required staggering amounts of time and the patience of Job; and it was not until the electrotype process was invented in Europe could Chinese-language printing be speeded up. In this process, letters were first cut in wood in the old way, a wax mould was made, and then through several steps of electrolysis a copper and brass matrix was created from which new typeforms could be cast. It was a big step forward for Chinese typography when William Gamble, who had trained in publishing houses in New York and Philadelphia, brought the new method to the Presbyterian mission in Ningbo in 1858. This was a breakthrough in the history of Chinese typography. From Ningbo, the press was to move to larger quarters in Shanghai, and there Gamble's fonts in several sizes were widely distributed,

sold to newspapers and eventually to Japan, England and France.

Gamble would transfer his type to Japan, taking equipment and supplies with him to Nagasaki and staying on there to teach his method. The Tsukiji Font Foundry, which became a major supplier of body-text type in not only Japan but China, was presently established in Tokyo with a branch in Shanghai, and for fonts used for the texts of newspapers, periodicals and books, China was to depend on Japan right up to the 1950s. When financial difficulties forced Tsukiji to close its Shanghai branch in 1900, the Japanese operation sold its equipment and type to the Commercial Press, a printer and publishing house that would become highly influential in the development of Chinese graphics. The three Chinese who founded it had learned their trade at the American Presbyterian Mission Press, which would itself be absorbed by the Commercial Press in 1923.

Gamble's font went by the Chinese name of the mission, namely Meihua, but it was also called Song type, after the forms of Chinese script prevailing in the Song dynasty. Whether it was the Meihua or Hong Kong type, or even, for that matter, Marshman's or Morrison's, the styles of all the earlier fonts stemmed

Rubbing of writing in Regular script by famous painter and calligrapher Zhao Mengfu (1254-1322). Used by woodblock cutters as a model, his calligraphy would inspire one of the commonest styles of typography to appear in printed books. The text is the *Dao De Jing* (the *Classic of the Way and Its Power*) by Laozi. National Library of China, Beijing.

(*From top to bottom*) Regular (Zhengkai), Thick (Cu), Neo-Song and Song fonts. From Christopher A. Reed, *Gutenberg in Shanghai*, Hong Kong, 2004.

曤楠噬捔焰潤昌活
抔夷尉窰彫挈完棕
姪吳撲曚敥器彎夜

中国是发明造纸和印
一世紀，已有紙張出
了造紙方法。此后，

Samples of printed script in Regular (*top*) and Neo-Song type. From Martin J. Heijdra: *The Development of Modern Typography in East Asia, 1850-2000*, Princeton, 2004.

from those of the texts produced by Chinese woodblock printers, which themselves harked back to the so-called Artisan style (*jiangtizi*), a style created by woodblock cutters of the Ming dynasty trying to imitate Song styles. This is why Gamble's font was, and still is, known as Ming-dynasty type in Japan, where this highly readable and best developed of styles caught on and remains a standard body-text typeface today. It was imported into China, where any Japanese variations of it, whether it was a new size or an improvement in the balance of thick/thin ratios, seldom escaped being pirated instantly.

If the missionary typefaces were, as Morrison put it, 'confessedly deficient in elegance,' it was because it was the policy of the Chinese court to withhold help and facilities from foreigners wishing to print texts in Chinese, and for a time the missionaries had to do without Chinese assistants – for his dictionary Morrison relied on an English printer to write the characters and Portuguese employers to cut them. The missionaries would have tried to make their faces more appealing to the Chinese eye if they could, for aesthetic considerations were never far from their minds. They were aware that writing was synonymous with art in China. But first they had to overcome the enormous technical and practical difficulties.

The Chinese were bound to disdain all these typefaces as less than pleasing to the eye, and to try to develop new ones. The Commercial Press, with its typographers and calligrapher-designers, was at it the hardest, and to it is credited the development of two of the four most popular fonts of the Republican period – the Zhengkai, or Regular, font and a version of the Cu, 'thick,' font. The other two are the highly popular Song font, introduced in the 1920s; and the Neo-Song, which took no fewer than seven years to develop with all its sizes and variants. What we call the Neo-Song today had appeared earlier also in Japan, where it was called Qing-dynasty-style font, and where its use came to be restricted to name cards.

To aesthetic considerations were added new

ones as type became a graphic design element and a medium of persuasion, as in advertising. As book, periodical and commercial publishing expanded – and it did so at a terrific rate in the interwar period – typographers had to think up ever better ways of visually distinguishing body-texts from titles, headlines, logos and taglines. In other words, they had to experiment with display text, or design lettering. In doing so they had to ask themselves what message they wished to communicate, and how expressive or symbolic of that message their design succeeded in being – whether, for example, tilting the characters, or giving them a diagonal stress, made them suggest movement and speed the way italicizing Latin letters did.

Cover of *Advance Not Retreat* by Feng Xuefeng, 1945. From Yao Zhimin et al, *Shu ying*, vol 1, Shanghai, 2003.

There can be no doubt that Western typography exerted an influence on Chinese lettering in the early decades of the twentieth century, and if a particular shape or treatment of type were chosen to represent something beyond its own aesthetic quality, that something was a quality or symbolism which Western typographers had bestowed on it. For an example consider the cover of a collection of essays, published in 1945, entitled *Advance Not Retreat*. The stylization and choice of sans serif type for the Chinese title, as well as its positioning, were as a Western designer would have it if his aim were to echo the meaning of the title and suggest forward movement. Equally, in varying the sizes of the characters according to vanishing perspective and in angling them across the layout, the Chinese typographer was using tools from the design canon pioneered by Western artists.

Similarly, it is immediately apparent that the lettering of *Paris Fragments* (1927) is meant to be expressive. It is designed by the artist-turned-poet Wen Yiduo, whose years in Chicago exposed him to contemporary Western graphic vocabularies. Song or Neo-Song fonts would have looked all wrong with the design of the cover and the heady mood it is intended to convey, nor would they have lent themselves to the crooked spatial arrangement. As it is, a Chinese reader

Wen Yiduo's design and asymmetrical arrangement of Chinese characters for *Paris Fragments* (which anthologizes Xu Zhimo's poems) join image to content, 1927.

Influence of European avant-garde graphic design, including typography, can be seen in cover image of novella by Hu Yepin, *Going to Moscow*, 1930. From Yao Zhimin et al., *Shu ying*, vol 1, Shanghai, 2003.

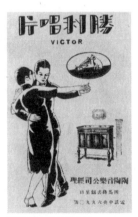

'Chinese Broadway' logotypes of (*top*) Soy Chong and Victor Records in periodical press ads, 1930s.

of the time would think it modern and daring, even exotic, at first glance.

Many Chinese titles or headlines simply followed the designs of the prevalent typefaces, but some were created in new forms to express not only the message but the time. In Europe the 1920s saw the emergence of radically new typography styles and graphic combinations, with letters formed with ruled lines and arcs of circles, among other experiments. The new styles found their way to Shanghai and into the forms of Chinese graphics, where they projected modern times just as they did in their countries of origin. Those times saw the international acceptance of sans serif faces, 'the only one in spiritual accordance with our time,' in the view of Jan Tschichold, whose *The New Typography*, published in Berlin in 1928, was a manifesto of the modern movement. Tschichold has said, 'To proclaim sans serif as the typeface of our time is not a question of being fashionable. It expresses the same tendencies to be seen in our architecture...'

His message was well understood in Shanghai, not least, for example, by he who designed the sans serif lettering to go with the modernist, geometrical imagery of the cover of *Going to Moscow*, a novella published in 1930. To see the period representation Tschichold points to, consider the typeface used for the trade name in the advertisements of Victor Records and Soy Chong Metalworks. Both use sans serif geometrics with heavy strokes that stand out against the thin, and both are strikingly redolent of the 1930s.

Their Latin-alphabet inspiration was the Broadway typeface, a high-contrast sans serif design created in 1929 by Morris Fuller Benton. Cut by the American Type Founders, it is a distinctive typeface with heavy main strokes and thin hairlines, frequently used nowadays by designers who wish to evoke the period style of the 1930s – indeed we now see in retrospect that it is the archetypal Art Deco typeface. Without necessarily knowing its name or that of its creator, Shanghai's typographers adapted it successfully to

Chinese. Transposing the contrasting-weight sans serif strokes of the Latin alphabet into those of Chinese characters, they came as close to the shapes of Broadway as anyone could without sacrificing legibility.

Broadway apart, another font used in Art Deco graphics in the West is Cassandre's visually arresting Bifur font. Cassandre, who is remembered for his custom-designed logo for Yves Saint-Laurent, was a poster artist who would use nothing but sans serif capitals if he could, irresistibly attracted as he was to the monumental inscriptions of the Romans, and tempted to giving the printed page the severe orderly appearance of architecture, an art to which he aspired above all others – indeed he did his work at an architect's table with an architect's T-square and

Broadway font (*first row left*).

Bifur font. (*second row left*).

Typography of *Shanghai manhua (Shanghai Sketch)* on Mar 22 and May 3, 1930 covers adapts Bifur to Chinese lettering.

compass. Bifur was adapted with great flair by the designers at *Shanghai Sketch*, as the two examples of cover typography illustrated here suffice to show. The editors clearly relished experimentation, changing the title typography often over the years. The style seen here, only one of several they played with, involves stripping the characters down to their essentials, and deforming them while keeping them legible, with the enclosed spaces in the characters *hai*, *hua* and *bao* solidly filled in like a Bifur B.

The Art Deco style has been so named only since

Four stars take the place of short horizontal strokes and one star a left falling stroke in the two Chinese characters that make up the title of the film magazine *Mingxing*, meaning 'star.' *Mingxing*, vol 1, no 2, June 1, 1933.

1966, long after Broadway and Bifur were created, and if we apply that style label to the two fonts, it is because we have grown accustomed to seeing them teamed up with illustrations of the Art Deco era, and have come to assume a design or style continuity between the type and the image. Naturally such continuity may not be assumed for Chinese layouts, whose borrowings were piecemeal and eclectic, without regard for the underlying or typical elements

One of many ads placed by ladies' fashion house Yunshang in *Shanghai Sketch*, Mar 15, 1930. The two Chinese characters *yun* and *shang* are made up of rectangles, circles, semicircles and hairlines.

Advertising copy for Qihua uses mix of innovative graphics to impart such information as 'gents' and ladies' hairdressing salon' and 'new shop opens.' *Shanghai Sketch*, Mar 8, 1930.

of style. For all their debt to the Bauhaus, whose ideas were working their way around Europe at the time of Art Deco's flowering, designs of what the Chinese called 'artistic lettering' (*meishuzi*) could be entirely idiosyncratic; indeed, some of them were so quirky they were illegible.

Still, it could fairly be said that, whatever may be their stylistic inconsistencies, Chinese designers did seem to have taken geometric hard edges on board, with some of the character strokes simplified, stylized or shaped into perfect squares, circles or triangles. Enclosed spaces in the characters are sometimes slits, dot-strokes are perfect circles, while multiple strokes are reduced to a squiggle. Lettering is given different treatments, with some forms elongated, skewed or distorted for effect, others laterally joined up as in a

Trademark of Tianxia Wei Gong ('the world is for all') cotton textiles manufacturer, 1930s. From Zuo Xuchu, *Lao shangbiao*, Shanghai, 1999.

Latin cursive script, and still others given added optical interest by shadowing or three-dimensionality. The grip of conventions and the enormous pull in the Chinese to repeat what he has learned, so powerful in the field of calligraphy, were relaxed for a long enough time during the decades leading up to 1949 for graphic styles with Western avant-garde references to have developed.

But these were the days before notions of corporate identity enjoyed any currency, and using type to project an image was still a new practice. The pictorial design of advertisements, labels and packaging was well-developed, but not the identifying typography of company or brand names. Occasionally, though, thought went into using type as image in a trademark, as for example in the way the characters *tian xia wei gong* ('the world is for all') were developed

into the focal point of a textiles label, with the type shaped and arranged as the image. There were also cases where type was made to match meaning. A style of type judged more in keeping with the times, for instance, was chosen for the characters displayed on a packet of cigarettes whose name, Shih Tai (or *shidai* in today's spelling), translates as 'of the day' and carries with it a suggestion of contemporaneity (indeed *shidai*, a buzzword of the time, was never not in a modernistic sans serif when it appeared in commercial graphics or editorial copy).

Modern spirit conveyed by typography of cigarette brand name meaning 'of the day.' From Hong Lin and Qiu Leisheng, *Zhongguo lao yanbiao tu lu*, Beijing, 2001.

Advertising agencies and their commercial artists had recourse to published manuals, some containing only examples of type, others combining these with decorative motifs and even whole pictures. These pattern books, which continued to be cheaply brought out by Shanghai's publishers after the communist revolution, show 'artistic lettering' of varying styles, appeal and legibility. There are styles which few would find visually pleasing, or even usable, but still they are animated by a spirit of experimentation – something which can't be said of those found in post-1949 manuals, when there was a return to Chinese form. Here as in other areas I've examined, the 'return to order' that culminated in the triumph of socialism re-affirmed established traditions and, simply through stressing the usefulness of graphics to propaganda work, narrowed typography's range of expressive possibilities. As a coda, I might add that right up to about 1990, a traveller to China would find his gaze falling everywhere upon propaganda slogans and advertising in a script modelled on Mao Zedong's calligraphy.

6

ARCHITECTURE & INTERIOR DECORATION

An aerial photograph of downtown Shanghai shot in the 1930s shows the skyward thrust of the twenty-four-storey Park Hotel to the left, the open space of the racecourse in the middle distance and, around and beyond them, row upon row of low-rise lane housing. The camera is too far away for this housing to be seen clearly, but the name for the most emblematic form of it, *shikumen*, will be known to almost all inhabitants of the city. The *shikumen*, of which more later, is a reduced urban form of the courtyard house of Chinese tradition. Shanghai's built environment was skyscraper and *shikumen* both – a mirror of the Janus face of Shanghai Style, with the up-to-date on one side, the immemorial on the other.

(Opposite) One of a pair of hardwood dining chairs (see illustration on page 252 for the other), with the fabric side of the reversible seat and back covered in patterned velvet and the wood side decorated with Art Deco speedlines, 1930s. Patrick Cranley Collection and photo, 2007.

The architectural heritage is the most visible of the legacies left by the age in which Shanghai Style developed and flourished. Until the tides of redevelopment overran the city in the 1990s, nothing else offered itself so readily, and on such a large scale, to anyone coming in search of Shanghai's past styles. A historian could slot whole scenes from the past in the fabric of his narrative like mortar between bricks, constructing layers of history as much from walls and pillars as from cracks and dilapidation. Part of the information filtering through his mind is the form and appearance of the buildings, their styles.

There is no such thing as a Shanghai architecture, but as the form that comes nearest to it, the *shikumen* has had 'Haipai' applied to it by Shanghai's writers. Of course it is far from the only style of building to have left a memory. The reason writers have applied 'Haipai' to it but not to the rest of the pre-1949 built environment is perhaps the latter's inescapable foreignness. Yet foreignness is integral to Haipai, and it is because the city was given its character by people from a dozen countries, planners and architects included, that the style evolved.

An observant European staying at the Cathay Hotel in the 1930s would recognize a family likeness somehow between its interiors' decorative details and what was 'in' in his own country, as well as between them and certain other local artefacts – an advertisement, say, or a bolt of patterned silk displayed in a shop window. He would detect an interconnectedness, a pattern, in these things, and he would take that pattern to be the prevailing style in not only Shanghai but where he came from. Buildings and their material fabric embody the style of their age no less than the design of advertisements or printed silk fabric. I said in the prologue that I chose to see Shanghai Style as, among other things, a period style, and architecture, after all, is the memorial any period in history leaves to itself. Yet all urban settings are marked by the coexistence of different styles, different generations of building, and it is not enough simply to

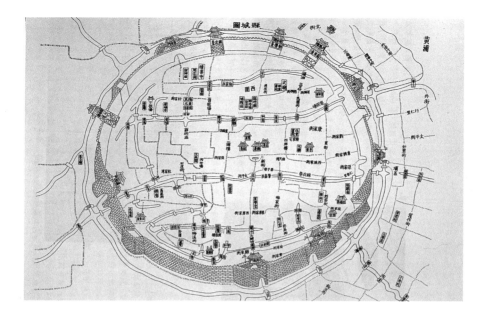

consider only one period, if only because architecture is not produced in an empty space and no structure stands apart from its precursors or its models. To write about the architectural manifestations of Shanghai Style without, again, going back to the beginning would be to look at the foliage of a tree without studying its trunk and roots.

The Shanghai which Captain Balfour found in 1843 was primarily a walled and gated town, but far from being only that. As was particularly noticeable to the east, where it was as hard to avoid the crowds outside the gates as inside, the 'native city,' as many Westerners came to call it, had long outgrown its encircling walls. In what might be called the extramural part of the city, the wholesalers had their warehouses, the craftsmen their workshops, the merchants their guilds, and the seamen their shipyards. There, beyond the walls, the city spilled away down to the Huangpu River in a confusion of streets and lanes and paths, dense, bustling, pungent, until it met the water's edge and the 'forest of innumerable masts' which the missionary

Map of walled and extramural city, Jiaqing period (1796-1820), Qing dynasty.

W.H.Medhurst, Balfour's interpreter, had seen in its harbour on an earlier visit.

Along the wharves, *shachuan*, the seaworthy 'sand junks' that plied the coastal routes to the north of Shanghai, were moored for the shipment of grain, fertilizer, soybeans, tea and cotton, the prime local commodity. Here ships from Singapore, Malacca, Penang, Java, Sumatra, Borneo, Japan, the Indian seas and the Polynesian islands also called. Balfour was not wrong in his belief that Shanghai was destined to become a great emporium for the China trade, even though by 'China trade' he meant sales of British goods in those inland provinces to which the coastal port would serve as a gateway.

This was visibly a city whose first and truest purpose was to be a commercial seaport. Its importance in the domestic trade was already considerable, its volume of shipping at around the time of Balfour's arrival estimated to be equal to or greater than that of contemporary London. Yet to this day people still repeat the cliché that Shanghai was a small fishing village before the British came. Many Western writers certainly portray it that way, from ignorance, perhaps, as much as from a belief that Westerners alone were Fairy Godmother to Shanghai's Cinderella. The starker the contrast between what Shanghai was and what it became, the greater would appear to be the Western role in its expansion.

Although the extramural part of town appeared spacious enough, the walled city proper would have seemed cramped to a European, and one such commentator did indeed think the streets 'narrow, filthy and close to a degree that cannot adequately be conceived of from any description.' We know how narrow they were: not much more than six feet, about a fourth of the width of the roads in the settlement, room enough for sedan chairs to pass, but no other kind of vehicular traffic. Arriving at the gates by carriage, passengers had to stop and transfer to a sedan chair, or else thread their way across the city on foot, through streets made even narrower by the stalls

spreading out along the shop frontages. Not all streets were flagged, and those without paving stones became very muddy in wet weather.

Some streets of the city and extramural section took their names from the clans that lived on them (Lane of the Tang Clan), others from the trades practised on them (Pickled Cucumber Street, named not for the vegetable but the yellow croaker which, because it was in season at the same time, was called 'cucumber' by the Fujianese fishmongers who dealt in it). Some were named for the numerous streams that crisscrossed the area (Baiyang Lane), others for the structures that stood on them (Street of Three Commemorative Arches). Still others suggested auspiciousness or Confucian virtues (Shared Benevolence Compound).

There were several different terms for street and ground space. *Jie* might be translated as 'street,' *long* as 'lane' or 'alley.' *Wan* was a bend in a stream. *Li* was a compound or neighbourhood, *fang* was a ward and *zha* a space beside a paling. This vocabulary and the arrangements it describes were extended to the expanding foreign settlements, indigenizing large swathes of them. The combination of *li* and *long* proved particularly adaptable to residential planning, and as Shanghai grew its building lots came to be filled with *lilong*, or compound-lane housing. As a real estate venture, the *lilong* was a residential development that could be incrementally extended, compound by compound, as the city expanded.

The British built their settlement in a different kind and to a different scale. Like Calcutta, Singapore and a host of other British colonies, Shanghai proved them unrivalled creators of municipalites. Here, on an orthogonal and roughly gridlike plan, they marked out roads and measured lots, shaping the settlement into a long rectangle in which streets running parallel to the waterfront were intersected at right angles by those more or less perpendicular to the river. This layout, eventually to be incrementally extended street by street as fingers of development poked out of the

settlement, recalled the ordered, rational urbanism of European cities. Though it was not guided by any design ideal or theory, the British having (unlike the French) no strong tradition of formal town planning, it was still in considerable contrast to the winding, concentric street pattern of the walled Chinese city.

As the British envisaged their settlement as a trading post, not a colony, they did not lay it out in the grand manner, with authority. There was no civic or architectural display of colonial power, no great boulevard terminating in a triumphal arch or domed structure. Shanghai was no imperial city, but an urban creation of international capitalism. The British who established themselves there were agents of not so much the Pax Britannica as the world's first industrialized nation, and the showiest physical signs of their presence were counting houses and commercial establishments, not High Courts or gubernatorial mansions.

Their settlement was orientated to the river and centred on the Bund, the quay that was the reason the British opened up Shanghai in the first place. There trading houses like Jardine, Matheson; Gibb, Livingston; Russell; and Sassoon and Sons soon raised their mansions. Boxy, two-storeyed, painted white or cream, with hip roofs and arcaded verandahs, these buildings were in the 'compradoric' style. Compradoric architecture was British Palladian or neoclassical style simplified. It was a treaty-port architecture which had earlier reached Canton from British India, one that was better suited to an equatorial Penang or Singapore than to the decidedly untropical Shanghai. All the same, it was the style of the first generation of the Bund's edifices. Exemplified by the 'factories' (merchant companies' foreign trading stations) in Canton, the style was always to be associated with opium.

It was an altogether different aesthetic from the Chinese. The British troops who were earlier glimpsed taking the city more or less unopposed in 1842 had found the City Temple, where they quartered three

Compradoric style of architecture embodied in headquarters of China Merchants Steam Navigation Company. Lithograph by Wu Youru, *Shenjiang shengjing tu*, 1884.

regiments, to be made up of 'many summer and grotto houses separated by arms of the garden pool.' One of the junior officers remarked on the 'fanciful wooden bridges' thrown 'across the arms of the serpentine waters,' and the 'light and aerial-looking' buildings. As the soldiers could not lay their hands on fuel for cooking, they fed their stoves with the temple decorations, carved screens, and the 'exquisite ornaments' they tore down.

If these soldiers entertained any notion of what a Chinese garden might be like before they arrived at the temple, it would have come from a fanciful vision of China, a China of the imagination such as was embodied in the pseudo-Chinese ornamental motifs of chinoiserie. The most likely source of such a notion would have been that well-known example of chinoiserie porcelain, the blue and white 'willow pattern' plate that pictured a Chinese garden of the English imagination. Developed in Shropshire in 1799, the design became widely popular as factory after factory reproduced it.

Encountered in the flesh, the temple garden, as well as those attached to many of the other buildings in the Chinese city, would have seemed to some European eyes crammed with too much outdoor architecture – pavilions, roofed walkways, walls, gates and bridges. The classical Chinese garden was not universally admired by Western travellers, who found it too artful and contrived for their taste. Of its essential features – water, buildings, plants, rock – the last would have most bemused them. Neither of the two forms, the single rock and the agglomerations of rock into artificial mountains, would have found much favour with these foreign observers, nor the connoisseurship which the Chinese moneyed and educated class had evolved around them. One of the most famous single rocks was the so-called Exquisite Jade in the Yu Garden in the Shanghai walled city, which was a cut above all others for its exact fit with the ideal type, a limestone simultaneously crapy, scraggy and holey. The most coveted limestone

Huxinting Teahouse in Old Chinese City, called Willow Pattern Teahouse by Western residents after 'willow pattern' plates whose teahouse depictions it supposedly inspired. Postcard, c.1900.

Chinese rock aesthetic appears to escape Chinese visitors to classical Chinese garden (Yu Yuan) no less than European sightseers, c.1906. Photo by Wilhelm Wilshusen.

Dongjiadu's St Francis Xavier Cathedral, 1847.

specimens, dredged up from Lake Tai to the west of Shanghai, were those which had been wrought or worn into pitted, tortuous and bizarre shapes. Such rocks would have seemed like grotesquerie to many Westerners. The Chinese, on the other hand, had at some moments in their history admired them to the point of 'petromania,' rock craze.

The appearance of a Chinese temple, which was made up of a succession of inward-facing low houses and courtyards, would have posed a marked contrast to the plan of the European church. For example, like others the Europeans erected, the Church of St Francis Xavier, built in 1853 at Dongjiadu, between the walled city and the river, was an outward-facing single structure, in this case a simplified adaptation, by a Spanish Catholic missionary, of an Italian Baroque model. Surmounted by a cross, this could not have had a more different silhouette from a Chinese place of worship, the most striking visual element of which, namely the roof, exhibited a curvature accentuated by upturned eaves at the ends to form sweeping 'swallow's tail' profiles.

From all this it can be seen that in architecture as

in aesthetic traditions, China and the West differed profoundly. Shall the twain meet? And if so by what means and how quickly? In no other place in China were the answers to these questions more visibly inscribed in stone, wood, brick and concrete than the Shanghai of the 1920s and 1930s. But these decades were a culmination: the cultural crossing that climaxed in those years had begun, as we have seen, generations earlier.

If cultural crossing were an essential element of Shanghai Style, then in architecture as in the other areas I cover, what crossed with the indigenous was not just one style but several, the Chinese-European mixing taking a different form, quantitatively and qualitatively, with each change of generation. In about 1910 a visitor would have taken away with him an impression of Shanghai formed chiefly of compradoric architecture, one with which he was familiar, perhaps, from his travels in other ports of the British Empire. But if he thought it the style of Shanghai, he would have had to change his mind only a decade later, when the city underwent astonishing growth and, as G.L.Wilson, of the British architectural firm Palmer & Turner, wrote in *The China Journal* in 1930, 'The skyline in every direction has completely changed... Shanghai today is a new city as compared with the Shanghai of a few years ago.'

The Shanghai held in aspic by communism until its massive redevelopment at the turn of the twentieth-first century was a 1920s and 1930s city. This was a Shanghai flushed with success and self-assurance, a city whose time had come. Take a hundred of its major historic structures today and you will find them dating overwhelmingly to the interwar period.

A place which showcases that layer of Shanghai's stratigraphy is the Bund. Most cities have places of which the visitor can say when he reaches them, 'Now I'm really here.' The Bund is such a place. In the 1910s it was fronted by villa-like buildings more suited to the sweaty settings of colonial possessions like Singapore and Bombay. These

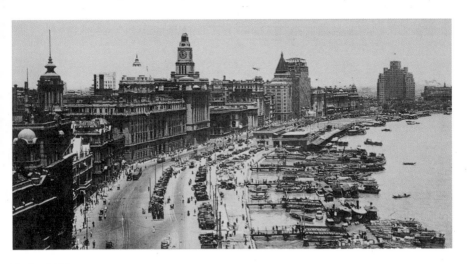

The Bund, 1935.

Hongkong & Shanghai Bank.
Artist's impression, 1930s.

compradoric-style buildings were now no more, and in their place stood structures with the look of Liverpool instead.

The Bund now quite deliberately appeared the sort of place where you would find doors emblazoned with the brass plates of successful trading companies. The Italianate cupolas and colonnaded façades of the solid grey buildings massed along it stand as monuments to the confidence of early capitalism, and of the banks and trading houses that served as its agents. In 1927, when a locally based monthly, *The Far Eastern Review*, declared it 'Shanghai's New Billion-Dollar Skyline,' it was still fairly new. Its grandest edifice, the neoclassical pile of the Hongkong and Shanghai Banking Corporation, the pre-eminent British financial institution in China, had been completed only four years before, replacing the three-storey structure which had earlier housed it. The Chartered Bank, another British institution, was completed in the same year, and the Yokohama Specie Bank a year later. What these buildings enacted in stone was the economic boom Shanghai was at that moment enjoying. That this was 'the golden age of the Chinese bourgeoisie' has been mentioned in an earlier chapter. Anyone visiting Shanghai during that period would find it throwing up buildings at a rate never before

seen in the city. Builders and speculators could do their best and their worst – and did, in a productive convergence of energy and capitalist cupidity.

Boom towns are property developers' dreams, and the Shanghai of the 1920s and 30s was no different. Material prosperity apart, the availability of new materials and sophisticated engineering technologies made it possible to erect taller and more modern buildings. Innovations, in architecture as in other areas, migrate from place to place. By the early 1900s, the modern revolution in architecture had already begun in Europe and America, its practitioners liberated from the past by new building technologies, and by designs exploiting the flexibilities of up-to-date materials like steel and reinforced concrete. These practices became universal; reinforced concrete construction, for example, swept the world within a few decades, and by 1908, Shanghai's first edifice to be built entirely of this material had been erected – the Shanghai Mutual Telephone Company on what is now Jiangxi Lu.

Just as the union of metal skeleton construction with the passenger lift had produced the modern skyscraper in Chicago and New York, so it raised the height of Shanghai's buildings. The Palace Hotel, which opened its doors in 1909 at the corner of the Bund and Nanjing Road, swept its guests up from floor to floor by two Otis lifts – the first building in Shanghai to be so equipped. And just as the invention of the elevator defined the modernity of America, so its transplantation to China defined Shanghai's.

The Palace Hotel was actually not that high, only six storeys, but the construction boom of the succeeding decades saw buildings rise up to more than twenty floors – the Park Hotel on Nanjing Road being, at twenty-four storeys, the tallest and best-known example. Land values having leapt, building taller allowed property developers to squeeze to the utmost the financial possibilities of their sites. A Chinese neologism, *motian dalou*, 'sky-scraping edifice,' came to be used for the city's skyline and, as a visual shorthand

Park Hotel, the tallest building in the Far East when it opened in 1934.

211

for the modern metropolis, became a signifier of the city itself. For contemporary cartoonists, writers and filmmakers, those high-rise buildings had an ambivalent attraction, representative of both glamour and squalor, the apex of the social heap as well as its bottommost layer, a heaven which doubled as hell.

In his article Wilson notes that until the architectural breakthroughs Shanghai architects were like the rest of the world in being 'slaves of what may be termed "Copybook architecture",' partly because, it has to be said in their defence, their clients frequently specified the design when they commissioned their buildings. As the architect of a number of the city's most imposing buildings, including, notably, the Cathay Hotel on the Bund, Wilson was bound to think that things were now different. Yet some of the structures on the Bund would still horrify a purist, being if not exactly 'copybook architecture,' then pattered after the heterogeneous European styles politely termed 'eclectic.' Commentators such as the contributors to *The Far Eastern Review* liked to make stylistic claims for the buildings, telling you at the time of their erection that this one was 'Neo-Grecian' (the Chartered Bank) and that one 'English Renaissance' (the Shanghai Club). We needn't take them as seriously as today's Chinese historians, expecting some classical marvel, for example, from what a commentator said of the Custom House in 1927: 'The entrance portico follows a pure Doric style, the inspiration being taken from the Parthenon at Athens.' In fact, what makes the strongest impression on the viewer is the middle layer's phalanx of verticals, which, with the spacing between them reduced to the width of a single window, suggests a modern office façade.

This eclecticism is encapsulated in another way in the Bank of China Building (1937), a modern skyscraper which would have nothing specifically Chinese about it did its architects not have to make it wear a Chinese hat by surmounting it with a blue Chinese-style

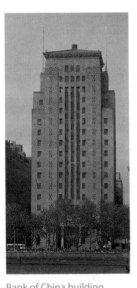

Bank of China building c.1990.

pavilion roof and embellishing the façade with Chinese motifs. Palmer & Turner designed it together with Lu Qianshou, a London-trained Chinese architect perhaps brought in to add the native references insisted upon by the client the Bank of China, never mind their incongruous effect on the end result.

In summary, if the image held of Shanghai by the popular mind had the Bund and the skyscraper in its make-up, it inevitably had eclecticism too, for not only were the architectural styles mixed in themselves, quoting from now this period of European evolution, now that, they were also superficially cross-cultural, incorporating indigenous forms or decoration. All this makes Shanghai's architecture the pastiche that defines Shanghai Style.

That the waterfront was essential to Shanghai's treaty-port character goes without saying; yet it would be to obscure a still more important facet of the city's identity if you were to ignore the compound-lanes, the *lilong* mentioned earlier, where the bulk of the population lived. To the man in the street, Shanghai would not be Shanghai without its swathes of lanes. With the future of these places placed in jeopardy by the firestorm of urban renewal which overtook Shanghai from the 1990s, the lanes have come to seem essential to the historical continuity which its denizens feel their city to be losing. The Chinese, who do not share the view of many preservationists in the West that all new buildings are inferior to all old ones, have been slow to rediscover the charms of rundown bricks and mortar. But they do think of the *lilong* as somehow embodying the spirit and flavour of their city, to judge from the books that have come out about it. One of them, *The Conservation and Renewal of Lilong Housing in Shanghai* by Fan Wenbing (2004), puts it this way: 'Mention *lilong* housing, and people can't help but think of the name "Shanghai." To a certain extent *lilong* has become a symbol of Shanghai: its unique blend of East-West architecture, its high-density yet rich use of space, the disorderly yet intimate living

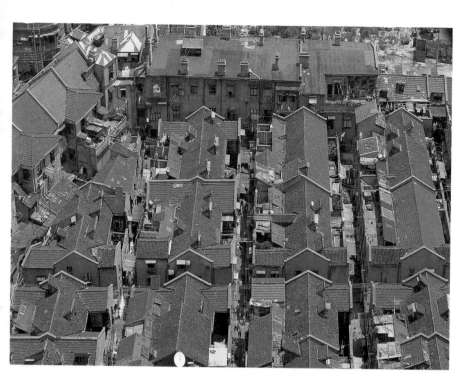

Lilong compound just north of the Suzhou Creek showing lanes and branch lanes, 2003.

A lane in a *lilong* compound, with smaller lanes branching off it, c.1990.

environment it represents, all express the special charm of Haipai.'

It was certainly linked inextricably to Shanghai's immigrant-city persona. The large pool of labour fuelling Shanghai's growth had to be housed, and housed quickly. The expedient which developers hit upon was to run up high-density compound-lane housing. *Lilong* housing was a residential development that could be extended compound by compound as population pressures increased. From the end of the nineteenth century to the 1930s, almost twenty-three million square metres of *lilong* dwellings were built.

In a *lilong* development, an entrance fronting on a street leads into a main lane intersected by branch lanes separating terraces of row housing. The dwellings give on to the branch lanes feeding into the main lane, not on to the street like the English terrace houses (identical houses built adjacent to each other by a developer, in a row sharing common walls and

'Stone-wrapped gate' houses, or *shikumen*, at 30 Chengdu Road. Chinese doors are flanked by pilastered Classical orders, a mix of styles typical of Shanghai.

in a block of uniform style) by which they are said to have been influenced. This gives them the inward, hemmed-in feel of a walled and gated community. Many *lilong* neighbourhoods bear names carved in Chinese characters on the lintel spanning the entrance, and this enhances their enclave feeling. The names might allude to the developers (Lane 291 of Xingfu Road, for example, was named 'Four Friends' for the four developers, Shen, Wu, Gu and Wu) or, much more frequently, include favourite Chinese terms like 'prosperity,' 'honour,' 'virtue' and 'harmony,' prefaced by words like 'ample' and 'eternal.' This last (*yong*, 'eternal') is particularly popular, appearing in the names of no fewer than 365 compounds.

These lane houses were a hybrid, Chinese in that their layout was adapted from the classical courtyard house; and Western in the pilasters or reliefs decorating their entrance. The smallest of these houses had narrow lane frontages, usually only

one room wide. From the lane outside, a simple gate opens to a shallow courtyard or airwell designed to admit light and air, and from this the main front room is entered. The surrounds of these gateways may or may not have inspired the Chinese name for the style of lane housing known as *shikumen*, or 'stone-wrapped gates.' The stone (or cement plaster) lent itself, as brick would not, to mouldings or carved decoration. These are often European designs. The frame was made of native Fuzhou poles or imported Oregon pine. The length of the poles set a limit to the height of the house, usually two storeys if the Fuzhou wood were used, with each floor measuring ten to twelve feet in height. As for the rest of the measurements, the house was generally eleven to twelve feet wide and from twenty to forty feet deep.

Inside, an opening at the far end of the front room leads to a very steep and narrow wooden staircase, and beyond this to the kitchen and sometimes a small backyard. Upstairs is a room similar in size to the main front room below. On top of the kitchen is a small back room roofed over by a flat open space that serves as a deck for clothes-drying. The Chinese name for this back room, *tingzijian*, or 'pavilion space,' came to have the resonance which 'artist's garret' does in the West, for it was frequently sublet to young men, greenhorns newly arrived in the big city with intellectual or artistic horizons far beyond their means. There was scarcely a struggling writer of that generation who didn't at some stage find lodgings in a 'pavilion space.' Small as it was, and dismal, it could be had for a lower rent than other rooms, and it could be made convivial with food, conversation and the camaraderie of friends and fellow-artists or scribblers.

Apartment living, like the skyscraper, is integral to the modern city, and Zhang Ailing, that most Shanghainese of writers, has published an essay celebrating it. Zhang, who has appeared before in these pages, and who has set some of her fiction in lane houses as well as in apartments, herself lived

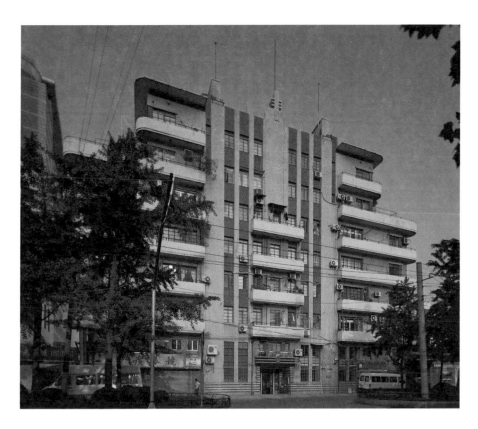

on the fifth floor of a modern block of flats in the International Settlement in the 1940s. Of all the places in which to escape from the world, she says, the apartment is the most ideal, not the country where you can't buy an extra half-catty of charcuterie without people talking. And 'I like city noise,' she says, adding that she can't fall asleep at night unless she hears the tram drive by. Now and then she made out from the floors below her the sounds of spoken German, Russian and Japanese. Such was the polyglot cosmopolitanism of the apartment block that newspapers in these languages, plus English and Chinese, were delivered daily, and distributed to each subscriber by the elevator operator, whose manners were the metropolitan politesse of his breed.

She lived in Eddington House, which was like

Eddington House, one of dozens of apartment blocks erected during Shanghai's building boom (late 1920s to mid-1930s). Photo by Edward Denison.

many apartment blocks dating from the 1930s in being self-consciously modern in style. Today's historians and guidebook writers invariably describe these apartments as Art Deco, but if visitors to Shanghai came expecting exuberant ornamentation – chevrons, sunbursts, maidens, floral patterns, stylized fountains, arcs and other geometric designs – they would be sorely disappointed, for by and large the decorative element is muted or absent.

You couldn't help noticing sunbursts and chevrons at the 1925 Exposition Internationale des Arts Décoratifs. But as architectural embellishments these archetypal Art Deco motifs found few takers in the rest of Europe, and it was in America that they acquired their most enthusiastic following. Not only were the Americans experiencing a building boom just then, but they also lacked a homegrown modernistic style, so they embraced the French designs with alacrity and made them their own. Indeed if there is such a thing as an Art Deco architectural style, it was Americans who developed and defined it, doing so by applying ornament appropriated from Paris to their classical or modernist buildings, in particular to skyscrapers.

The Art Deco vocabulary took such hold that architects did not have to design ornamental friezes, spandrels and entrances to their buildings from scratch, but could have them supplied as stock items by terracotta and bronze manufacturers. One of these, the American Brass Company, is quoted by Alastair Duncan in his book on Art Deco as offering 'limitless possibilities for the creation of original design by utilizing the 2,313 shapes for which dies are maintained.' These, Duncan tells us, were decidedly Parisian shapes.

That it is ornament such as these that defines a building as Art Deco is the view of experts like Duncan, who has written that 'the subject "Art Deco architecture" does not relate to a specific style of 1920s/30s architecture *per se*, but to the distinctive style of modern ornamentation applied to new

American buildings at the time.' This is why to him New York's Empire State Building is not a classic Art Deco structure – its 'Modernist ornamentation' he notes, 'is restrained, even cautious,' unlike the iconic Chrysler Building, whose architecture, he observes, is little different from other commercial buildings of the time but which stands out as an Art Deco classic on account of its exuberant ornamentation, so excitingly symbolic of 'the romance of the period.'

You could similarly say of Shanghai's Cathay Hotel,

Cathay Hotel, hostelry of choice of international café society. Drawing by Palmer & Turner, 1929.

Bronze frieze of whippets on Cathay Hotel window. Note repetition of motif in logo in picture on page 4.

Glazed panels on doors flanking entrance to Cathay Hotel at 20 Dianchi Road. Photo by Catherine Stenzl.

Ornamental details of Cathay Hotel's interior plasterwork. Photo by Er Dongqiang.

a building already glimpsed in the prologue to this book, that while its architecture has the modern look of the 1920s and 30s, its formal inspiration is less obviously Art Deco than its decoration. Raised in 1929 to share its quarters with Sassoon House to a design by G.L.Wilson, in its vertical composition the building conforms to the traditional organization of skyscraper mass into base, shaft and capital (a design rooted in the divisions of the Classical column). The model for this was New York's nineteenth-century elevator building.

What has earned it its Art Deco label is its ornamental detailing. The building has decorative plasterwork displaying stylized natural forms in combination with geometric motifs. A distinctive feature is the exterior and interior metalwork, notably a finely wrought bronze frieze across a window showing a pair of stylized whippets, a motif that appears also as carved stonework at the cornice and plinth, just beneath the green pyramidal roof, as well as in the hotel's logo. Yet styles are fluid things, often too mixed to be defined as such at the time; as has been the case with Art Deco, they are labelled only in hindsight. As is apparent in the pattern of the glass doors flanking the entrance on Dianchi Road, the Cathay's decoration did not escape the influence of Vienna Secession geometry, which is as integral to the Art Nouveau aesthetic as the curvaceous linearity of Paris.

In the main lobby, the walls are of light grey and rose mottled marble, with dove grey marble strips marking the panels, and above the marble are soft-coloured paintings (which have not survived) of imaginary cities in various styles of architecture – 'just fantasies and nothing more,' notes a newspaper in 1929. The pictorial style of the stained-glass windows at the top of the entrance hall is distinctly modern. There are glass panels and light fittings made by Lalique, the French glass manufacturer who had exhibited at the Paris exposition six years before and who was the single most influential source of the link

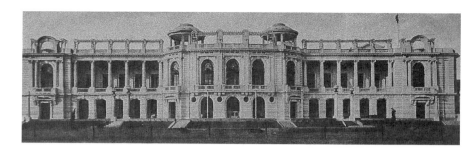

which Art Deco forged between glass and glamour. Lights are housed in metal mounts designed in a spiral pattern that is profusely repeated in the plasterwork decoration. A local with an eye for such things would notice these spirals, and perhaps recall them as having appeared as a design feature elsewhere in Shanghai. If he were a Ding Song or a Ye Qianyu, he'd have used them in his own sketches.

In the Cercle Sportif Français, the French Club that forms part of the Okura Garden Hotel today, architecture can even more clearly be distinguished from decoration. In the club's interior is the closest thing Shanghai has to the rich décors shown at the Paris exposition, the style of which some commentators have dubbed 'high-end' Art Deco to contrast it with the mass-market American variety. Yet this is not what you'd expect from looking at the building's decidedly unmodern exterior, which is given a classical stamp by two colonnaded balconies of Corinthian orders on an upper floor, one to each side of an apsidal front.

But go into what was then the entrance lobby, and you will find the Classicism stripped down in a direction influenced by the Vienna Secession antecedents of Art Deco. Friezes of plasterwork nude reliefs surmount geometric decoration on pilasters and cornices. Geometric and stylized floral motifs pattern a palm jardinière niche faced in gold mosaics. The iron balusters of the staircase are ornamentally coiled in those spirals seen also on the lampshades and wall brackets of the Cathay Hotel. And the modernity of the style is carried through in the furnishings and

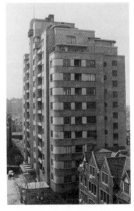

fixtures of the ballroom, restaurant, card-, billiard- and other rooms.

Seeing all this after the club opened in 1926, a contemporary would not hesitate to call it 'modern,' a word he'd use of many of the other buildings designed by its architects, the young Paul Veysseyre and Alexandre Leonard. As is illustrated by the Gascogne (1934), a host of commissions for apartment blocks undertaken by the two Frenchmen show them to be well in touch with the fashionable modern idiom.

The architectural style of the Gascogne Apartments did not develop in France, though, but in midtown Manhattan, where the imagery of the modern metropolis was translated into the jagged skyline and thrusting masonry of the skyscraper. New York zoning laws requiring buildings above a certain height to recede from the vertical to leave more open sky gave rise to the new form of architecture: the setback skyscraper. In Shanghai this architectural form is at its most distinctive in the Broadway Mansions, the twenty-two-storey 1934 apartment-hotel that stands on the far side of the Suzhou Creek like a book-end to the line-up

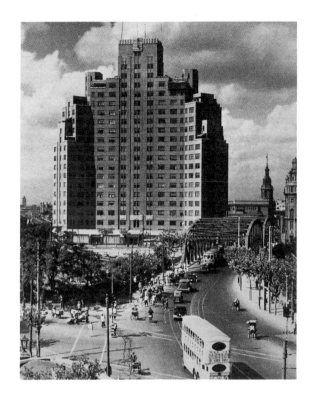

of edifices on the Bund. Three setbacks on the east and west walls step the building up to the roof, while the brown cladding is textured in chevrons, an Art Deco pattern.

Cascading setbacks and a strong verticality also mark the 1935 apartment block once known as Grosvenor House (now part of the complex run by the Jinjiang Hotel), a Palmer & Turner design. The latter's design of the Hongkong and Shanghai Bank might have drawn on the Imperial Baroque style favoured by Edwardian England's public buildings, but this was something out of corporate Manhattan. We know that G.L. Wilson, for one, was susceptible to the appeal of modernism, and we know this as much from his Shanghai projects as from work further afield – his design for the Hongkong and Shanghai Bank headquarters in Hong Kong was praised for being right 'up-to-date, not to say quite a few minutes ahead

Grosvenor House, now part of the Jinjiang Hotel on Maoming Road South, c.2003.

Hamilton House, c.1990.

With its vertical and horizontal emphasis, the Dauphine (*top*), photographed c.2001, contrasts with the high modernism of the Ecole Remi (*bottom*), which is designed on a horizontal plan with the ribbon windows of the International Style.

of the clock' at the time of its opening in 1935. And it was another of Palmer & Turner's commissions that gave to Shanghai the most modernist of all its intersections – the square formed by the junction of Fuzhou and Jiangxi roads and surrounded by the firm's setback tower blocks, namely Hamilton House and the Metropole Hotel, and two other structures. Placed in a semicircle, and experienced not as single, unconnected buildings but as a series of fronts framing the square, the four structures and their main entrances face each other across the intersection. The fact that Hamilton House and the Metropole Hotel were architecturally twinned further helps to make the square seem all of a piece visually.

But even more 'up-to-date' than Palmer & Turner were architects like Veysseyre and Leonard. The latter's design for the Ecole Remi (1933), whose use of lateral recessed windows and spandrels is reminiscent of the factories of Walter Gropius and the Bauhaus school, brought the French architects full circle from the historicism of the French Club, through the stepped form of the Gascogne Apartments and the transitional style of the Dauphine Apartments (1935), to the slab shape and ribbon windows of the International Style.

Similar influences were reflected in the work of another French speaker, a Geneva-born, Zurich-trained architect named René Minutti. The latter was a practitioner of international modernism who had taken to heart Walter Gropius's call for the 'development of modern architecture in the dynamic functional direction, without ornament or mouldings.' Two of his best-known buildings, the Picardie Apartments (1934) and the headquarters of the Messageries Maritimes (1939) on the French Bund, embrace the flat roofs and stepped profile of the setback skyscraper but eschew the lavish ornament of the Art Deco idiom in keeping with the spirit and practice of the Bauhaus. Equally, the bare, stripped look of the interlocking cubes he designed for his own house in the French Concession is a reflection of his susceptibility to international trends. It is as if he said

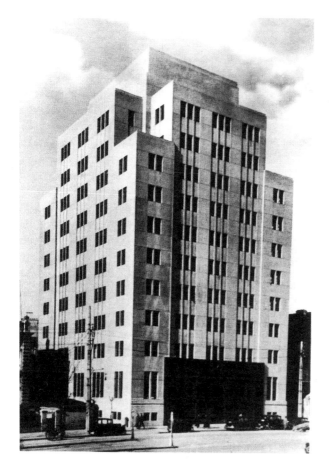

The Picardie, an apartment block at the time of its construction, 1934, is today the Hengshan Picardie Hotel.

Messageries Maritimes building at French end of Bund, 1939.

to himself, a frieze or two is all right in its way, and the spandrels under the eaves of my Savoy Apartments are suitably embellished with plasterwork detailing. But it's been ten years since I raised that building, the world has moved on since 1928, and to add such decoration to a 1939 building like the Messageries Maritimes offices would offend the avant-garde taste for austerity.

In Europe the decorative styles of the 1920s and '30s had largely played out by the eve of World War II, and though the time lag seen in Shanghai's other Western-inspired arts is also apparent in the stylistic affiliations of its architecture, still there is no doubt that the Western

Empire Mansions, 1948, photographed c.1990.

Markets on Seymour Road (*right*) and Fuzhou Road (*below left*), 1930s; and Chengdu Road Police Station, 1930 (*bottom*). Shanghai History Museum.

trends followed by the buildings had changed. For example, the vintage of the Empire Mansions, which was not completed until 1948, is apparent in the horizontal emphasis of its long continuous spans of windows and such other hallmarks of the International Style (a starker and more radical modernism) as the absence of surface decoration and corner windows where glass meets glass. Although some Art Deco elements linger, this postwar apartment block's commitment to that style seems half-hearted – not surprisingly given the latter's demise in Europe.

The International Style pioneer, Le Corbusier, was clearly the inspiration for the indoor market raised by the Municipal Council at the corner of Seymour Road and Shaanxi Road North. This came remarkably close to realizing Le Corbusier's vision of a building raised on stilts, with a free façade and horizontal ribbon windows. Its geometrical purity would have pleased him, but proved insufficient to save it from demolition in the course of the city's redevelopment. Windows running from one end of the façade to the other, as well as the independence of the columns and floor slab from walls and partitions, are seen also in the Fuzhou Road Market, which still stands at the time of writing, but altered beyond recognition. The rounded corners of these buildings contrast with the sharpness of those in the Chengdu Road Police Station, knife-edged and clean-cut like something designed by the Bauhaus's Walter Gropius.

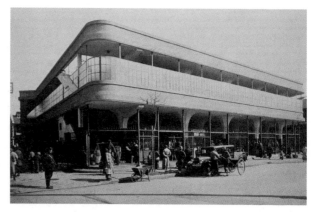

Another changing trend to influence Shanghai was the emergence of 'streamline moderne' in America. If the strong verticality and stepped form of the setback skyscraper belong chiefly to the 1920s, the rounded corners, porthole windows, curved parapets and horizontality of the streamline style became popular there in the 1930s. But while the streamlined style in America was a scaling-back of the lavishly decorative strain of Art Deco, and was expressive of a time of intensified commercial competition (brought on by the stock market crash of 1929) and an increased need for new designs to impart more glamour to the mass-produced and mass-marketed goods and services on offer (notably those of the automobile industry), in Shanghai it did not so signify. Here it was a case of the architect and his client being affected by the winds of change, and of keeping up with fashion.

Residence of Rong Desheng, built 1939. Photo, 2001.

The styles of Shanghai's grander homes varied according to the taste of the individual patron, the choices (not least of architect) available to him and the fashions of the day. Not surprisingly, the patrons of the clutch of streamline moderne villas in Shanghai were the well-heeled. To name just three, they were the captains of industry Rong Desheng, whose family's business empire comprised flour and cotton mills; Guo Dihuo, whose family owned the Wing On Department Store as well as cotton mills; and Wu Tongwen, a dyeing works magnate. Guo's house (on Huashan Road) has streamline moderne features (asymetricality, half-circular drum with bands of glass bricks enclosing the stairwell), but it doesn't seem fully committed to that style, perhaps because it was not built until 1948, by which late date the style had lost its appeal in the West. Inside, one is reminded of the Shanghainese weakness for pastiche on seeing the mismatch in style between the modernistic glass-bricked stairwell on the one hand, and the iron balustrade in the flower and leaf scroll design of an older day on the other. Nor would a purist feel altogether comfortable in Wu Tongwen's house. A Chinese architectural historian, Yang Bingde, has remarked on the room

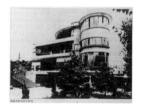

Wu Tongwen's villa, 1930s.

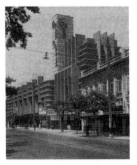

Grand Theatre, 1933.

Wu had set aside for ancestor worship there, finding it as incongruous as the ornate Chinese furnishings: the modernism of the architecture masks the traditionalism of the owner, whose aspirations after modernity, Yang reckons, were merely superficial.

The designer of Wu's green mosaic-clad take on streamline moderne was Ladislaus Hudec, a Budapest-trained architect whose string of commissions has left Shanghai with many of its most distinctive buildings. He is perhaps best remembered for his design of the Park Hotel, but one of the most beguiling of Shanghai's many frissons was watching a Hollywood extravaganza with fabulous Art Deco sets in Hudec's Grand Theatre (Daguangming), built in 1933 for the period's dominant mass-entertainment medium. From the foyer, this movie palace swept its patrons up an immensely wide double staircase to take their places among the 2,000 upholstered seats, all equipped with headphones for simultaneous translation. An illuminated tower of frosted glass, mirrors and a brightly lit indoor fountain combined to produce the glossy, lustrous quality so central to Hollywood's appeal, an appeal which the screen images circulated worldwide.

Contrasting with the rectilinear look of Hudec's cinema, the Majestic Theatre has a rounded façade, as might be expected of a 1941 building. The clean lines of its balconies' sweeping curves reflect the fact

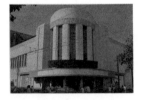

Robert Fan's Majestic Theatre (*top*). From Sang Ronglin, *Shanghai jianzhu fengmao*, Shanghai, 1992. Foyer with sweeping staircase. Photo by Er Dongqiang, 1993.

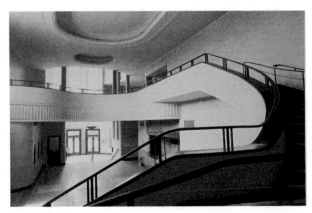

that streamlined forms now defined the architectural expression of modernity. The cinema was designed by Robert Fan (Fan Wenzhao), one of a crop of Chinese architects to graduate from the University of Pennsylvania in America.

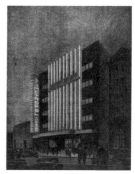

Artist's impression of the Metropol. From *The Builder*, vol 1, no 3, 1933.

With their lighting and painted hoardings, the movie houses made for a sense of spectacle, an excitement that was part of the folklore of glitz and glamour the Shanghai of the time generated, along with the allure of jazz bands, cabarets and dance halls. One such was the Metropol Theatre, a cinema built in 1933 to a modernistic design by Zhao Shen and Chen Zhi, two University of Pennsylvania graduates with their own firm, Allied Architects, in Shanghai. Illumination by eight long verticals of neon lighting across its façade dramatically transformed the cinema by night into a shimmering spectacle worthy of the Hollywood movies it showed and the dreams they purveyed. The imagery was potent, as contemporary published photographs of the lighting attest.

Streamline moderne was the architecture of commerce and pleasure, and so was a fitting stylistic choice for the construction of a fashionable nightclub like Ciro's, whose name you could see from a great distance modishly spelt out in Broadway, the Art Deco typeface. The foxtrot and jitterbug just had to be danced in a modern setting. And going dancing would not be the *modeng* experience it was, nor the trope it became in the new writing and cinema, if it didn't come with all the trappings – modern décor, wine glasses, white tablecloths and, not least, the atmosphere of sexual promise.

All this was epitomized in the Paramount dance hall (1932), one of the enduring symbols of the interwar decades, shorthand for the city's newness and its inviting corruptions. Its Chinese architect, Yang Xiliu, no doubt meant the building's glass tower and streamline moderne façade to suggest not only the technically advanced facilities and the fashionable furnishings to be found within, but also the modern pleasures to be had there. As many as a thousand

Entrance of Paramount dance hall, 1930s.

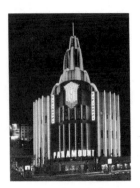

Paramount dance hall at time of opening in 1932 (*right*) and c. 2003 (*above*).

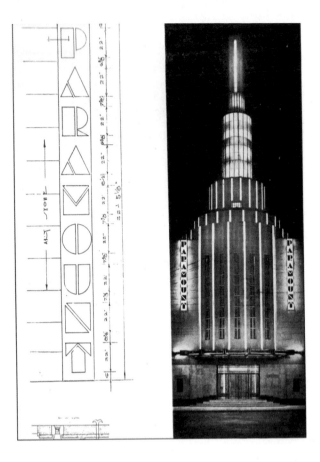

dancers could take to the floor at once, as the jazz band struck up and whirring air-conditioners cooled temperatures to a comfortable 20 degrees C.

The Paramount catered not to high society, which wouldn't have found it exclusive or elegant enough, but to the thousands who were uncritically enthusiastic for whatever was new. It crystallized the age, letting you know by its architecture, details and effects the moment you stepped inside its doors that you were in a 1930s space.

Yang had trained in China, but many of the Chinese architects working in Shanghai at the time had studied architecture or civil engineering in universities in the US and Europe, from where they

had started coming home in 1921. Of all Chinese cities Shanghai had the largest number of foreign-trained architects – forty-one out of the fifty-five members of the Chinese Society of Architects in 1933. This matched the dominance the city had acquired in commerce, banking, communications and, of course, most forms of cultural activity. Some of these architects began to experiment with a 'Chinese Renaissance' style that sought to combine traditional Chinese forms with up-to-date reinforced concrete technologies.

The Chinese Renaissance style was controversial, and was nicknamed 'pigtail architecture' by one critic, the Philadelphia-trained architect Chuin Tung (Tong Jun), who observed in 1937 that the antiquated Chinese temple roof borrowed to cover a modern building looked 'not unlike the burdensome and superfluous pigtail' once worn by male Chinese. The flat roof of the modern building had come to stay, he added, while the temple roof had definitely had its day. Classical Chinese architecture, he went on to say, 'has nothing to offer to the modern building except surface ornamentation, and as the enduring and sublime qualities in architecture rest on structural values alone, it requires little imagination to foresee the rapid and universal adoption of the international (or modernistic) style in steel and concrete.' Since a building's plan was 'a logical and scientific arrangement of rooms according to the most up-to-date knowledge available,' he said, the façade, a product of the plan, should naturally 'be nothing but modernistic,' while any attempt to give a building local colour should do so for structural rather than merely ornamental reasons.

Chinese architects who studied with Walter Gropius, of course, were all for modernism, but these only started returning to China in 1945, not long before civil war and revolution curtailed all opportunities for building. Writing in 1930, G.L. Wilson observes that very few buildings of 'modern design' had appeared in Shanghai, 'and it is doubtful whether the extreme

modernism' of Le Corbusier, 'for instance, will find much favour with Shanghai residents.' In fact, had he consulted the opinion of Shanghai's Chinese residents, he might have thought differently, because there had been Chinese enthusiasm for Le Corbusier's ideas from as early as 1920. An article which appeared that year in *Shenbao*, the leading Chinese newspaper, raved about Le Corbusier's suggestions for an ideal city of the future, praising his book about it as being of the 'highest value' and eminently 'worthy of our attention.' Le Corbusier's scheme for how three million men might inhabit a modern metropolis proposes to increase density by building widely spaced highrise towers, which would give back the land area they have saved to ponds and lush greenery, thereby enabling ordinary people to live with air, light and foliage. The article relates all this with approval, using 'cloud-reaching buildings' as the Chinese term for what would later be called *motian dalou*, 'sky-scraping edifices.'

Returned students revealed their Beaux Arts training in their earlier work in Shanghai, but sooner or later showed themselves to be moving with the times by designing modernist buildings. Within a matter of a few years, for example, Zhuang Jun, who had studied at Illinois and Columbia University, abandoned neoclassicism for modernism, using Art Deco detailing in his Continental Emporium Building (1932) on Nanjing Road East and the International Style for his Sun Keji Obstetrics Hospital (1935). At the same time he went into print to call for 'a modern architecture that can be popularized and is functional.'

Robert Fan was a late convert to modernism, as is evident from the neoclassicism of the Nanking Theatre, a cinema he had designed in 1928, much earlier than the Majestic. Fan had also been one of those American-trained Chinese architects who had thought to combine Chinese elements with Western ones in what has been called 'pigtail architecture.' However, he later decried those earlier efforts in no uncertain terms, repudiating them utterly and

Robert Fan (1893-1979).

committing himself wholeheartedly to modernism instead, a commitment reinforced by a six-month journey he made to Europe in 1935.

The name of another returned architecture student from the US, Dong Dayou, will forever be linked to the Nationalist government's plans for Greater Shanghai, a new town to be built beyond the purlieus of the International Settlement, and to the Chinese Renaissance buildings he placed there – the civic centre; library; museum, and a sports complex comprising stadium, gymnasium and swimming pool. It was no doubt incumbent on Dong, who had won the competition to design these Nationalist public edifices, to make them look Chinese, and if the civic centre recalls a Chinese palace of the imperial age, it was no doubt meant to, though one wonders if he wouldn't have repudiated 'pigtail architecture' if nationalist *amour propre* hadn't been involved. His design for his own house is certainly uncompromisingly modernist, making us wonder if he wasn't a reluctant follower of the Chinese Renaissance style.

Dong Dayou (1899-1973).

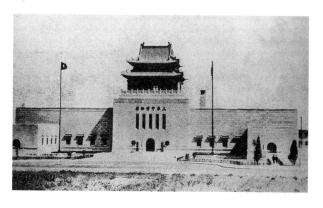

Library designed by Dong Dayou for Greater Shanghai, 1936.

Fan and Zhuang Jun were prime movers in the establishment of a learned architectural society in Shanghai. Later Chinese contractors in Shanghai organized themselves into an association too, the Shanghai Builders' Association; and, like the architectural society, put out a journal. This, the

233

monthly periodical *The Builder*, mirrors in its graphics and language the rapid stylistic shift from old to new that architecture and construction were undergoing as a whole. It looked to various Western sources, especially the US, and while it did not entirely neglect Chinese tradition, it did not assert it with any insistence until, abruptly and dramatically, the Japanese attack in 1937 brought out the nationalist in every class of Chinese. In the periodical's cover graphics, the modernist and cosmopolitan became the traditionalist and nativist with a speed that is nothing short of astonishing.

Whatever its source and inspiration, whether European or Chinese, the physical fabric of the city is a historically constituted ensemble of disparate elements that separately or together call up 'Shanghai.' If 'skyscraper' is a shorthand for the city, then so is *'shikumen,'* just as the modernism of its apartment blocks signifies the city as much as the period styles of the Bund. The physical fabric is moreover inextricably linked to the imaginary space of the city – that is, to the way it exists in the minds of its inhabitants and visitors, and in the varied media that shape their experience. It is a means of access to past tastes and to the changes which these have undergone: no more than other types of cultural production can architecture escape its times. The structures I have named in this chapter speak of an age, a period of energetic building in which, as we have seen, much other cultural activity unfolded. This activity was not only particularly urban but inconceivable beyond the frontiers of the modern metropolis. And only Shanghai was that, among Chinese cities. It was certainly there that broader international movements and tendencies such as modernism had their greatest impact.

Houses and flats dating from pre-1949 have nowadays become highly desirable properties, especially among the city's foreign community. To make them more comfortable and better suited

to present-day living, their new owners modernize them to a greater or lesser degree, putting in new bathrooms and kitchens, for example, but leaving the floors and windows as they were. Some have gone to great lengths to 'restore' the interiors to their original style, sourcing fixtures like period lighting from the flea markets and old ironwork from the salvage yards, or replacing windows in bad repair with made-to-measure reproduction ones.

Inspecting these artefacts, one is reinforced in one's belief that the way things look is, in the broadest sense, a result of the conditions of their making: a design or style may not prevail if the article embodying it is not easily available in the shops or if it doesn't maximize profit for the manufacturer. Take Crittall metal windows, a feature of the majority of the houses and apartments of the interwar period. Such windows were imported into Shanghai from the original manufacturers in England in increasing quantities in the 1910s and 1920s, their value reaching 1.5 million taels in 1921-22. This prompted a Tang Jingxian of the China United Engineering Corporation (Taikang in Chinese), which happened to be the sole agents for the Truscon Steel Company (of the US), to look into the possibility of manufacturing them locally. He did so successfully, and managed to sell his windows at a price competitive enough to deal a serious blow to the foreign imports. Other Chinese firms followed his example, notably the Asia Steel Sash Company and China Metal Works, and by the early 1930s the market had expanded to 3 million taels annually, with domestic manufacturers winning 70 to 80 per cent of the market in five years. To remain competitive, Crittall set up a plant in Shanghai, offering what it claimed (in its advertisements in *The Builder*, for example) were unbeatably low prices, prices called for by 'this age of commercial warfare.'

Notions of what was proper and therefore tasteful no doubt shaped the choice of décor of many middle-class homes in Shanghai, but an American lumber and shipping firm, the Robert Dollar Co., had much to do with the fitting-out too. Born a Scot but settled in the

Crittall window on the Midget, a 1931 apartment block on Wukang Road.

US, Robert Dollar had founded the Dollar Steamship Company to ship his sawmills' products along the Pacific coast and presently to Asia, where the vessels' black and red funnels, with their white dollar sign, became a familiar sight and where the Dollar Line's round-the-world liners regularly called in the 1930s. The Oregon pine and Philippine lauan (a timber also named Philippine mahogany or meranti) imported into Shanghai by the Robert Dollar Co. were to cover the floors of an overwhelming majority of homes in the city. In the words of the company's own advertisements in *The Builder*, the parquet and planks it manufactured could be used 'for all purposes where a hygienic floor is required.' Philippine lauan was half the price of teak and was therefore used widely, so much so that it became synonymous with flooring, while pine was even cheaper.

Not a few of the floors would have been laid by the American Floor Construction Co., which offered 'new floors designed in modern style' in 'all classes of hardwood' and whose list of satisfied customers included the Grand Theatre, the Hamilton Building, the Shanghai Club, the Country Club and a number of notable Shanghai residents, one of them Chiang Kai-shek. In choosing wooden floors over fitted carpets, the foreign model would seem to be America rather than Britain, where wall-to-wall carpeting was more common, though there is no knowing if the

Terrazzo-covered staircase in the Midget, a 1931 apartment block on Wukang Road.

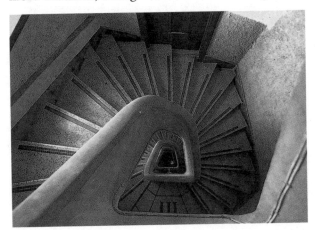

236

story would have turned out differently if Wilton or Axminster Carpets had entered the China market as aggressively as Robert Dollar.

As can still be seen today in the lobbies of Shanghai's prewar apartment blocks and public buildings, another popular flooring material was terrazzo, the 'concrete mosaic' that is made by embedding marble chips in a cement medium, then grinding and polishing the surface to a smooth sheen. Terrazzo floors would have been thought modern in the 1930s, and this is borne out by the modernistic, frequently geometric designs chosen to embellish them.

Another feature of Shanghai's home was the ironwork in banisters; gates; grating; and balcony, door and window grilles. The leading manufacturer of this was Soy Chong (Ruichang in Pinyin romanization), a specialist in bronze, brass, iron, steel and other metal fixtures. One of Soy Chong's more notable projects was the making of steel doors, light canopies and wrought ironwork for the Park Hotel, where little of the interior décor survives today apart from the fourteenth-floor parquetry and the iron railing Soy Chong made for the staircase. The railing was done to a modernistic, geometric design to match the style of Ladislaus Hudec's building. Metalworking, particularly bronze casting, is an old Chinese métier, and Soy

Metalwork on entrance gates of Shanghai Electric Company, today East China Electric Power Administration, at corner of Nanjing Road East and Jiangxi Road Central. Photos by Catherine Stenzl, 2007.

Grille on door panel of lane house. Photo by Patrick Cranley, 2006.

Chong exemplifies the interfusion of a Chinese craft tradition with the new foreign forms favoured by the market. Similarly, instead of calling upon traditional Chinese decorative motifs, the grillework that is everywhere to be found covering small glass panels in the front doors of Shanghai's prewar houses and apartments comes in modern geometrical patterns. Spencer Dodington, a Shanghai-based American restorer of interwar houses, has studied these grilles and reports that he has yet to find a single design repeated.

The impulse to be modern in the industrial, applied and decorative arts was far from universal but it was general enough for there to have been calls by the periodical press to integrate everyday material life with a new aesthetic. For the old Chinese craft tradition to move with the times, the artisan had to turn designer. The notion of 'design' had to have a new Chinese word for it, one that the Japanese were the first to translate from the English. The neologism, *tu'an*, was soon adopted by the Chinese, and employed to mean an applied art which tackles form, model and colour aesthetically. Japan's approach was a revelation to the Chinese educators who went there to study how design was taught and regarded by the Japanese. A report published in 1920 expressed amazement at the interest the Japanese

showed in things Chinese, down to the calendar advertising poster, which the Chinese themselves took completely for granted and for the most part ignored. To think that the Japanese would want to frame and display such crude and unconsidered things, exclaims the reporter!

In China there had been no mass production of household items, let alone any dissatisfaction with it, to provoke a return to honest, anti-industrial hand-making methods, nor new technological advances to be eagerly exploited by avant-garde designers. So strong remained the handicraft tradition that no Arts and Crafts Movement advocating small workshop practice over mass manufacture could have emerged there. If any reform ideas were in the air in Shanghai, they were aimed at elevating the status of the artisan and at modernizing craftwork to meet the needs of modern living. Among other things, modernizing craftwork, according to the art educators who urged it, meant using drawings and designs more frequently than the artisanal rule of thumb.

Here, as elsewhere, Western forms and material culture provided a guide. Exactly when the Shanghai-nese started to produce Western-style furniture for domestic use cannot be fixed with precision. The first Chinese to make European-style furnishings on a large scale were not Shanghainese but Cantonese, those coastal people whose port became the hub of China's export industry in the mid-eighteenth century. Chinese craftsmen there made 'trade' ceramics, silks, furniture and other luxuries to meet the varying requirements of far-flung markets in Europe, the Middle East and Asia, producing goods in a wide range of export styles that were adapted to Chinese materials and skills on the one hand, and to foreign taste and 'buyer-supplied' designs on the other.

Chinese copying or interpretation of European prototypes was not always exact, however, resulting in products somewhat Chinese in feeling; or else it couldn't help but allow Chinese decorative motifs (a dragon's mask, for instance) to creep in, giving to

the supposedly European-style item recognizably Chinese detailing. In other cases, the craftsmen very faithfully followed the stylistic trends in Europe and America. In the words of Matthew Turner, who wrote the catalogue to the exhibition *Made in Hong Kong: A History of Export Design in Hong Kong 1900-1960*, which was held at the Hong Kong Museum of History in 1988, 'The epitome of mimicry was reached when fanciful Western chinoiserie designs were self-consciously copied by Chinese artists for European markets.'

In his book *The Decorative Arts of the China Trade*, Carl Crossman notes how closely certain pieces he has studied correspond to Chippendale's *Design Book* and wonders if the Chinese cabinetmaker was working from the illustrations and measurements of such books rather than from an actual piece of furniture. Chippendale apart, Canton-made furniture came in a variety of European styles, including Adamesque, Queen Anne, Georgian and Victorian. This last would have been the style of furnishings found in the Western homes and trading houses of the mid- and late 1880s in Shanghai, an example being the mansion of the American merchant Abiel Abbot Low behind the Bund. The Low house was full of furniture produced by Chinese cabinetmakers that would have been thought the last word in Victorian fashion had it not been so obviously influenced by native Chinese tradition.

Western-style furniture found its way into Chinese

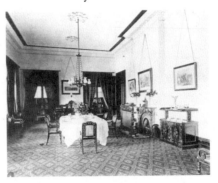

Drawing room of Abiel Abbot Low's house in Shanghai, 1880s. From Carl L.Crossman, *The Decorative Arts of the China Trade*, Woodbridge, Suffolk: Antique Collectors' Club, 1991. Photo courtesy Peabody Essex Museum.

homes and establishments too. As the first generation of Chinese entrepreneurs to succeed in business with Westerners, compradors acquired Western tastes in interiors, or at least liked to appear to have done so. The turn-of-the-century drawing room in the Shanghai home of one such Chinese, the banker Yu Xiaqing, looked like something out of Victorian England. Ceilings are coffered and corniced, doors are pedimented and bracketed, walls are wainscoted and skirted, while chairs are upholstered and fringed. The chandeliers look as though they could have come from the shop depicted in Wu Youru's lithograph and reproduced in the first chapter of this book (see page 31). Even the display of Chinese porcelain seems fitting, such displays (the 'trade' ceramics mentioned earlier) being characteristic of many contemporary English interiors.

Native and imported styles coexisted freely in Chinese interiors, and though otherwise thoroughly Chinese, many of the décors depicted by Wu Youru and other painters would feature one or more items of Western-style furniture. This could be a framed picture, a mirror hung on a wall, a tripod table or

Depiction of room where courtesan (with maid) receives patron in pictorial daily *Tuhua ribao*, no 54, 1909. Note Western-style furniture and ornaments: round pedestal table with tablecloth, Western-style dining chairs, uncurtained iron bed, settee, artificial flowers in Victorian glass dome, framed mirror on wall.

Planter's chair in Wu Youru's lithograph, late nineteenth century, and (*top*) Ding Song's drawing in *Shanghai shizhuang tu yong (Shanghai Women's Fashion in Illustrations and Verse)*, c.1915.

some chairs of Western design with, say, baluster-turned front legs and sabre back legs. It could also be a pedestal table – not part of Chinese tradition, but domesticated and even, in some cases, gone thoroughly native, with Chinese detailing such as carved cloud decoration added to the central support. Of course we can't be sure that such detailing were drawn from life, but Chinese naturalization of foreign-style furniture in the late nineteenth and early twentieth centuries is not in any doubt.

In one of Wu Youru's pictures, a woman sits back in a planter's chair while she plays an accordian, the chair appearing all the more unusual for the completely Chinese furniture featured in the rest of the picture. A planter's chair is one of a number of Western-style chairs drawn by Ding Song, the Early Haipai illustrator, in his *Shanghai Women's Fashion Book* (1915). A girl lounges, indeed drapes herself over it, in a posture that would have appeared unseemly, even disgracefully lax, to an earlier generation of Chinese. In fact the comportment of all the girls shown seated in Western-style chairs exhibits a greater degree of relaxation than would have been judged suitable. A change in furniture results in concomitant changes in posture.

One imagines the Shanghainese taking to Western chairs with cheerful readiness, the native variety was so penitentially uncomfortable. The American writer Emily Hahn, for one, has bewailed this, writing in *China To Me* (1944), 'How, how, how can they have gone all these thousands of years sitting on stiff, slippery, shallow, spindly chairs? When I look at loving drawings of the ancient gardens of Soochow [Suzhou] my bottom recalls the cold, inadequate comfort of those keglike porcelain stools where the sages sit while they regale their souls with the deliberate symmetry of nature. Even when the Chinese try to make decent chairs they can't do it. I have been in many a foreign-style house with knives and forks at dinner, and framed oil paintings, and Axminster carpets. In vain: there is always something wrong with the chairs. The overstuffed ones are imitation and are

too short, so that when you lean back there is nowhere for your head and neck.'

Of course Chinese bodies are smaller than European ones and so require shallower seats, but getting the proportions right could not have been easy for carpenters who would not themselves have had such furniture in their own homes. While eating their dinner they would have sat on 'keglike' stools. Indeed, most Chinese would have done so. In some cases such stools would have their seats padded and covered like the two drawn by Ding Song's 1918 picture of a girl reading (see illustration). The room in which she does so is seen to be furnished with a sofa whose seat seems too shallow even for a Chinese.

When they sat on stuffed chairs the Chinese were following Western precedent, as they were

Covered stools in Ding Song's drawing in *Collection of a Hundred Beauties,* 1918. Note half-seen sofa to right. From reprint *Minguo fengqing baimeitu,* Beijing, 2004.

when lying or sleeping on spring mattresses. These were acquired habits, adopted with the importation, diffusion and domestication of the foreign goods on which they depended. To this day, the Shanghainese word for 'mattress' is *ximengsi* ('seat for dreams and thoughts'), actually a transliteration of Simmons, the American mattress manufacturer. And the Chinese word for 'sofa,' also a transliteration, must have been coined in Shanghai because it only sounds like 'sofa'

(*Left*) Iron bedstead in Ding Song's *Collection of a Hundred Beauties*, 1918. Numerous other visual examples, newspaper advertisements included, exist. From *Minguo fengqing baimeitu*, reprint, Beijing, 2004.

(*Right*) Shanghai homes had chests of drawers like the one depicted by Wang Yuezhi (1894-1937) in his oil painting, 1921-23. Made in China but European in style, their kind may be found in antique shops in today's Shanghai. From Su Lin, *20 shiji Zhongguo youhua tu ku*, Nanning, 2001.

if pronounced in the Shanghainese dialect and not in Mandarin.

Shanghainese took also to iron bedsteads, which the Victorians had considered more hygienic, being less hospitable to bedbugs than wooden ones, as well as to dressers, wardrobes and desks, all of which they became adept at making. Alongside examples of the modern European taste of the interwar period, tables, chairs, chests of drawers and other items of furniture representing Chinese interpretations of Victorian styles turn up periodically in the local antique shops and are collected by today's Shanghainese. The latter regard their pieces as Shanghai memorabilia – not without reason since 'Shanghai' in this case could mean something that integrates local skills, tastes and treaty-port heritage. These pieces would have been seen in interiors in Western and Chinese homes (in the latter alongside Chinese-style furniture), hotels, restaurants and offices.

The domestication of these and other foreign goods was facilitated by the longstanding tradition of manufacturing things to European 'buyer-supplied' designs. Of these designs, Chippendale has already been mentioned, but many other Western models found their way to Shanghai, including, for example, Charles Rennie Mackintosh, arguably the most original

architect-designer working in Britain in the first years of the twentieth century. Though his earlier work was within the Arts and Crafts tradition, his later designs were entirely his own. It so happened that Annie McColl, the first ever female student of the Glasgow Art School in Scotland, came to live in Shanghai in 1909 when her husband, Donald McColl, was appointed General Manager of the Shanghai Tramways. She designed furniture and other items in the style of Charles Rennie Mackintosh and then had them made by local craftsmen in Shanghai. Although this could have been an isolated instance without consequence, and so far as we know the craftsmen who produced the furniture for Annie McColl did not start turning out copies for sale to the local populace, it is nevertheless the case that 'buyer-supplied' designs played a part in the adoption of Western taste, an element of Shanghai Style. China had the craft base, the labour and a large enough population for foreign goods to be copied and mass-manufactured locally. This sets it apart from other places of the world, where foreign material culture was imported for consumption by the moneyed few.

The Chinese consumer's taste for Western designs was shaped and influenced by books, magazines and the cinema. One who urged his fellow-countrymen

to be modern was Zhang Guangyu, the commercial artist and cartoonist familiar to us from earlier chapters. Never, never, he urges them in a small book he published in 1932 called *Modern Applied Arts*, feel complacent, for it is the hankering for the new that is the true mark of modern man. Look at the astonishing changes that have taken place in Europe since the First World War; and at the ingenuity of the conception behind its architecture and furniture. It is from Berlin, Paris and Vienna that the new trends in the applied arts are emerging, he continues, and it is to Europe, rather than to the fanatically fashion-conscious America, that you should be in thrall. His book, Zhang says, aims to introduce the reader to some examples, there being none among those handed down from the Chinese past that is not mere 'skeleton-like wreckage.'

Just then the West had a taste for clean lines, functionality and the 'pictorial' values of unornamented surfaces. With the fashion for lacquer, ebony and richly grained woods went a tendency for simplifying the forms and design of furniture that would become more marked with time. The names

Zhang lists are all famous exponents of this aesthetic: Le Corbusier; Walter Gropius and the Bauhaus school; Josef Hoffmann, the Austrian founder of the arts and crafts workshop Wiener Werkstätte and the most inspired, surely, of the practitioners of the new style; Maurice Dufrène, the artistic director of the design studio of the Parisian department store, Les Galleries Lafayette; Norman Bel Geddes, whose design of a 'skyscraper' cocktail set with a 'Manhattan' service tray is justly celebrated; Marcel Breuer, who gave the world the tubular steel chair; Suzanne Guiguichon, who designed modernist rugs and carpets; Serge Chermayeff, the Russian émigré designer for the British furniture maker Waring & Gillow; Robert Mallet-Stevens and René Herbst, the French modernist designers; and so on. Among the illustrations he put in his book are pictures of four Art Deco doors in the New York apartment of the American film star Gloria Swanson. Of lacquered ebony, each is opulently painted in gold and vermillion with the figure of a knight clothed in fabrics of zigzag, curlicue, chevron and peacock eye patterns.

Notable among magazines promoting furniture design and foreign-style home décor was the interwar periodical *Arts & Life*, in a November 1934 issue of which, for example, readers are given instructions, down to the dimensions and species of timber (Russian pine), on how to make a sofa, armchair, side table, magazine rack and cabinet. Emily Hahn would have

Instructional diagrams for making sofa, armchair and other furniture. From *Arts & Life (Meishu shenghuo)*, Nov 1934.

found fault with the depth of the sofa and armchair, which suited only the shape of Chinese bodies, but she would definitely have welcomed the comfort afforded by the upholstery.

The furniture featured in the pages of *Arts & Life* is of modern design, the trim lines and unadored geometric shapes of which are in keeping with the modernism that was then fashionable in the West. The style was what the Shanghainese settled for when they aspired to up-to-date interior décor. One item they might own was the chrome-plated metal chair; the prototype for this, probably the best known of the products of the Bauhaus workshops that had pioneered the use of tubular steel for the construction of armchairs, was an icon of modernism.

Dahua's advertisement for chrome-plated metal furniture, 1930s.

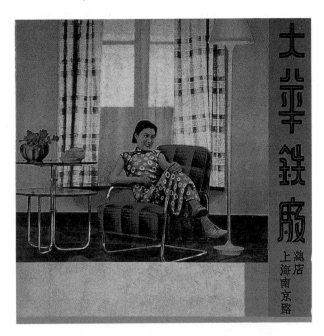

That Shanghai's homeowners and consumers should aspire to modernity in their domestic arrangements and in the accoutrements of everyday life was also enjoined by the *Young Companion*, which ran articles and illustrations on 'the latest styles'

in interior decoration and fittings, some of them showing Western and Japanese designs and others indigenous Chinese ones. It is often the avant-garde designer's disillusioning discovery that the world is not ready for his new creations, nor for a radical change in public taste. As against that, however, there was the Shanghainese weakness for novelty and fashion. To be in step with the times was always a Shanghai brag, and the word *modeng* had so much cachet in Shanghai that few copywriters could resist using it, attaching it in advertisements to even cookers, lamps and geysers (as 1930s advertisements of the Shanghai Electric Company show). In the advertising copy of Studio d'Art, a Chinese interior decorating company of the early 1930s, *modeng* is collocated with 'Parisian,' 'novel' and 'intriguingly strange.'

With its power to persuade the cinema was another conduit of style. The Shanghainese saw modern interiors in not only American and European films but in those made by studios at home. Homegrown movies imitated those of Hollywood in employing chrome strips, mirroring surfaces and glass panels as detailing in their Art Deco sets to signify glamour and modernity.

In one Shanghai-made movie, *New Women* (1934), we see the humble home of a struggling writer played by Ruan Lingyu, the Chinese Garbo, contrasted with the home of a rich bad man who has designs on her. His apartment has decorative details straight out of

Scene from *Earthly Immortal* shot in fashionably modern and glamorous set with Art Deco graphics. From *Arts & Life*, Nov 1934.

the vocabulary of Art Deco: ribbed mouldings on walls, parallel lines and ogees on window panes, wall lights in chevron and stepped rectangular shapes, tubular chairs of chrome-plated steel. In his first appearance in this setting, he is in a dressing gown of Deco-patterned silk; in his next appearnce he is in a tuxedo. Like the furnishings, such clothes potently suggest a luxurious, modern lifestyle. Modernist styling appears in the sets of many other Chinese films of the 1930s: *A Flowered Islet; Earthly Immortal; The Maidens' Classic* and *Plunder of Peach and Plum*, to name just four. In a scene from one of Ruan Lingyu's films, *Goodbye, Shanghai*, the style is emphasized by a framed poster of an ocean liner with the sharply raked prow, seen from below and disproportionately large, that is still familiar to us from the travel graphics of the Deco era, a time when speed and transportation were exalted.

As with Hollywood movies, the cinema-set interiors did not reproduce reality so much as heightened it, film itself being a purveyor of dream worlds and illusion. The sets could simply have mimicked those of American movies. After all, the Chinese were dab hands at copying published Western images: in her book *Selling Happiness:*

Calendar Posters and Visual Culture in Early Twentieth-Century Shanghai, Ellen Johnston Laing juxtaposes Xie Zhiguang's calendar poster *Girl Holding Ken-i-kocho-jo Box* for 1931 with a page from the 1928 issue of the *Ladies' Home Journal* to show how faithfully Xie had copied his background room setting from an American advertisement for Karpen furniture. Hang Zhiying could have done the same in his 1930s poster

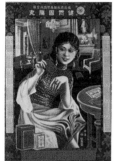

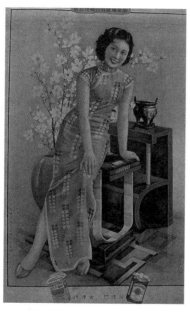

(*Top and bottom left*) Artwork by Xie Zhiguang in poster advertising ken-i-kocho-jo tablets plagiarizes *Ladies' Home Journal* (Oct 1928), 1931. From Ellen Johnston Laing: *Selling Happiness*, Honolulu, 2004.

(*Right*) Poster by Hang Zhiying advertising Hatamen and Gold Bar Cigarettes, 1930s.

for Hatamen and Gold Bar cigarettes: the piece of furniture pictured in it, an assemblage of arcs, verticals and horizontals with a flat aluminium band curved in tension could have been taken from an imported magazine rather than from life.

Yet the cinema images did reflect the newest trends towards horizontal lines, rounded corners or angular, cubic forms, and, more to the point, they did influence taste. Between the 1980s and 1990s (and even into the 2000s) furniture like the kind seen in the movies I named filled whole warehouses in Shanghai, sourced from prewar homes that were

Chair in 'Shanghai Deco' style, 1930s. Patrick Cranley Collection and photo.

demolished in the frenzy of urban renewal that overtook the city during those decades. The pieces are bought and sold as antiques, often to expatriates keen to acquire examples of 'Shanghai Deco' to go with the 1930s homes they rent or own.

The locally produced furniture was a world apart from the one-off, luxuriously veneered and inlaid furniture of the star French decorators at the 1925 Paris exposition. By and large the Shanghai pieces, which combined machine with hand production, were made for the average consumer rather than the luxury market, and their makers used materials nowhere near as exquisite as those exploited by French cabinetmakers. If they produced home furnishings in a modern European style, they did so with recourse to the woods with which they were already familiar, either because they were homegrown or they had been used for classical Chinese furniture.

A Chinese habit trying to taxonomists is the naming of woods by their appearance, colour and smell rather than by genus or botanical classification, with the result that more than one species of tree could go by the same name, or the same timber by different names. Hence references to 'elm' or 'mahogany' found in antique dealers' advertisements or brochures today are seldom accurate; nor could they be when a way has yet to be found of matching all three nomenclatures, the Chinese with the English *and* the botanical. Nevertheless, much of the furniture that has been passed down from that time to the present-day collector can be identified with certainty as *hongmu*, the 'rosewood' that is Burma padauk by another name, and as woods of the Ulmaceae family – what is called *yumu* in Chinese and, subordinate to it, the species *jumu*.

In the interwar period padauk pieces came second to white-painted furniture in the desirability scale, the latter judged the most upmarket if it was in the Western or *modeng* style. Such furniture, often acquired from European homes and repainted, was sold or hired out by woodwork shops. Shanghai, a

city of immigrants and transients, harboured a large number of inhabitants who rented rather than owned their furniture. The shops from which they did this charged ten dollars a month for a full suite of white-painted Western-style furniture, six or seven dollars for padauk, and three or four dollars for China fir. According to a guide to Shanghai published in 1934, shops which hired out the first two types would be located in upscale neighbourhoods like Avenue Joffre (in the French Concession) and Sichuan Road North (in the International Settlement), and their customers would be courtesan houses (the appointments of which were customarily fashionable), shops, and couples secretly living in sin.

(Left) Tiaoji, Ming dynasty (1368-1644). Collection of Mdm Chen Mengjia. From Huang Shixiang, Mingshi jiaju zhenshang, Hong Kong, 1985.

(Right) Console, 1930s. Photo by Edward Denison.

In terms of style, Shanghai's Western furniture was indigenized to the extent that with some pieces, it is hard to say if they are Art Deco given a Chinese interpretation or classical Chinese with an Art Deco inflection. Take the Ming-dynasty table the Chinese call *tiaoji*, which stands on scrolled feet termed *juanshu*. When this comes in an early twentieth-century version, it is a *tiaoji* still, and the scrolled feet are there, but the whole is now contoured in a style that is decidedly modern. It takes little to recognize that there is a formal and stylistic affiliation between Art Deco and the more pared-down examples of classical Chinese furniture. Perhaps the well-defined outlines of modernist furniture would have caught on less quickly if the ground had not been prepared by the characteristic purity of Ming-style furniture. For

Chinese furniture makers to accept simple, unadorned shapes, no formal radicalism was required.

These craftsmen did not, however, eschew decoration altogether, and for detailing they had the stock of traditional Chinese motifs to draw upon in addition to the Art Deco vocabulary. The latter comprised sharply incised parallel ribs or indentations as well as stepped or ziggurat elements, while the Chinese patterns, ususally carved, were often floral. Sometimes a single piece could be claimed by both idioms, classical Chinese and modern Western, the whole being a stylistic mingling that was very much in the spirit of Shanghai. Occasionally the mingling resulted in a hodgepodge, as when a 'keglike' Chinese stool mixed parallel rib decoration with baluster-turned legs instead of straight ones.

But then the Shanghainese took forms and motifs from a wide range of sources and used them unapologetically. That, after all, was how Shanghai Style evolved. As these sources were subject to changes in taste and fashion, a widely produced Shanghai-Style object like a mahjong table, one made of Burma padauk wood and decorated with Art Deco's speed lines, would lose its appeal too and eventually become outdated. Today such objects are back in favour and seriously collected, or else they are reproduced and incorporated into interior designs I could only call Revival Shanghai Deco. One example of this would

do for all. The interior decoration of a haut-cuisine restaurant called the Whampoa Club mixes Revival Shanghai Deco with Chinese kitsch to provide a modishly nostalgic effect, attempting to achieve this by, among other things, mounting wall panels whose design is copied almost wholesale from *Oasis*, the exquisite iron and brass screen created in about 1924 by the French metalworker Edgar Brandt.

Nowadays the built environment is chief among representations Shanghainese use to see, affirm and present themselves, with the shiny towers of glass and immense clumps of office blocks and shopping malls serving to attest the identity and, they imagine, the value and modernity of the city and its inhabitants. But those observers who think this identity continuous with that of six, seven decades before are mistaken, for, as anyone who witnessed Shanghai's urban degradation in the intervening years knows only too well, life, art and style took a different turn with the triumph of communism and the attendant change of ideology in 1949.

EPILOGUE: SINCE THEN

It may be wondered why my account barely touches on the Modern Woodcut Movement when, like the other types of art and design I survey, it was centred on Shanghai, it borrowed similarly from the modernist West, and its practitioners were thrown up by the same intellectual ferment that brought the other avant-garde artists into being. There was also a link in Lu Xun, who started it and brought to it his own cosmopolitan taste in art and design, recommending to Chinese students the work of the Belgian Frans Masereel, and above all that of the German Expressionist Käthe Kollwitz. There was equally a connection to Japan, by way of which so many Chinese learned about things European, with

(*Opposite*) Detail of illustration on page 10.

the Japanese instructor Uchiyama Kakichi teaching woodblock techniques to the first batch of Chinese students during his visit to Shanghai, where his brother owned the bookshop Lu Xun frequented. Yet it would occur to no Shanghainese to call it Haipai, and all would agree that something about it places it beyond the category of Shanghai Style.

Just looking at the prints of the 1930s, or even their titles – *Demanding a Three Eight-Hour Work System* (eight hours of work, eight hours of rest, eight hours of education), say, or *Harvest* – is enough to reveal what that something is. The first title indicates an engagement with social, and hence political, issues; the second a rural interest. The printmakers put utopian store by the potential of individual creativity to transform society and believed it necessary for the visual image to play a socially critical role. If they looked to Käthe Kollwitz for inspiration, as her devoted fan Lu Xun urged, it was, as he writes, because she shows that 'there are others "injured and insulted" like us in many places on earth, as well as artists who mourn, protest and struggle on their behalf.' These printmakers were largely left-leaning, apt to believe, as the manifesto of an art club exhibiting at the Shanghai

Harvest. Woodcut, 1933. Lu Xun Memorial Museum, Shanghai.

YMCA in 1932 put it, that 'Modern art must follow a new road, must serve a new society, must become a powerful tool for educating the masses, informing the masses and organizing the masses. The new art must accept this mission as it moves forward.' Not for nothing was the movement canonized by the communist regime as the art of the revolution. There could be no question of such a movement making its values out of the materials of commercial life, the very stuff of Shanghai Style, or engaging with the urban marketplace the way so many Haipai artists did from necessity and preference.

Of course this is not to say that to be Haipai was to be socially uncritical, since one has only to remember sketch artists like Lu Zhixiang and Cai Ruohong to know that this was far from the case. Yet Haipai can be grasped without understanding national politics, radical political ideology or utopianism, whereas the woodcut movement certainly can't. The latter was what Haipai works could never be, namely a call to arms. This became all the truer when, with the Japanese invasion in 1937, the movement grew more urgently ideological.

The war marked a break for all artists, with most art schools moving out of Shanghai to inland locations. Its brutalities politicized many and persuaded not a

Captions to sketches by Liang Baibo in anti-war cause read: 'Leaving the kitchen and boudoir to assume the heavy responsibility of killing the enemy' (*left*), and 'Soldiers and civilians cooperate to resist violent enemy' (*right*).

few to put their art in the service of resistance and propaganda. That patriotic response already contained the seeds of Haipai's decline, though killing it off would take the famous – and later canonized – talks which Mao Zedong gave on literature and art in 1942 in Yan'an, the communists' mountainous stronghold during the war, and all that was to follow from them. Those talks set the stage for the subservience of art to politics, for party patronage and control of artists, and for the promotion of imagery that used the vernacular of 'the masses' and could be easily grasped by them.

Following the inauguration of the People's Republic the Central Academy of Fine Arts in Beijing, headed by Xu Beihong, whose hostility to modernism we have already seen, became the dominant influence on the direction of art in China. 'What accounts for Xu Beihong's leap to the number one position in the Chinese art world?' asks Zheng Gong in her book *Movement and Evolution: The Modernization of the Fine Arts in China* (2002) His dedication from start to finish to realism, she answers. This became Soviet Socialist Realism, which prevailed until about 1957, when, at Mao's instigation, a style purportedly integrating Revolutionary Realism with Revolutionary Romanticism replaced it.

None of this took place without a great deal of what now seems pointless and absurd debate among art critics and theoreticians. Meanwhile, a student of oil painting could go through art school in complete ignorance that there had been a modernist interlude in Shanghai, denied all access to the materials of the 1930s and taught by teachers who complied with official policy by giving no hint whatsoever of their past involvement in the avant-garde.

The case of one such student, Zheng Shengtian, is typical. In 1962, when state controls briefly loosened, he stumbled upon a survey of European art translated and compiled by Lin Fengmian in a secondhand bookshop in Beijing. At the time Zheng was studying in Hangzhou, at the art academy once thoroughly identified with Lin; but such was the official hostility

to modernism that Lin himself was then living in reclusion in Shanghai, his art eliminated from the academy following a 1950s campaign against 'new-style' painting. The book, published in Shanghai in 1936, had sections on Fauvism, Cubism and other European movements, together with reviews of exhibitions held in Paris and Brussels. Zheng reports (in the catalogue of an exhibition called *Shanghai Modern* in Munich in 2004-2005) that he was astonished by the book, having had no inkling that readers knew such things in Shanghai in the 1930s and were so much in step with the times, just as he was surprised when Lin's ink paintings were allowed for the first time to be exhibited in Beijing. He came away from the show 'drunk,' from the 'extraordinary artistic treat,' he writes, only to be met with scorn by an older viewer, who told Zheng that it was nothing new and he could have seen it all thirty years back.

So in a manner of speaking Zheng's generation was thirty years behind and Lin's was right up to date. The latter had access, as Zheng's generation did not, to other cultures, other worlds, and that access was at its widest and easiest in Shanghai, the place you had to be, as the Storm Society co-founder Ni Yide has said, if you couldn't get to Paris; Shanghai was 'the hub of the newly emerging art' where novel excitements galore could be experienced.

It ceased to be so not only because of the deliberate historical amnesia but because the government privileged Beijing over Shanghai, establishing and supporting art and design academies there while leaving Shanghai out in the cold. Shortly after 1949 Shanghai suffered a brain drain, losing many of its most accomplished artists to teaching, publishing or bureaucratic jobs in Beijing. Of the painters Liu Haisu stayed, but Ni Yide, Pang Xunqin and others all ended up in Beijing. Qian Juntao resisted relocation, indeed was simply too thoroughly Shanghainese to take to Beijing, but among others Ding Cong, Lu Shaofei, Lu Zhixiang, Ye Qianyu and Zhang Guangyu all left for the capital, depleting the ranks of graphic artists in Shanghai.

The calendar poster artists were set to work painting propaganda posters, politically correct images extolling industrial productivity, bountiful harvests and the like, and reincarnating the sexy, wavy-haired pin-up in a fresh-faced, pigtailed country lass. Communism's victory was the cue for people of a bourgeois, business or moneyed background to quit China altogether, and among those numbered Zhang Yingchao, who went abroad and was never heard of again; and Guo Jianying, who decamped to Taiwan and died there a successful banker in 1979.

'Chairman Mao, Great Leader of the People of China.' Propaganda poster by Li Mubai, 1951. Li, a member of Hang Zhiying's Studio, was clearly generalizing to this poster from the style in which he painted calendar girls: only very little modification would be required to transform the faces of the children back into those of the pin-ups.

There was something in Haipai that could not transplant into a different society, be this Beijing or Taipei, nor to another age, for all the talk in the 1990s of Shanghai regaining its former glory. It was not simply a matter of visual style; it issued from a way of life rooted in a particular set of historical and economic circumstances that prevailed in the late nineteenth and early twentieth centuries and was stopped in mid-flow by war and revolution. It came of that moment when the very old and the very new ran not one behind the other but hand in hand. Inseparable from commercial enterprise, it could not outlast private capital's death by central planning.

No place merely exists; it must be imagined, supplied with legends, stories and symbols. When these change, style changes. When the once-booming book, print, entertainment and leisure market ceased to glamorize the hedonism and conspicuous consumption of the city, Shanghai Style lost much of its sustenance. Since the nineteenth century, bright lights that turned 'night into day' (powered first by gas, then by electricity) had been a stock image of Shanghai. Now neon-lit Haipai gave way to a darkening, literally, as lighting for display and publicity dimmed, and the surface and sometimes tawdry glitter faded.

The Destruction of Shanghai.
Sketch by Hu Kao, 1937.

ACKNOWLEDGEMENTS

For permission to use their excellent photographs, I am grateful to Er Dongqiang, Edward Denison, Ip Kung Sau and Patrick Cranley. I must also thank Jean-Yves Bajon for allowing me to reproduce an image from his collection of Chinese propaganda posters, and to Didier and Marie Claude Millet for helping to contact him. Nancy Berliner put me in touch with Christine Michelini, who was kind enough to send me a photograph from the Peabody Essex Museum. I learned a great deal from Anne Carmichael's memories of her grandparents' house in Shanghai and from the photographs she sent me of its interiors. I am grateful to them all.

Jonathan Hutt kindly gave me a copy of *Xunmei wencun*; Shao Min a copy of *Zhongguo youhua zhan zuopin ji*; Lee Chor Lin a copy of W.L. Wilson's article and Anna Jackson her essay for the catalogue of the Victoria & Albert Museum exhibition *Art Nouveau 1890-1914*. My thanks to them all.

I am indebted to Kazuko Asakura for her translations of Japanese texts, and to Catherine Stenzl for her translations of German ones. My thanks also to Liu Jing, who provided research assistance, particularly at the Shanghai Library; to James Chang, who drove me to the Pang Xunqin Art Gallery in Changshu, where I benefited from the kindness of Zhong Weixing. Qian Zonghao identified two of the buildings named in this book, and most proficiently photographed many more. The page layout of this book would have been infinitely more protracted had it not been for the help of Tony Wan, Frank Zheng and Yao Zhang.

I count myself lucky to have had a sharp-eyed

editor in Tina Kanagaratnam, a creative designer in Edith Yuen, and an ever supportive publisher in Anne Lee. But I have been dependent above all on Fan Jianfeng, a computer genius whose technical help has been invaluable.

Finally, I should thank all the authors from whose books and collections (named in my text) I have taken illustrations and other material. Without their work and expertise, I could not have written this book.

Shanghai
June 2007

267

SELECTED
BIBLIOGRAPHY

Andrews, Julia F. and Kuiyi Shen. *A Century in Crisis: Modernity and Tradition in the Art of Twentieth-Century China*. New York: Guggenheim Museum, 1998.

Bajon, Jean-Yves. *Les Années Mao: Une Histoire de la Chine en Affiches (1949-1979)*. Paris: Les Éditions des Pacifiques, 2001.

Barmé, Geremie R. *An Artistic Exile: A Life of Feng Zikai (1898-1975)*. Berkeley: University of California Press, 2002.

Bergère, Marie-Claire. *The Golden Age of the Chinese Bourgeoisie*. Trans. Janet Lloyd. Cambridge: Cambridge University Press, 1986.

Bi Keguan. *Zhongguo manhua shihua* [A History of Chinese Cartoons]. Jinan: Shandong meishu chubanshe, 1982.

Chen Chaonan and Feng Yiyou. *Old Advertisements and Popular Culture: Posters, Calendars and Cigarettes, 1900-1950*. San Francisco: Long River Press, 2004.

Chen Chuanxi and Gu Ping. *Chen Zhifo*. Shijiazhuang: Hebei jiaoyu chubanshe, 2002.

Chen Congzhou and Zhang Ming (eds). *Shanghai jindai jianzhu shigao* [A Draft History of Modern Architecture in Shanghai]. Shanghai: Sanlian shudian, 1988.

Chen Xing. *Li Shutong*. Wuhan: Hubei renmin chubanshe, 2002.

—— *Feng Zikai manhua yanjiu* [Researches on Feng Zikai's Sketches]. Hangzhou: Xiling yinshe, 2004.

Chen Zishan (ed). *Modeng Shanghai: sanshi niandai yangchang bai jing* [Modern Shanghai: Scenes of Shanghai's Foreign Enclaves in the 1930s]. Guilin: Guangxi shifan daxue chubanshe, 2001.

—— *Ye Lingfeng san wen* [Ye Lingfeng's Selected Essays]. Hangzhou: Zhejiang wenyi chubanshe, 2003.

Chou, Ju-hsi (ed). *Art at the Close of China's Empire.*

Phoebus Occasional Papers in Art History 8, Arizona State University, 1998.

Clarke, David. *Modern Chinese Art*. Hong Kong: Oxford University Press, 2000.

Cochrane, Sherman (ed). *Inventing Nanjing Road: Commercial Culture in Shanghai, 1900-1945*. Ithaca: East Asia Program, Cornell University, 1999.

Cohn, Don J. *Vignettes from the Chinese: Lithographs from Shanghai in the Late Nineteenth Century*. Hong Kong: The Chinese University Press, 1987.

Croizier, Ralph. 'Post-Impressionists in Pre-War Shanghai: The Juelanshe (Storm Society) and the Fate of Modernism in Republican China.' In *Modernity in Asian Art*, John Clark (ed). Broadway, New South Wales: Wild Peony, 1993.

Crossman, Carl L. *The Decorative Arts of the China Trade: Paintings, Furnishings and Exotic Curiosities*. Woodbridge: the Antique Collectors' Club, 1991.

Dai Yuyun. *Shanghai xiaojie* [The Shanghai Miss]. Shanghai: Shanghai huabao chubanshe, 1999.

Deng Ming (ed). *Shanghai bainian lue ying 1840s-1940s (Survey of Shanghai 1840s-1940s)*. Shanghai: Shanghai renmin meishu chubanshe, 1996.

Denison, Edward and Guang Yu Ren. *Building Shanghai: The Story of China's Gateway*. Chichester: John Wiley & Sons, 2006.

Ding Cong. *Ding Cong lao manhua* [Ding Cong's Old Sketches]. Beijing: Sanlian shudian, 2004.

Ding Song. *Shanghai shizhuang tu yong* [Shanghai Fashions in Pictures and Verse]. Shanghai, 1916. Reprint, Taipei: Guangwen shuju, 1968.

Duncan, Alistair. *Art Deco*. London: Thames & Hudson, 1988. Reprint, 2001.

Fang Ailong. *Hongyi dashi xin lun* [New Essays on Master Hongyi]. Hangzhou: Xiling yinshe chubanshe, 2000.

Feng Yiyou. *Lao xiangyan paizi* [Vintage Cigarette Cards]. Shanghai: Shanghai huabao chubanshe, 1996.

Field, Andrew D. 'Selling Souls in Sin City: Shanghai Singing and Dancing Hostesses in Print, Film, and Politics, 1920-49.' In *Cinema and Urban Culture in Shanghai, 1922-43*, Yingjin Zhang (ed). Stanford: Stanford University Press, 1999.

Gu Yinhai. *Banhua: ke xie shiqu de changjing* [Woodblock Prints: Past Scenes Engraved]. Shanghai: Shanghai shudian chubanshe, 2003.

Guojia tushuguan (ed). *Ding Song manhua ji* [A Collection of Ding Song's Sketches]. Beijing: Zhongguo wenlian chubanshe, 2004.

Haipai huihua yanjiu wenji [Studies on the Shanghai School of Painting]. Shanghai: Shanghai shuhua chubanshe, 2001.

Hay, Jonathan. 'Painters and Publishing in Late Nineteenth-Century Shanghai.' In *Art at the Close of China's Empire*, Ju-hsi Chou (ed). Phoebus Occasional Papers in Art History 8, Arizona State University, 1998.

Heijdra, Martin J. 'The Development of Modern Typography in East Asia.' *The East Asian Library Journal*, vol xi, no 2, Autumn 2004.

Hibbard, Peter. *The Bund, Shanghai*. Hong Kong: Odyssey Books & Guides, 2007.

Hong Lin and Qiu Leisheng (eds). *Zhongguo lao shangbiao tu lu* [An Illustrated Collection of Vintage Chinese Trademarks], vols 1 & 2. Beijing: Zhongguo shangye chubanshe, 2001.

Huang Zhiwei and Huang Ying. *Wei shiji daiyan: Zhongguo jindai guanggao* [Speaking for their Age: Modern Chinese Advertisements]. Shanghai: Xuelin chubanshe, 2004.

Huebner, Jon W. 'Architecture on the Shanghai Bund.' *Papers on Far Eastern History* 39, 1989.

Hui Lan. *Liu Haisu.* Shijiazhuang: Hebei jiaoyu chubanshe, 2003.

Hutt, Jonathan. 'La Maison d'Or: The Sumptuous World of Shao Xunmei.' *East Asian History*, no 21, June 2001.

Jackson, Anna. 'Orient and Occident.' In Paul Greenhalgh (ed). *Art Nouveau 1890-1914.* London: Victoria & Albert Museum, 2000.

Jiang Deming. *Shuyi bai ying 1901-1949* [A Hundred Book Covers 1901-1949]. Beijing: Sanlian shudian, 1999.

——— *Shuyi bai ying 1906-1949* [A Hundred Book Covers 1906-1949]. Beijing: Sanlian shudian, 1999.

——— *Chatu shi cui* [Selected Illustrations]. Beijing: Sanlian shudian, 2000.

Johnston, Tess, and Deke Erh. *A Last Look: Western Architecture in Shanghai.* Hong Kong: Old China Hand Press, 1993.

——— *Frenchtown Shanghai: Western Architecture in Shanghai's Old French Concession.* Hong Kong: Old China Hand Press, 2000.

Jones, Richard. 'Metalwork of the Shanghai Bund.' *Arts of Asia*, 14, no 6, Nov/Dec 1984.

Laing, Ellen Johnston. *Selling Happiness: Calendar Posters and Visual Culture in Early-Twentieth-Century Shanghai.* Honolulu: University of Hawai'i Press, 2004.

Lang Shaojun and Shui Tianzhong. *Ershi shiji Zhongguo meishu wenxuan* [Selected Essays on Twentieth-Century Chinese Art], vols 1 & 2. Shanghai: Shanghai shuhua chubanshe, 1999.

Lang Shaojun. *Lin Fengmian.* Shijiazhuang: Hebei jiaoyu chubanshe, 2002.

Lee, Leo Ou-fan. *Shanghai Modern: The Flowering of a New Urban Culture in China 1930-1945.* Cambridge: Harvard University Press, 1999.

Li Chao. *Shanghai youhua shi* [A History of Oil Painting in Shanghai]. Shanghai: Shanghai renmin meishu chubanshe, 1995.

Li Guangyu. *Ye Lingfeng zhuan* [A Biography of Ye Lingfeng]. Shijiazhuang: Hebei jiaoyu chubanshe, 2003.

Li Hui. *Ding Cong: huajuan jiu zheiyang zhankai.* [That's the Way the Paintings Unscroll]. Zhengzhou: Daxiang chubanshe, 2001.

Li Runbo. *Gu zhi yi yin: zaoqi baokan shoucang* [Traces Left by Old Paper: Collecting Early Periodicals]. Hangzhou: Zhejiang daxue chubanshe, 2004.

Li Tiangang. *Renwen Shanghai: shimin de kongjian* [Human Shanghai: Civic Spaces]. Shanghai: Shanghai jiaoyu chubanshe, 2004.

Liao Jingwen. *Xu Beihong de yi sheng* [A Life of Xu Beihong]. Jinan: Shandong huabao chubanshe, 2001.

Lishi shang de manhua [Historic Sketches]. Jinan: Shandong huabao chubanshe, 2002.

Liu Chun. *Zhongguo youhua shi* [A History of Chinese Oil Painting]. Beijing: Zhongguo qingnian chubanshe, 2005.

Liu Xilin. *Jiang Zhaohe*. Shijiazhuang: Hebei jiaoyu chubanshe, 2003.

Liu Xin. *Shu xiang jiu ying* [Images of Books from the Past]. Changsha: Hunan meishu chubanshe, 2003.

Liu Yunlu (collector) and Lu Zhongmin (editor). *Yang hua'er* [Cigarette Cards]. Beijing: Renmin meishu chubanshe, 2004.

Lou Chenghao and Xue Shunsheng (ed). *Shanghai yingzaoye ji jianzhushi* [Shanghai's Builders and Architects]. Shanghai: Tongji daxue chubanshe, 2004.

Lü Peng. *Ershi shiji Zhongguo yishu shi* (*A History of Art*

in Twentieth-Century China). Beijing: Beijing daxue chubanshe, 2006.

Luo Suwen. *Shikumen: xunchang renjia* [Shikumen: Ordinary Households]. Shanghai: Shanghai renmin chubanshe, 1991.

Merrill, Linda. 'Whistler and the Lange Lijzen.' *The Burlington Magazine*, vol 136, no 1099, Oct 1994.

Minguo congshu [A Republican Series], vol 4, 82. *Lu Xun xiansheng jinian ji* [Lu Xun: A Commemorative Collection]. Shanghai: Beixin shuju, 1936.

Minick, Scott and Jiao Ping. *Chinese Graphic Design in the Twentieth Century*. London: Thames and Hudson, 1990.

Mittler, Barbara. *A Newspaper for China? Power, Identity, and Change in Shanghai's News Media, 1872-1912*. Cambridge, Mass: Harvard University Asia Center, 2004.

Mu Shiying. *Shanghai de hubuwu* [Shanghai Foxtrot]. Shanghai: Xiandai shuju, 1932. Reprint, Beijing: Jingji ribao chubanshe, 2002.

Ng Chun Bong, Cheuk Pak Tong, Wong Ying and Yvonne Lo. *Chinese Woman and Modernity: Calendar Posters of the 1910s-1930s*. Hong Kong: Joint Publishing Company, 1996.

Petrova, Yevgenia (ed). *Russian Futurism*. Trans. Kenneth MacInnes. St Petersburg: State Russian Museum, 2000.

Pollard, David E. *The True Story of Lu Xun*. Hong Kong: The Chinese University Press, 2002.

Qian Zonghao, Chen Zhengshu, Hu Baofang, Hua Yimin. *Zou zai lishi de jiyili* (Walking into the Historical Memory). Shanghai: Shanghai History Museum, 2000.

—— *Bainian huiwang* [Looking Back a Hundred

Years]. Shanghai: Shanghai kexue jishu chubanshe, 2005.

Qiu Ling. *Shuji zhuangzhen yishu jianshi* [A Brief History of Chinese Book Design]. Harbin: Heilongjiang renmin chubanshe, 1984.

Reed, Christopher. *Gutenberg in Shanghai: Chinese Print Capitalism, 1876-1937*. Hong Kong: Hong Kong University Press, 2004.

Renditions. Special Issue: *Middlebrow Fiction*. Nos 17 & 18, Hong Kong: The Chinese University of Hong Kong, 1982.

Roschen, Axel and Thomas Theye (ed). *Abreise von China: Texte und Photographien von Wilhelm Wilshusen 1901-1919*. Basel: Stroemfeld; Frankfurt: Roger Stern, 1980.

Rybczynski, Witold. *The Look of Architecture*. New York: Oxford University Press, 2001.

Sang Ronglin (ed). *Shanghai jianzhu fengmao (A Variety of Shanghai Buildings)*. Shanghai: Shanghai renmin chubanshe, 1992.

Shi Meiding (ed). *Zhuiyi – jindai Shanghai tu shi* [Reminiscences – An Illustrated History of Modern Shanghai]. Shanghai: Shanghai guji chubanshe, 1996.

Shūji Takashina. 'Eastern and Western Dynamics in the Development of Western-Style Oil Painting During the Meiji Era.' In *Paris in Japan: The Japanese Encounter with European Painting*, Shūji Takashina, J.Thomas Rimer with Gerald D. Bolas. Tokyo: The Japan Foundation, 1987.

Song Jialin. *Lao yuefengpai* [Old Calendar Posters]. Shanghai: Shanghai huabao chubanshe, 1997.

Su Lin. *20 shiji Zhongguo youhua tu ku 1900-1949* [A Storehouse of Twentieth-Century Chinese Oil

Paintings]. Nanning: Guangxi meishu chubanshe, 2001.

Sullivan, Michael. *Chinese Art in the Twentieth Century.* London: Faber & Faber, 1959.

Sun Ping. *Pang Xunqin.* Shijiazhuang: Hebei jiaoyu chubanshe, 2001.

Tan Chuliang. *Zhongguo xiandaipai wenxue shi lun* [Historical Discourses on Modernist Chinese Literature]. Shanghai: Xuelin chubanshe, 1996.

Tang Wenyi and Mu Dingsheng. *Xiaoshi de fengjing: xin wenxue banben lu* [Vanished Scenes: Editions of Works of New Literature]. Jinan: Shandong huabao chubanshe, 2005.

Tang Zhenchang (ed). *Jindai Shanghai fanhua lu (Shanghai's Journey to Prosperity 1842-1949).* Hong Kong: The Commercial Press, 1996.

Tata, Sam and McLachlan, Ian. *Shanghai: 1949 The End of An Era.* London: Batsford, 1989.

Turner, Matthew. *Made in Hong Kong: A History of Export Design in Hong Kong 1900-1960.* Hong Kong: Urban Council, 1988.

Wang, Eugene Y. 'Sketch Conceptualism as Modernist Contingency.' In *Chinese Art: Modern Expressions,* Maxwell K. Hearn and Judith E. Smith (eds.) New York: Metropolitan Museum of Art, 2001.

Wang Xirong. *Huazhe Lu Xun* [Lu Xun, Maker of Pictures]. Shanghai: Shanghai wenhua chubanshe, 2006.

Wen Liming. *Wen Yiduo hua zhuan* [A Pictorial Biography of Wen Yiduo]. Zhengzhou: Henan renmin chubanshe, 2005.

Wen Lipeng and Zhang Tongxia. *Wen Yiduo.* Beijing: Renmin meishu chubanshe, 1999.

Wilson, G.L. 'Architecture, Interior Decoration, and Building in Shanghai Twenty Years Ago and Today.' Shanghai: *The China Journal*, vol xii, no 5, May 1930.

Wu He. *Zhishang jingling: 20 shiji 30 niandai de manhua mingxing* [Spirit on Paper: 1930s Comics Stars]. Beijing: Sanlian shudian, 2003.

Wu Jiang. *Shanghai bainian jianzhu shi (The History of Shanghai Architecture 1840-1949)*. Shanghai: Tongji daxue chubanshe, 1997.

Xiao Chan. *Feng Zikai*. Shijiazhuang: Hebei jiaoyu chubanshe, 2002.

Xie Qizhang. *Chuangkanhao: Fengjing* [Inaugural Issues: Scenes]. Beijing: Beijing tushuguan chubanshe, 2003.

—— *Chuangkanhao: jianying* [Inaugural Issues: Silhouettes]. Beijing: Beijing tushuguan chubanshe, 2004.

—— *Jiushu shoucang* [Collecting Secondhand Books], Shenyang: Liaoning huabao chubanshe, 2004.

—— *Fengmian xiu* [The Beauty of Book Covers]. Beijing: Zuojia chubanshe, 2005.

Yang Li'ang and Peng Guoliang. *Gen Lu Xun ping tu pin hua* [Appreciating Pictures with Lu Xun]. Changsha: Yuelu shushe, 2003.

Yang Yi. *Jingpai Haipai zonglun* [Beijing Style and Shanghai Style Summarized]. Beijing: Zhongguo shehui kexue chubanshe, 2003.

Yao Zhimin, Wang Zhongming, Zhang Zhenhua and Bian Qiangsheng (ed). *Shu ying* [Book Images], vols 1 & 2. Shanghai: Shanghai yuandong chubanshe, 2003.

Ye Shusui and Yang Yanli. *Cong Lu Xun yiwu renshi Lu Xun* [Understanding Lu Xun Through His Relics]. Beijing: Zhongguo renmin daxue chubanshe, 1999.

Ye Xiaoqing. *The Dianshizhai Pictorial: Shanghai Urban*

Life, 1884-1898. Michigan Monographs in Chinese Studies 98. Ann Arbor: Center for Chinese Studies, University of Michigan, 2003.

Ye Yonglie. *Fulei hua zhuan* [An Illustrated Biography of Fu Lei]. Shanghai: Fudan daxue chubanshe, 2005.

Yeh, Catherine Vance. *Shanghai Love: Courtesans, Intellectuals, and Entertainment Culture, 1850-1910.* Seattle: University of Washington Press, 2006.

Yi Bin, Liu Wenming and Gan Zhenhu. *Lao Shanghai guanggao* [Old Shanghai Advertising]. Shanghai: Shanghai huabao chubanshe, 1993.

Yokohama and Shanghai: Two Modern Treaty Ports. Catalogue of an exhibition, Yokohama and Shanghai, Oct 30, 1993-Feb 6, 1994. Yokohama Treaty Port Archives.

You Guoqing. *Zaijian lao guanggao* [Vintage Advertisements Revisited]. Tianjin: Baihua wenyi chubanshe, 2003.

Yu Runqi. *Tang Tao cangshu* [Tang Tao's Book Collection]. Beijing: Beijing chubanshe, 2004.

Yuan Yunyi. *Pang Xunqin zhuan* [A Biography of Pang Xunqin]. Beijing: Beijing gongyi meishu chubanshe, 1996.

Zhang Ailing. *Chuanqi* [Romances]. Expanded edition. Shanghai, 1945.

—— *Liu yan (Written on Water).* Shanghai: Zhongguo kexue gongsi, 1945.

Zhang Guangyu. *Jindai gongyi meishu* [Modern Decorative Arts]. Shanghai: Shangguo meishu kanhang, 1932.

Zhang Leping with Ding Yanzhao and Yu Zhi. *Shanghai Memory: Zhang Leping huabi xia de sanshi niandai.* [Shanghai Memory: The Thirties as Revealed

by Zhang Leping's Brush]. Shanghai: Shanghai cishu chubanshe, 2005.

Zhang Tianman. *Ye Qianyu*. Shijiazhuang: Hebei jiaoyu chubanshe, 2002.

Zhang Wei. *Hudu jiu ying* [Images of Shanghai's Past]. Shanghai: Shanghai cishu chubanshe, 2002.

Zhang Yingjin (ed.). *Cinema and Urban Culture in Shanghai, 1922-1943*. Stanford: Stanford University Press, 1999.

Zhang Zexian. *Shu zhi wu ye: mingguo banben zhi jian lu* [The Five Leaves of Books: A Record of Known and Seen Republican Editions]. Shanghai: Shanghai yuandong chubanshe, 2005.

Zheng Gong. *Yanjin yu yundong: Zhongguo meishu de xiandaihua* [Evolution and Movement: the Modernization of the Fine Arts in China]. Nanning: Guangxi meishu chubanshe, 2001.

Zheng Zu'an. *Bainian Shanghai cheng* [A Hundred Years of Shanghai]. Shanghai: Xuelin chubanshe, 1999.

—— *Haishang jianying* [Shanghai Silhouettes]. Shanghai: Shanghai cishu chubanshe, 2001.

Zhong Weixing. *Yishu chizi de qiusuo: Pang Xunqin yanjiu wenji* [An Artist's Search: Research Papers on Pang Xunqin]. Shanghai: Shanghai shehui kexue yuan chubanshe, 2003.

Zhongguo youhua xuehui (ed). *Zhongguo youhua zhan zuopin ji (China: Art in the Twentieth Century)*. Nanning: Guangxi meishu chubanshe, 2000.

Zuo Xuchu. *Lao shangbiao* [Vintage Trademarks]. Shanghai: Shanghai huabao chubanshe, 1999.

Index

Numbers in **bold** refer to illustration captions